James Frank's
COLORADO

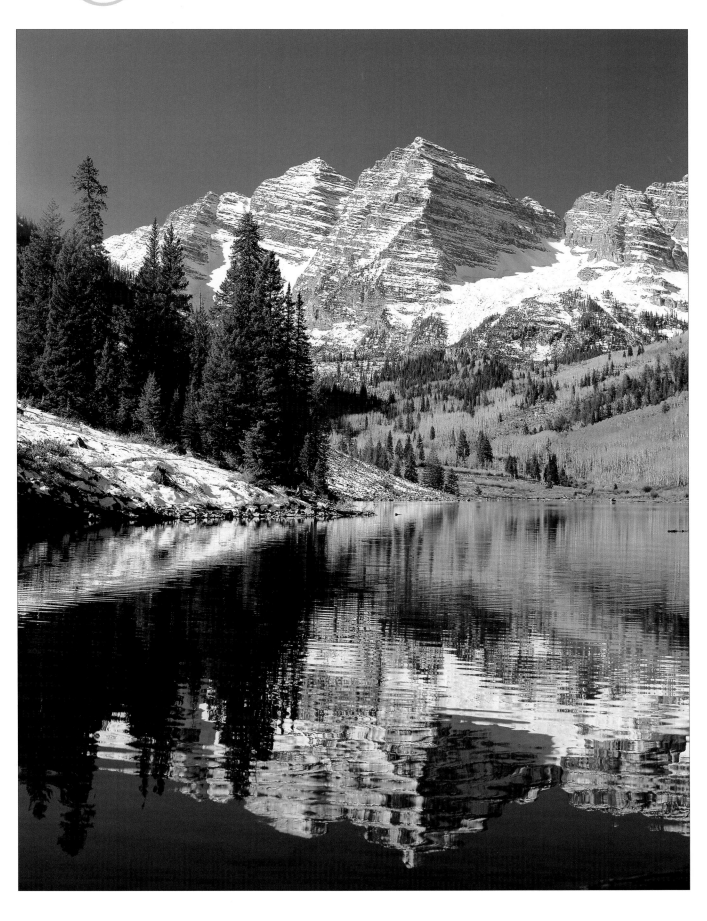

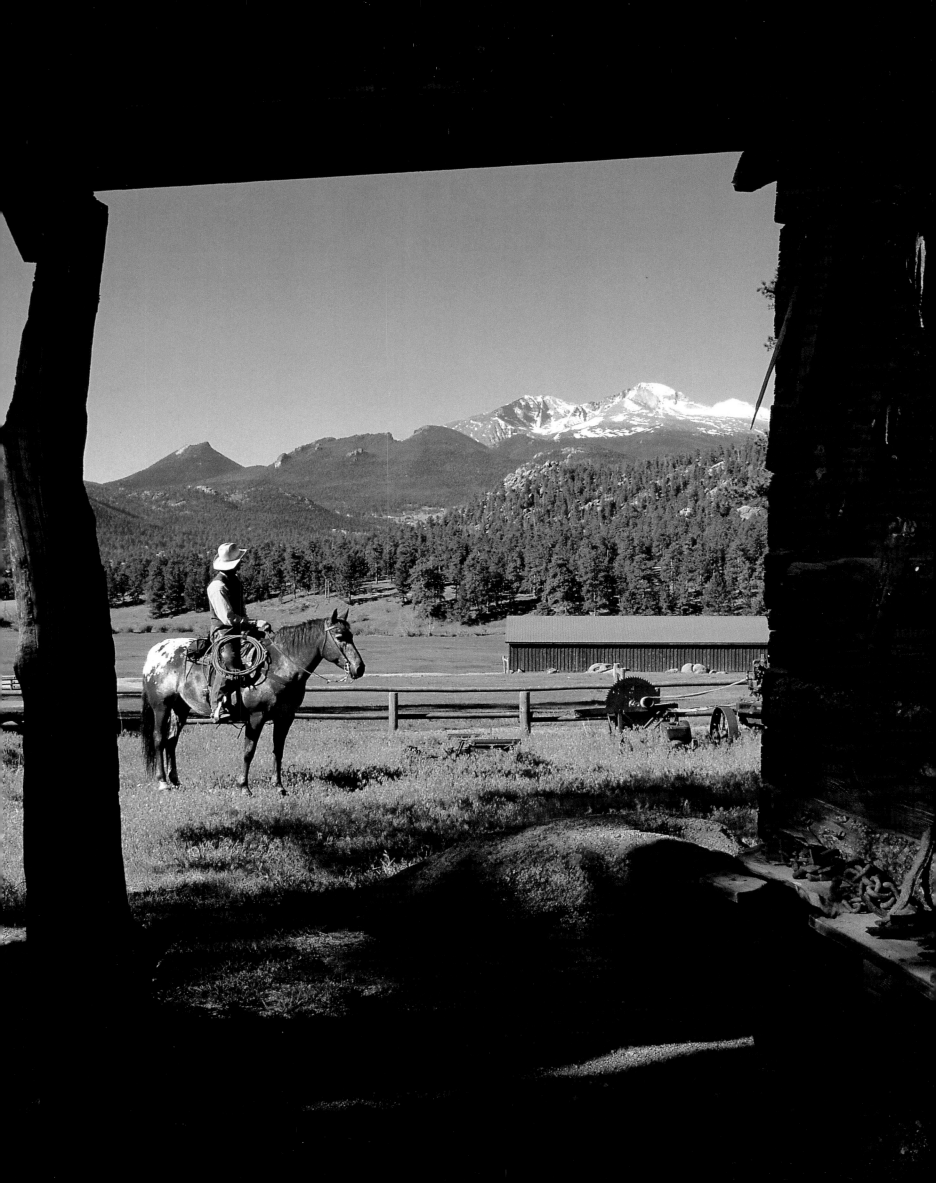

James Frank's
COLORADO

photographs and text by James Frank

Altitude Publishing

PUBLICATION INFORMATION

Cataloging in Publication Data

Frank, James.
Colorado
Maroon Bells cover: ISBN 1-55265-018-9
Waterfall cover: ISBN 1-55265-019-7
1. Colorado--Pictorial works. I. Title.
F777.F72 1999 978.8′022′2 C99-910045-9

Production

Concept/Design by Stephen Hutchings
Electronic page layout by Scott Manktelow
Edited by Dan Klinglesmith
Copy Edited by Sabrina Grobler
Financial management by Laurie Smith

Dedication

For the extraordinary people who have touched my life and freely give of themselves to
others. For all those who love nature and find it a revitalizing force. For my family—all of
them—and especially my lovely wife and daughter, Tamara and Claire; mom and dad, Charles
and Catherine Jarolimek; and my sister, Barbara. Thank you for your support and inspiration.

Altitude GreenTree Program

Altitude Publishing will plant twice as many trees as were used in the manufacturing of this
book. To date, Altitude is responsible for the planting of over 32,000 trees.

Printed and bound in Canada by Friesen Printers, Altona, Manitoba

Front cover, *Maroon Bells edition: Maroon Bells, White River National Forest*
Front cover, *waterfall edition: Glacier Creek, Rocky Mountain National Park*
Back Cover: *Garden of the Gods*
Previous page: *Cowboy and companion, MacGregor Ranch*

Right: *Bighorn sheep, Rocky Mountain National Park*
*Bighorn sheep (Ovis canadensis) are Colorado's official state mammal
and the animal symbol of Rocky Mountain National Park.*

Altitude Publishing Ltd.
4255 South Buckley Road, # 309
Aurora, Colorado 80013
1-800-957-6888

James Frank's COLORADO

CONTENTS

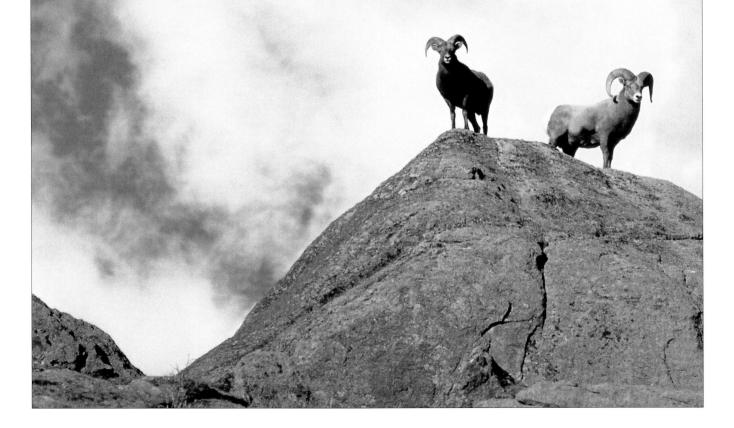

7 – Introduction

9 – Eastern Plains

15 – Denver and the Front Range

35 – Pikes Peak Country

57 – Rocky Mountains

87 – Western Slope

105 – Four Corners

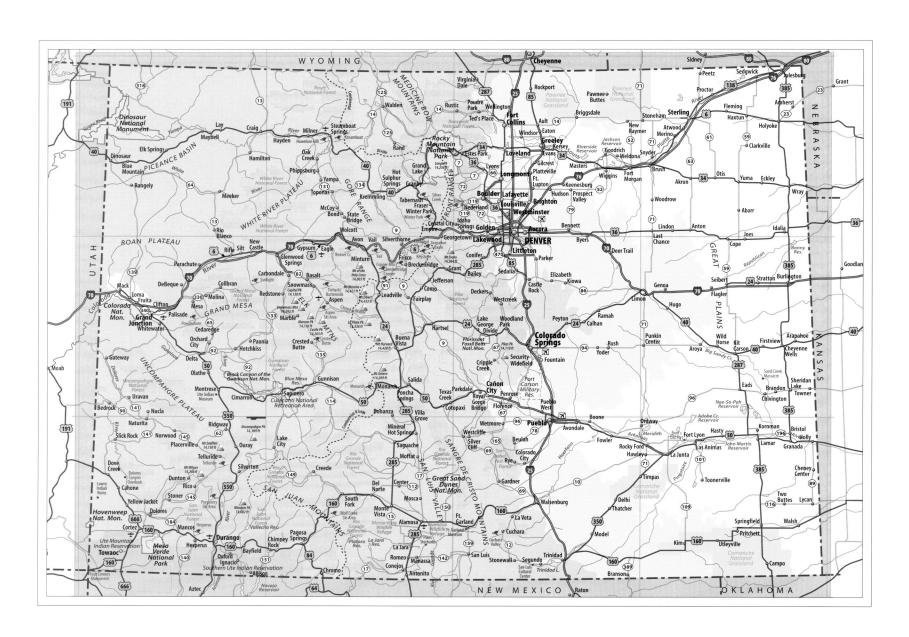

Colorado State map

INTRODUCTION

*C*olorado is a state truly gifted with superlatives: 104,237 square miles of purple mountain majesty and amber waves of grain. Indeed it was a mule ride up Pikes Peak that inspired *America the Beautiful*.

Shaped like an unfurled flag, Colorado is a sewn-together patchwork of domed mountains, rugged plateaus and rolling prairie. Look to the sunrise for the undulating Eastern Plains. Once home to Native Americans and thundering bison herds, the great plains' landmarks today are impressive sandstone buttes, vast grassy hillocks, and fertile river valleys carpeted with farms and ranches—the heart of western, small-town life.

Where the prairie ends the Front Range begins. Along this easternmost mountain chain reside 80 percent of the state's population, thriving in Denver, Boulder, Colorado Springs, Fort Collins, Greeley and Pueblo. The Front Range, along with Pikes Peak Country, hosts some of the region's best-loved attractions—the Denver Museum of Natural History, 14,110-foot-high Pikes Peak, the prestigious Air Force Academy, as well the immensely popular Rocky Mountain National Park.

In Colorado's midsection rise the full glory of the Rocky Mountains, three dozen ranges of snowcapped mounts, forested ridges and alpine valleys. More than 1,000 peaks reach two miles high; many support the zigzagging Continental Divide, which separates the watersheds of the Atlantic and Pacific oceans. Millions of acres of wilderness along with world-class summer and winter recreation resorts explain why Coloradans can't resist extolling the high country's virtues.

Dropping west of the Continental Divide, the Western Slope descends from the Rockies into weathered mesas cut by the mighty Colorado River and its tributaries. The great outdoors fuels a nature-loving lifestyle for many who relish the ruddy-colored chasms of the Colorado National Monument, the "painted walls" of Black Canyon of the Gunnison and the quiet splendor of the Uncompahgre Plateau.

Claiming Colorado's extreme southwest is the Four Corners region where the San Juan Mountains set the high mark for an awe-inspiring terrain crafted by fire and ice. The San Juans' volcanic summits and glaciated peaks erupt amid the plateaus and river drainages flowing into the high desert bordering Utah, Arizona and New Mexico—the only place in America where four states intersect.

Indeed, America the beautiful. Perhaps President Teddy Roosevelt summed up Colorado's scenic allure best when he described his sojourn here as "the trip that bankrupts the English language." That it certainly does, while delighting the eye as well.

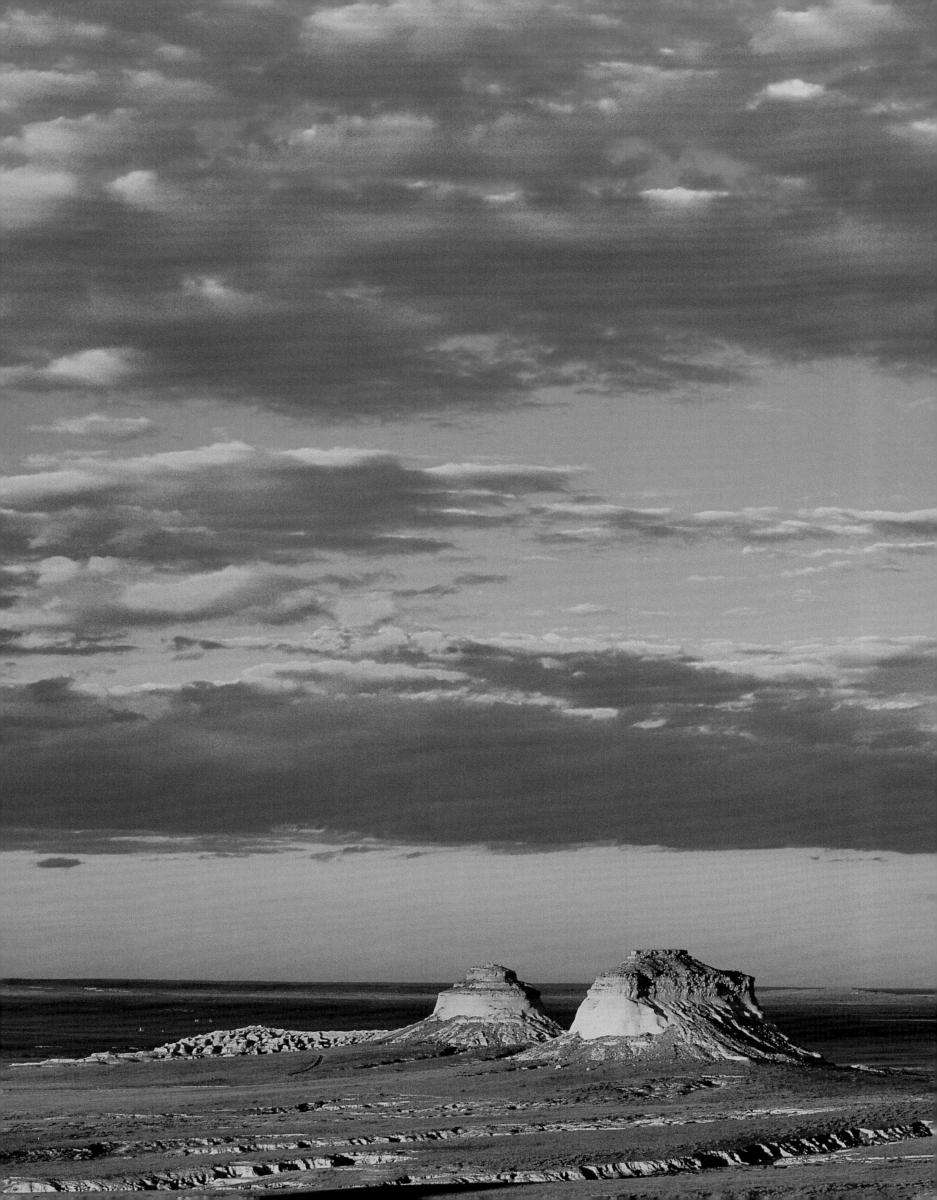

EASTERN PLAINS

*B*lue sky and wide-open spaces define Colorado's expansive Eastern Plains, that sunrise third of the state patched together by countless acres sown with wheat, corn, and soybeans, interspersed with grassy hills and vales, laced with thirst-quenching riverways, and hushed by breezes wafting over a loping landscape. Rolling in for mile upon mile from the Great Plains of Kansas, Nebraska and Oklahoma, Colorado's Eastern Plains break into high plateau within sight of the Rocky Mountains, then finish like exhausted waves washing against a beach, brushing the Front Range.

At first glance, the contrasting topography between horizontal plain and nearly vertical mountain may seem to disregard any intimate connection between the two. But during the ancient past, the rise and descent of mountain ranges and the ebb and flow of great inland seas created geologic scenarios only visible in telltale signs today. Massive and repetitive upheavals of the earth's crust were augmented by violent volcanic eruptions, followed by calmer eons of relentless scouring by wind, water and ice. Nature's erosive forces sent sand, silt and gravel spilling from mountains onto plains, nourishing the vast expanse with deep alluvial soil.

Between Denver and Pueblo, the Rockies throw out a wedge of high prairie dividing tandem river basins flowing east from the Front Range. The South Platte River escapes the mountains not far from the Mile High City, veers north to find strength in numerous creeks before snaking ever eastward past the city of Greeley. To the south, the Arkansas River tumbles through the Royal Gorge before slowing and watering the grassy lowlands east of Pueblo. Again, creeks and rivers feed the Arkansas on its meandering descent across the southeastern plains. Sustained by these life-giving waterways, what appeared to early explorers as the "Great American Desert" in fact held rich potential for farmland and pasturage.

Before immigrants made their great migrations west, Native Americans roamed the grasslands, finding sustenance in ways harmoniously balanced with nature. With spiritual reverence for the land and its gifts, nomadic tribes hunted bison, deer and elk, taking only what they needed for food and clothing. By the mid-1800s, the thundering herds of bison had been silenced, however, and the proud native peoples of the Eastern Plains were banished to reservations. Sod-busting farmers and ranchers learned to harvest the prairie's bounty as surely as early prospectors mined Colorado's mountains, creating the breadbasket of the Centennial State.

Even today, deep-rooted farming and ranching communities characterize the rural, small-town life of the Eastern Plains. Utilizing tried-and-true dryland irrigation methods, these quiet prairie towns form important notches in America's farmbelt and successful strongholds of Colorado's ranching heritage.

Left: Sunset, Pawnee Buttes, Pawnee National Grassland

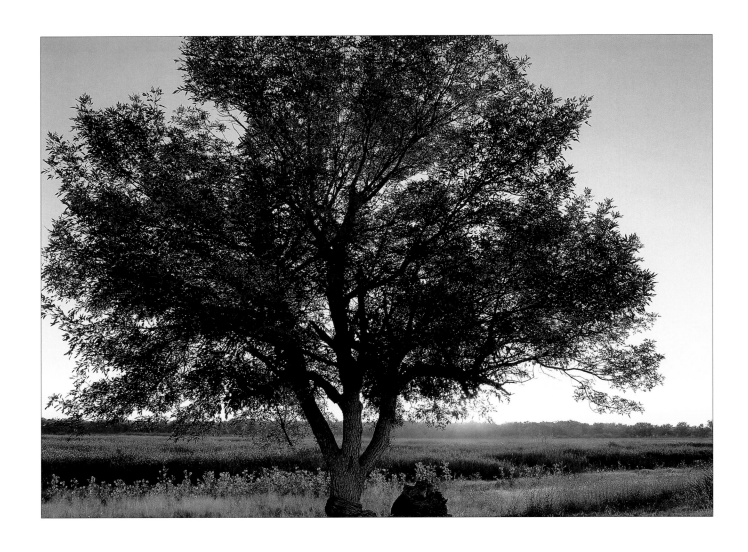

Cottonwood and prairie marshland, Arkansas River Valley

*M*eandering east through Colorado's southeastern plains, the Arkansas River Valley is blanketed with farms producing not only grains but also some of the state's best fruits and vegetables. The riparian habitat along riverbanks and the surrounding lowlands sustain many species of wildlife and native plants, including tall cottonwoods whose shade is a welcome relief on hot summer days.

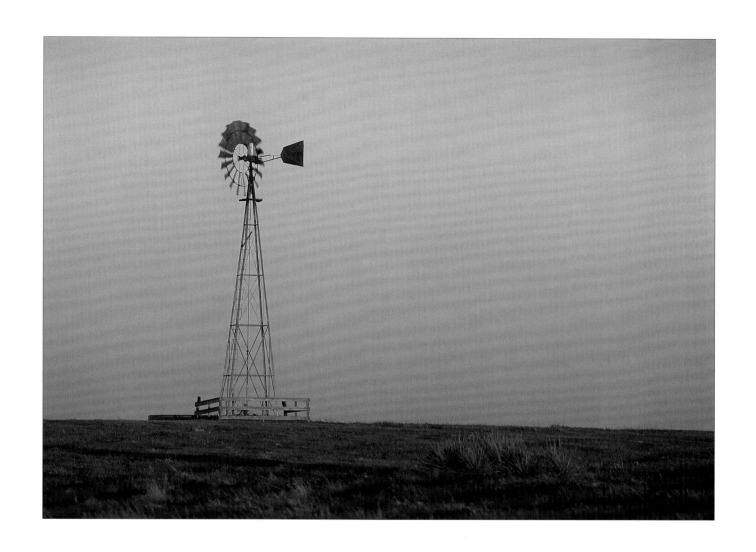

Windmill at sunrise, Weld County

\mathcal{I}rrigation is a way of life on the often-parched plains of eastern Colorado. Farming and ranching communities were founded along waterways and from their frontier inception have used reliable means to tease moisture from wells for thirsty cattle and fields.

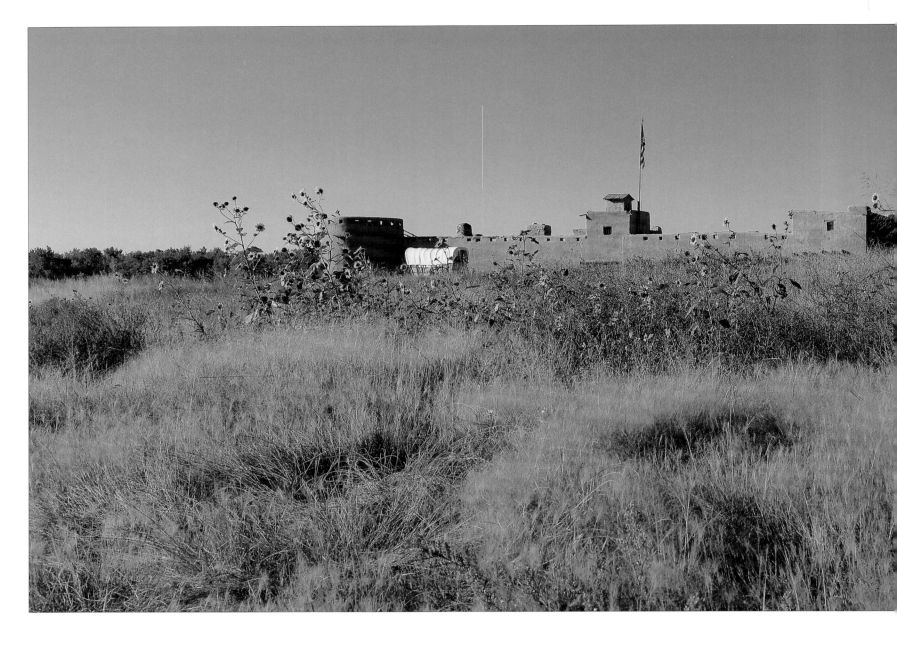

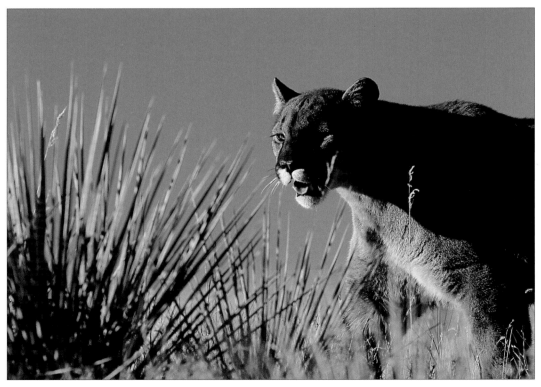

Bent's Old Fort, Bent's Old Fort National Historic Site

*I*n the decades following the Louisiana Purchase, explorers, trappers and traders pushed America's economic frontier west. Bent's Old Fort, constructed in the mid 1830s on the north bank of the Arkansas River near present-day Las Animas, became the principal trading center along the Mountain Branch of the Santa Fe Trail, a true oasis in the "Great American Desert." Today's authentic reconstruction is a living legacy of America's westward expansion.

Left: Mountain lion, Eastern Plains

*T*he mountain lion (*Felis concolor*), also called puma and cougar, flourishes in a range of habitats including the grassy plains as well as the mountains of Colorado. The cat's stealth and strength are singularly impressive, equipping it to prey on small rodents as well as larger mammals such as deer and elk.

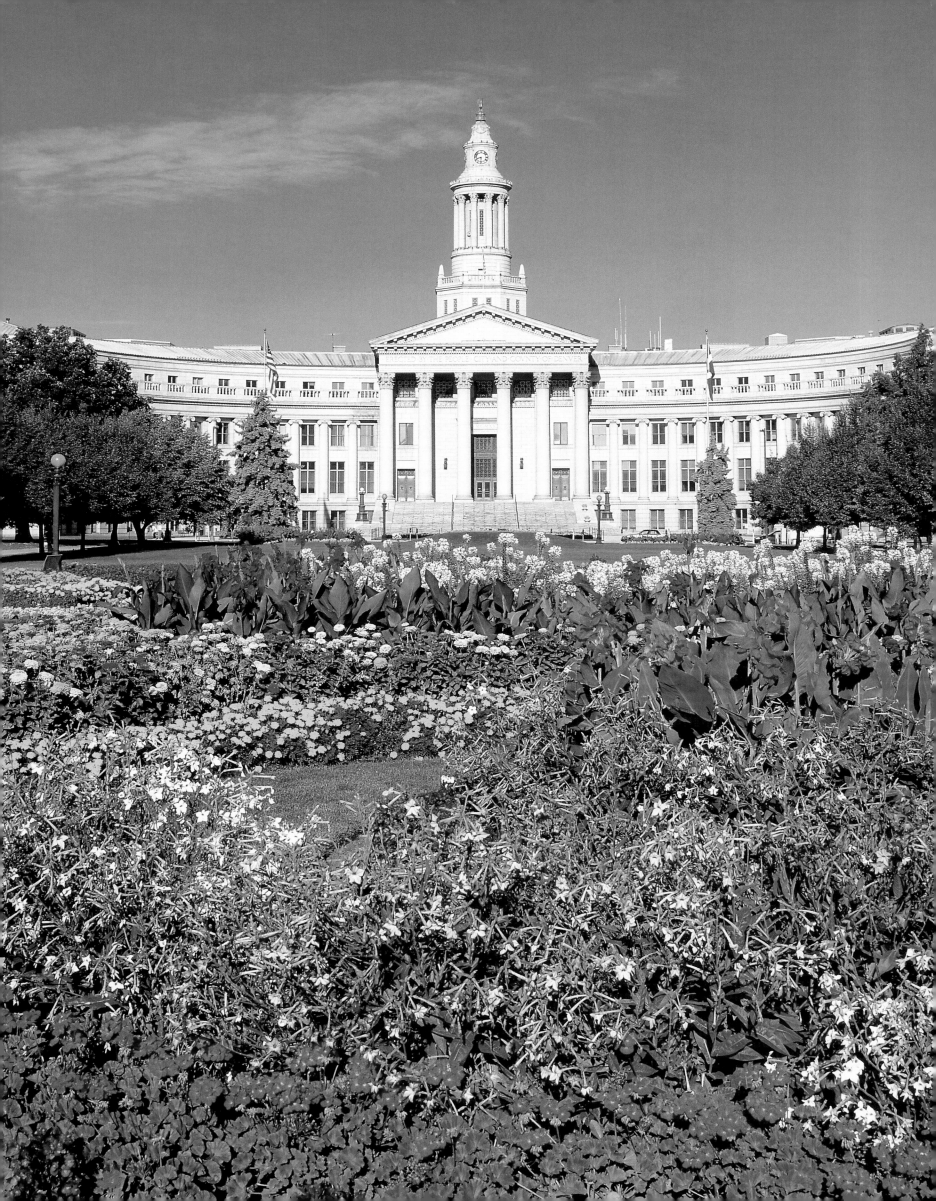

DENVER AND THE FRONT RANGE

*O*n a clear day, the view from Colorado's northeastern prairie westward is mesmerizing. Shouldering into the blue sky in a long, ragged purple line runs the Front Range, the first in a series of muscular mountain ranges stretching for 150 miles west into Colorado's Rocky Mountain midsection.

Seemingly uniform in its makeup, the Front Range is in fact fantastically diverse with a distinctive environment transitioning between grassy plains and alpine tundra. Anchoring the Front Range are three "Fourteeners," peaks cresting more than 14,000 feet above sea level. To the north stands flat-topped Longs Peak, slicing a 14,255-foot profile above Mount Meeker at 13,911 feet. Southward, the graceful prominence of Mount Evans dominates the skyline west of Denver. Farther south still reclines the east flank of Pikes Peak, the symbol of Colorado's gold-rush rallying cry, "Pikes Peak or Bust," and the inspiration for Katharine Lee Bates' poem turned national anthem, *America the Beautiful*.

The Front Range deserves honor among the country's natural and historical treasures. For generations, Native Americans—Kiowa, Comanche, Cheyenne, Arapaho—lived along the range's fringe, finding sanctuary and spiritual renewal among its rocky outcroppings and mineral springs. Their bucolic lifestyle changed forever in 1858 when the discovery of glittering flakes along a South Platte River tributary triggered one of North America's great gold rushes. In the following years, tens of thousands of prospectors and pioneers jostled toward Colorado's Front Range.

Only a handful of those adventurers struck it rich, yet even those who didn't made dreams come true. These were the farmers and town builders, ranchers and traders—motivated visionaries determined to weather the dangers of frontier life to create new beginnings for themselves and their families. From such resolute resources grew the communities of Denver, Boulder, Greeley, Fort Collins, Colorado Springs and Pueblo, the principal Front Range metropolitan areas.

The Front Range of today would surely astound those early settlers; what began as rustic camps evolved into Colorado's glittering urban and urbane heartline. Nearly 80 percent of the state's population lives along the Front Range. Multinational corporations—leaders in fields ranging from engineering to entertainment—make their home here, as do top-flight (and top secret) military installations and several critical U.S. government agencies.

Denver, Colorado's capital, lives up to her moniker: "Queen City of the Plains." The largest municipality within a 600-mile radius, the mile-high metropolis is the commercial and cultural hub for the mountain West. Interstate highways, railroads and flight patterns spin to every compass point, making Denver not only a business center but also a modern crossroads of the world where the splendor of nature mixes with the past's pioneer legacy.

Left: Denver City and County Building, Civic Center Park

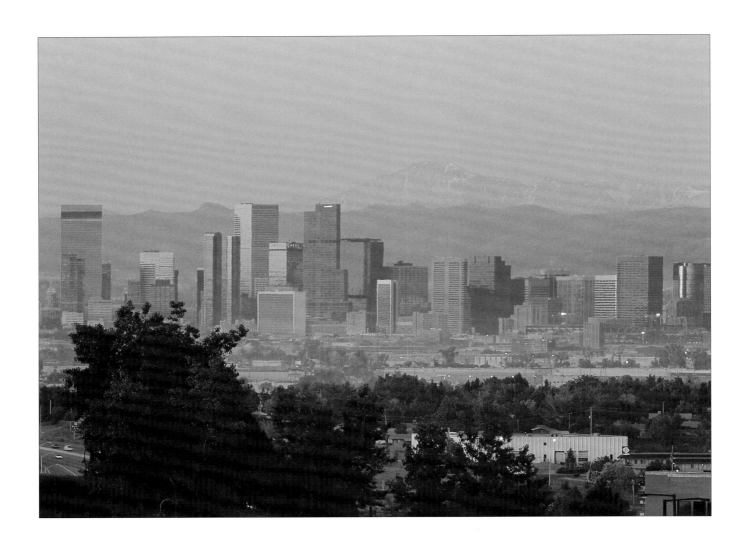

Denver and Pikes Peak

\mathcal{D}enver's skyscrapers echo the imposing profile of the "Long One," the name Native Americans called the 14,110-foot-high mountain which later became known as Pikes Peak. Nearly 80 miles south of Denver, this view of America's anthem-inspiring mountain captures the sense of spaciousness enjoyed by those who live along and visit Colorado's Front Range.

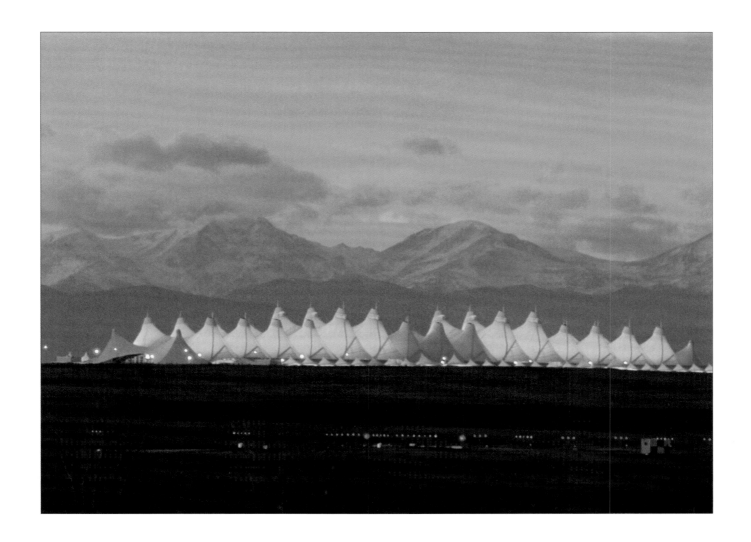

Denver International Airport

*D*IA is the nation's largest international airport, encompassing 53 square miles of prairie northeast of Denver. Its striking Teflon-coated tent-top design mimics the panorama of snowcapped mountain ranges rising west of the city. Not only is the $4 billion complex an architectural marvel with state-of-the-art aviation equipment, its interior design features an extensive public arts program.

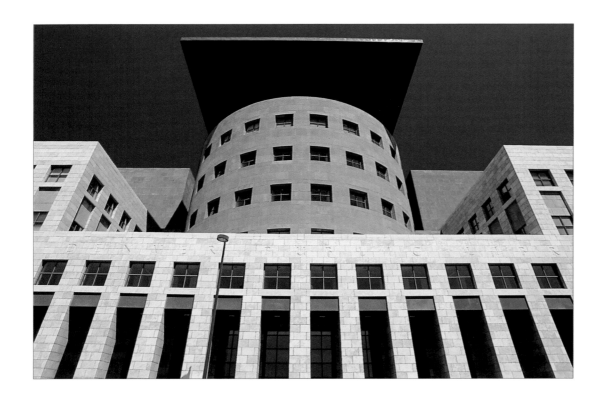

Denver Public Library

Commanding a corner across from Civic Center Park, the strong geometric shapes and earth-tone color scheme of the Denver Public Library (DPL) sounds a contemporary note amid downtown's historic structures. Housing extensive research materials, DPL is best known for its priceless Western History collection of manuscripts, letters, diaries, photos, sketches and paintings documenting the American West.

Right: Civic Center Park

Civic Center Park is Denver's classic urban plaza graced with monuments, fountains and dazzling flower gardens. The crossroads between several city and state government buildings, in particular the gold-domed Colorado State Capitol on the east, this park is best loved for its outdoor Greek-style theater, which hosts numerous lively events and festivals.

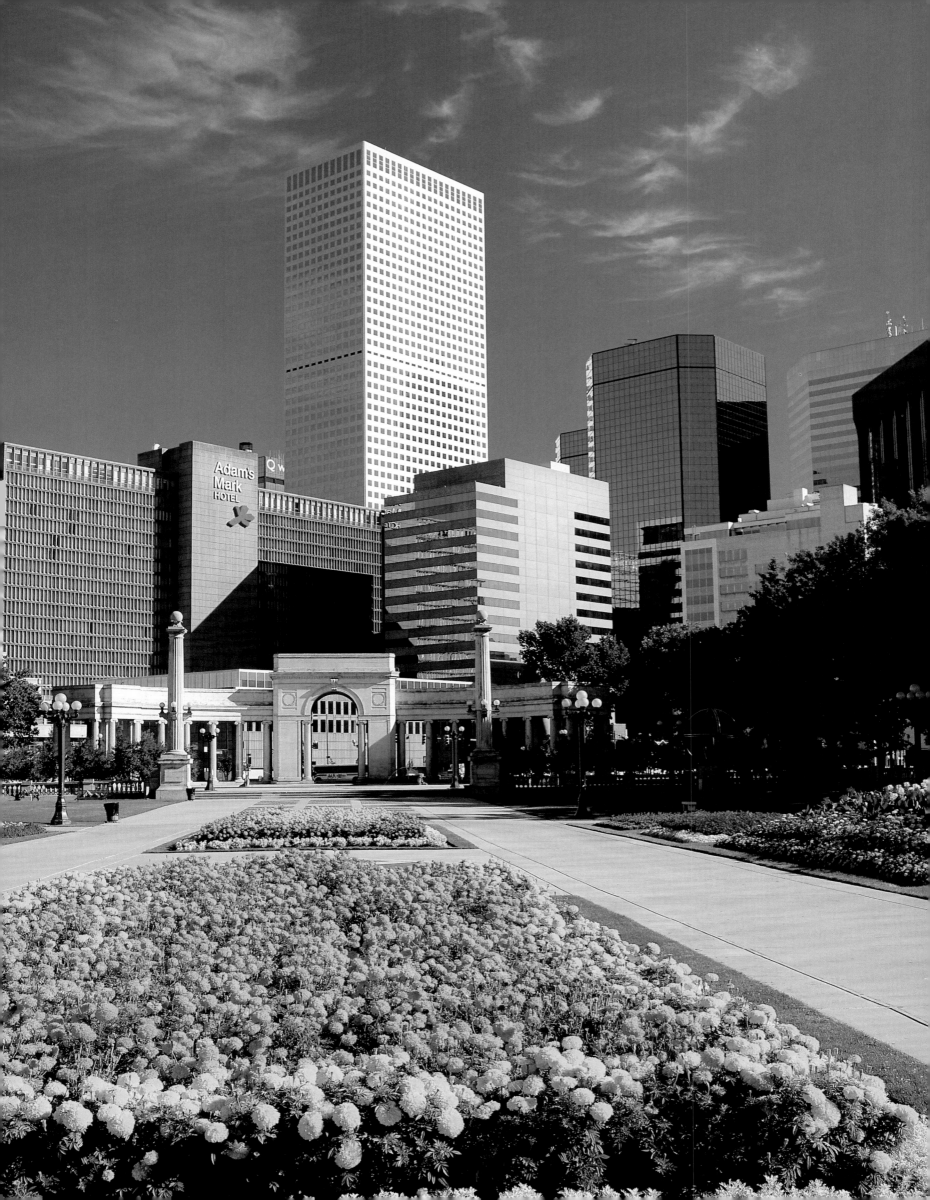

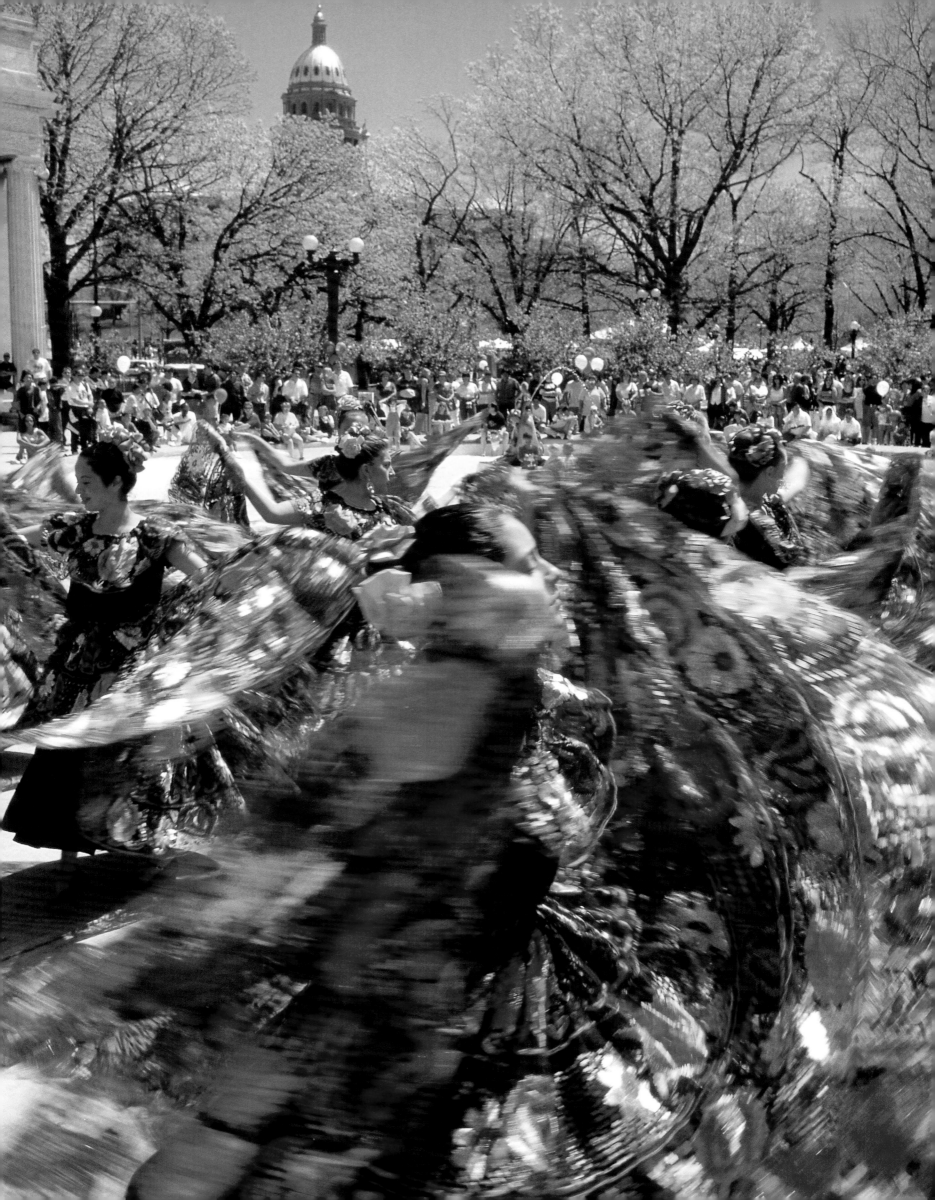

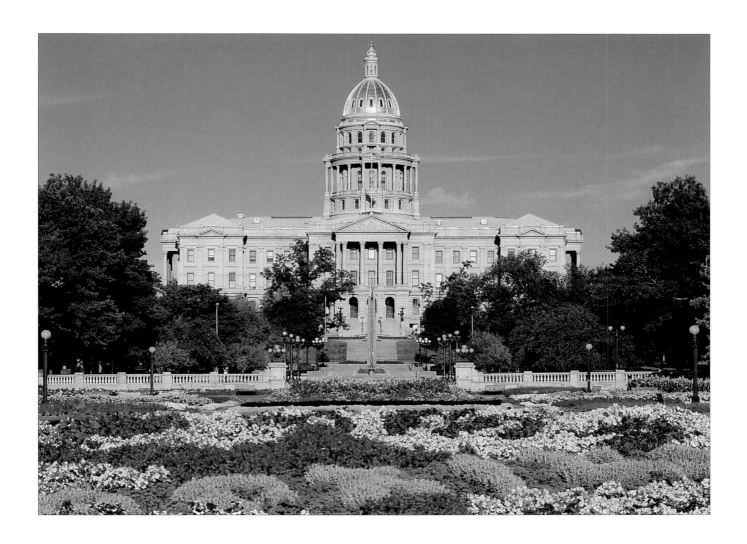

Colorado State Capitol, Denver

*C*onstructed in a classical grand style, the Colorado State Capitol sums up the Centennial State's late-19th-century ebullient spirit of optimism and opulence. The gold-leafed dome sparkles with 200 ounces of 24 karat gold, while the interior is decorated with the world's only rose onyx, a rare stone mined at Beulah, Colorado, and never found elsewhere. The eighteenth step of the west entry marks the elevation—5,280 feet—of the "Mile High City."

Left: Cinco de Mayo, Denver

*S*wirling dancers beneath budding cherry trees punctuate the merriment and pageantry of Cinco de Mayo, Denver's springtime festival celebrating Colorado's rich Hispanic heritage.

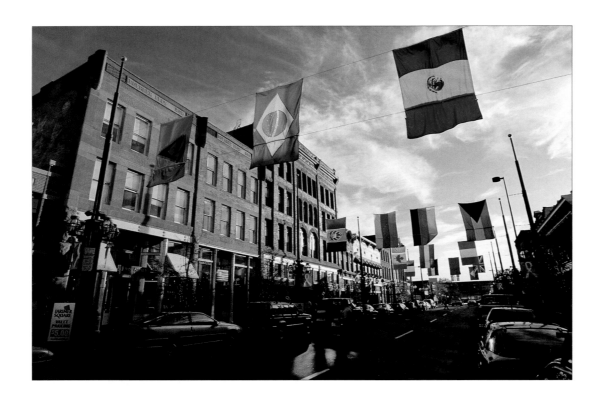

Larimer Square, Denver

\mathcal{L}ocated along one of Denver's oldest streets, Larimer Square is a block of elegantly restored Victorian-era buildings. Now home to stylish eateries and modern emporiums, this revitalization of Denver's past set the standard and tone for the city's numerous subsequent historic preservation projects.

Right: Denver Skyline

\mathcal{R}eflections of Denver's modern skyline shimmer at dusk along the quiet ripples of the South Platte River. In 1858, the glimmer of gold enticed miners to establish crude camps here, which would later blossom into Denver. Rich gold strikes along the Front Range sparked the Mile High City's boom as a trading center. Today, Denver's strategic mid-continent location makes it a 21st-century hub for world communications and commerce.

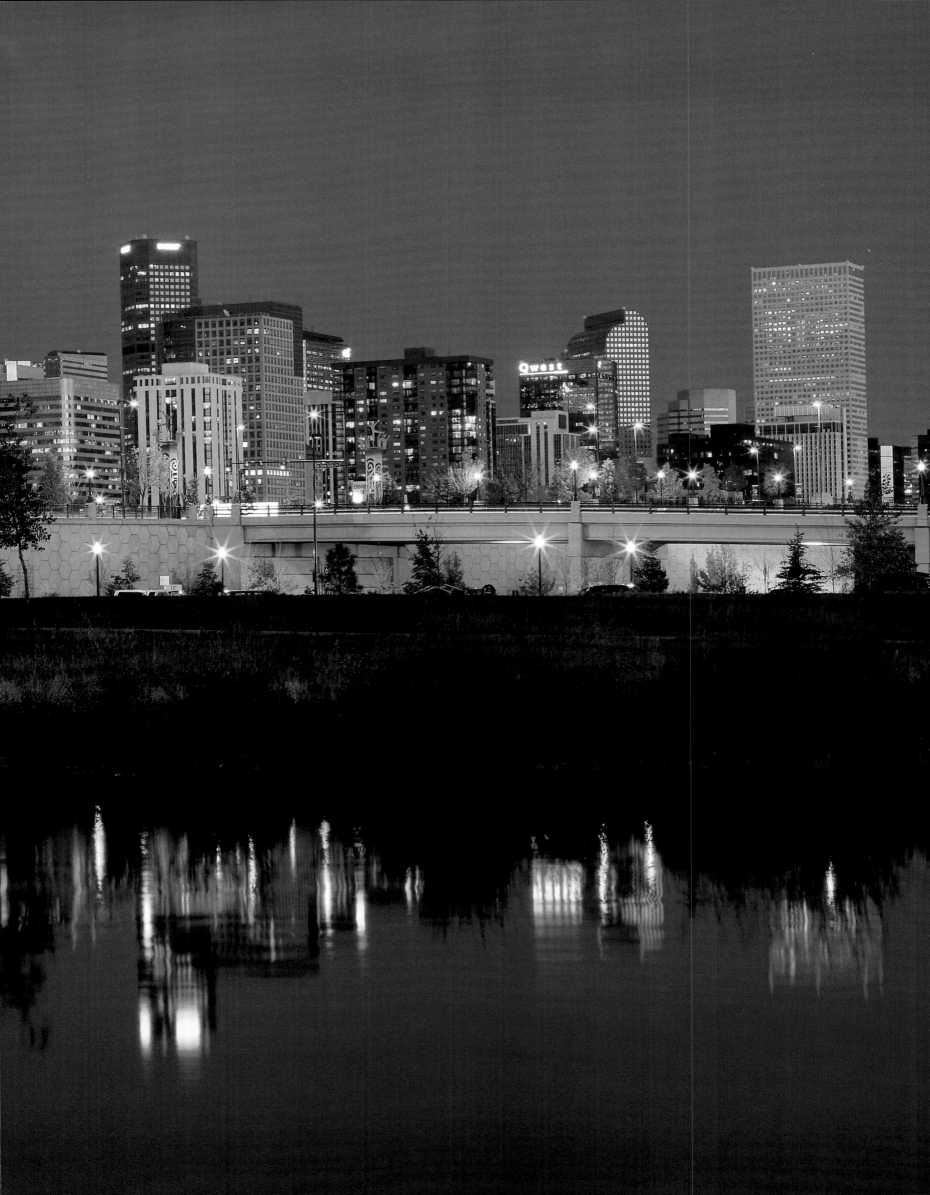

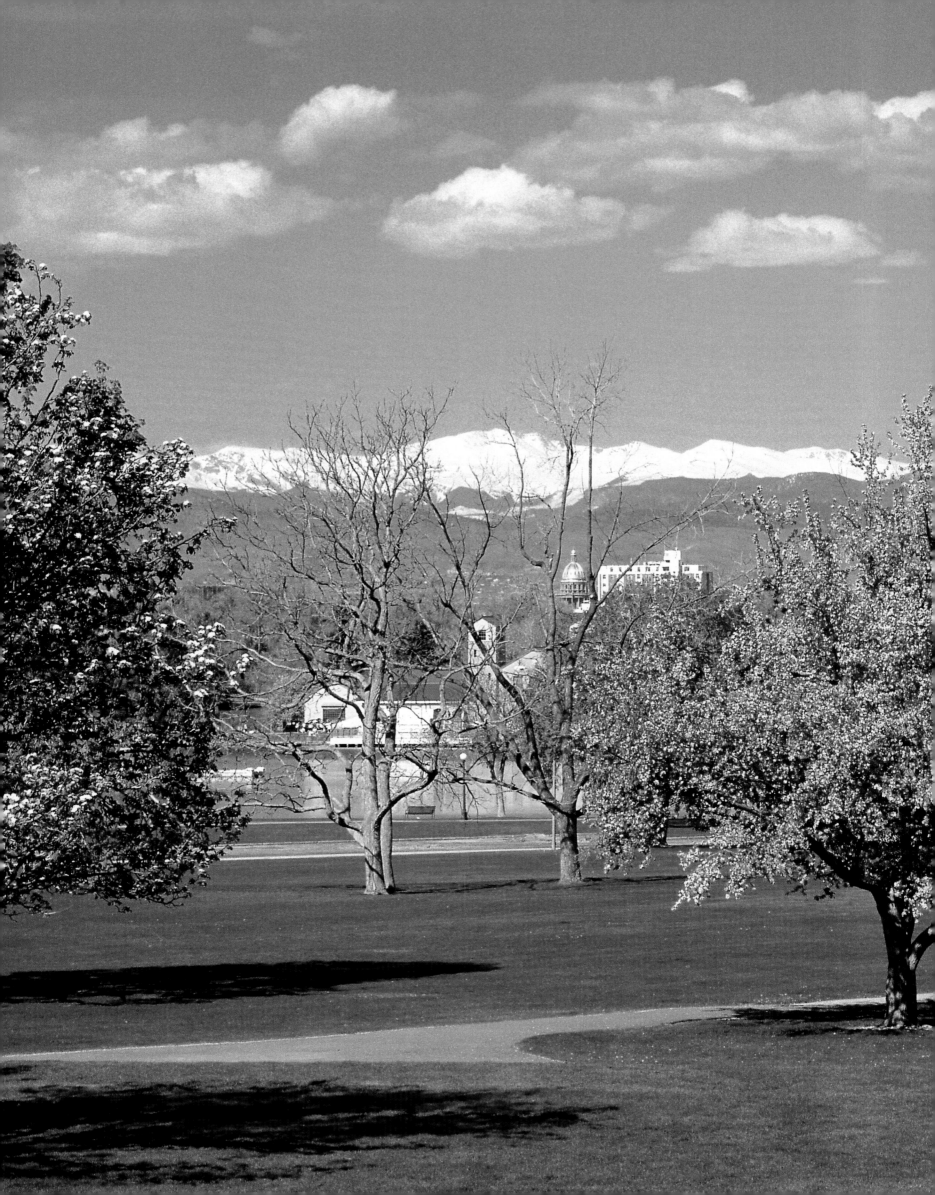

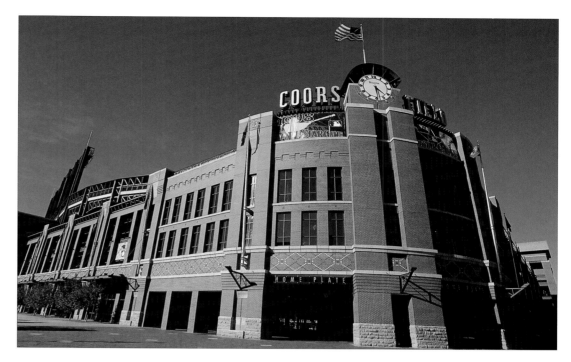

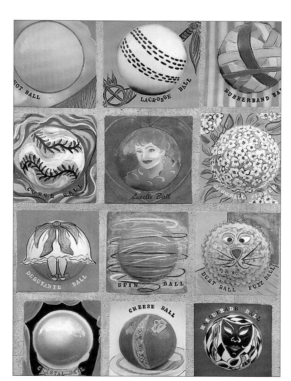

Top: Coors Field, Denver

*C*oors Field is home to the Colorado Rockies, a baseball team that found an adoring following not only with Coloradans but also fans across the globe. The "hitter-friendly" ballpark scores big with residents and visitors, as does its historic neighborhood location in lower downtown Denver or simply LoDo.

Evolution of the Ball, Coors Field

*E*volution of the Ball, which decorates an archway at Coors Field, is typical of many sculptures which can be found in downtown Denver.

Left: City Park, Denver

*W*ith hundreds of parks and recreational sites, the Front Range deserves its reputation as one of the country's most nature-friendly urban centers. Denver's City Park not only sports acres of greenery and blooms, its attractions include the Denver Zoo and the Denver Museum of Nature and Science.

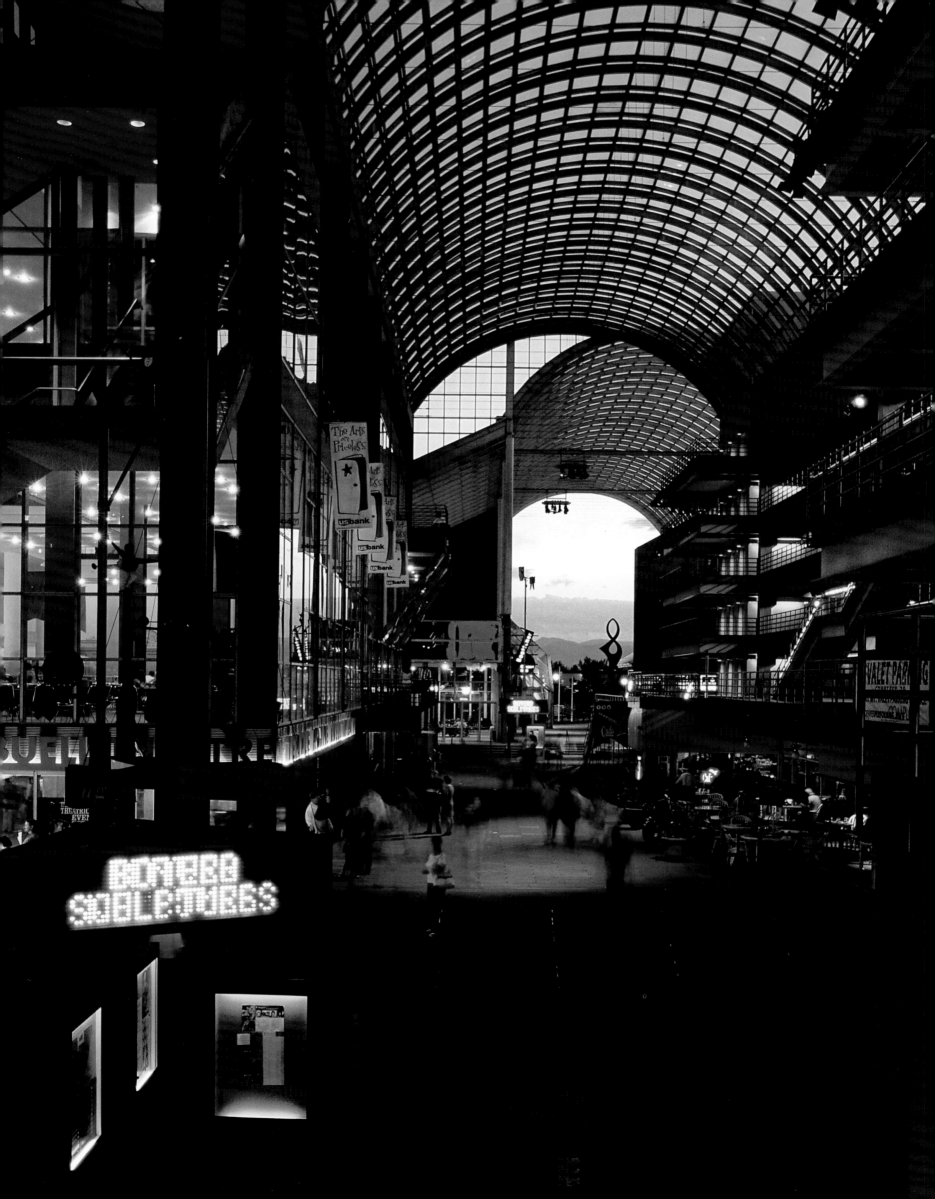

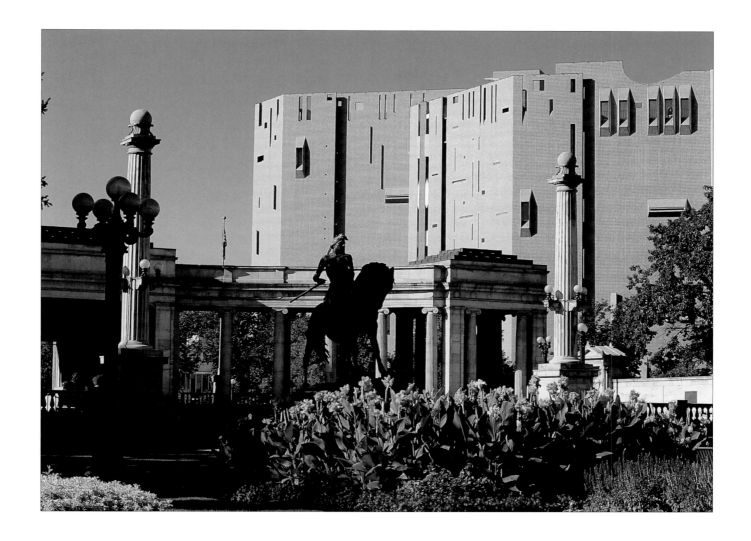

Above: Denver Museum of Art

*C*lassical and modern architectural styles mixed with western motifs merge in this view of the Denver Museum of Art. Designed by noted Italian architect Gio Ponti and Denverite James Sudler, the medieval castle-like walls fashioned from thousands of glass tiles shelter dozens of galleries—from English painting to Chinese ceramics—including one of the nation's finest collections of Native American ceremonial arts and handicrafts.

Left: Denver Performing Arts Complex

*S*econd only to New York City in venue size, the Denver Performing Arts Complex is equally well respected for the quality and caliber of its entertainment ranging from extravagant Broadway shows and full orchestral presentations to small-production theater and intimate recitals.

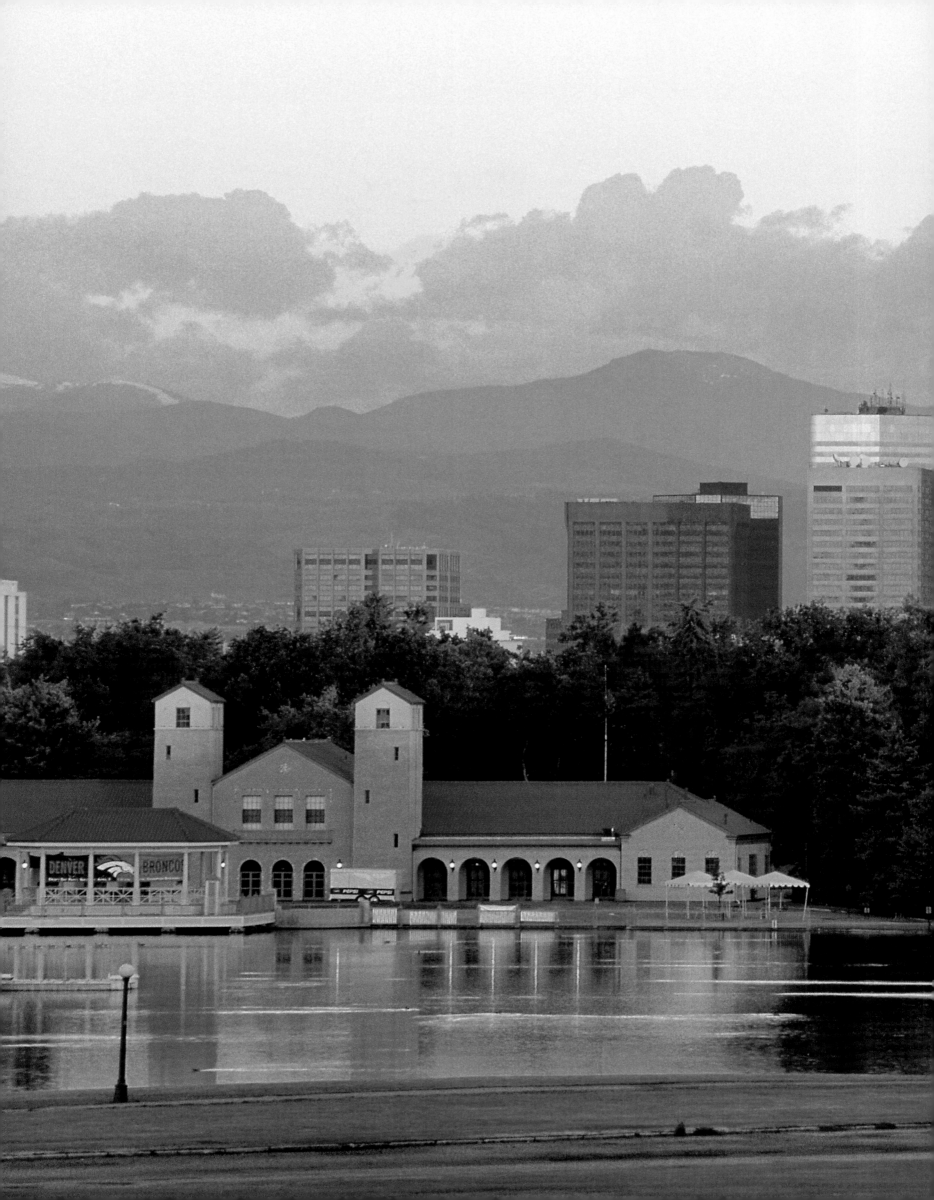

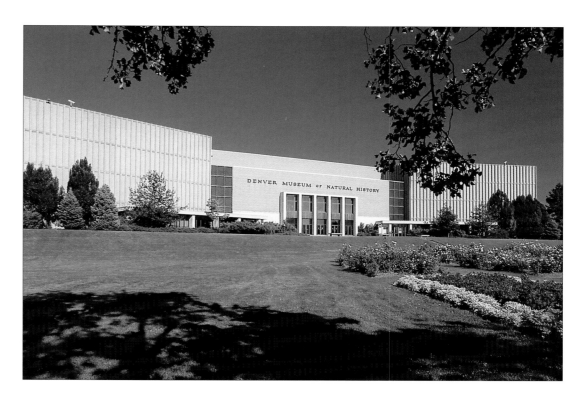

Denver Museum of Nature and Science

𝒞onsidered one of the country's best natural history institutions, the Denver Museum of Nature and Science features an impressive collection of dinosaur fossils and the fascinating "Prehistoric Journey," which chronicles 3.5 billion years of life on earth. Extensive geological and mineral displays plus dioramas of North American flora and fauna complement its IMAX Theater and Gates Planetarium.

Left: Denver Skyline at Sunrise

𝒯he Denver skyline assumed its modern profile largely in the 1970s and early 1980s, when a boom in petroleum and mining interests fueled the city's building growth as a commercial center for the West's natural resources.

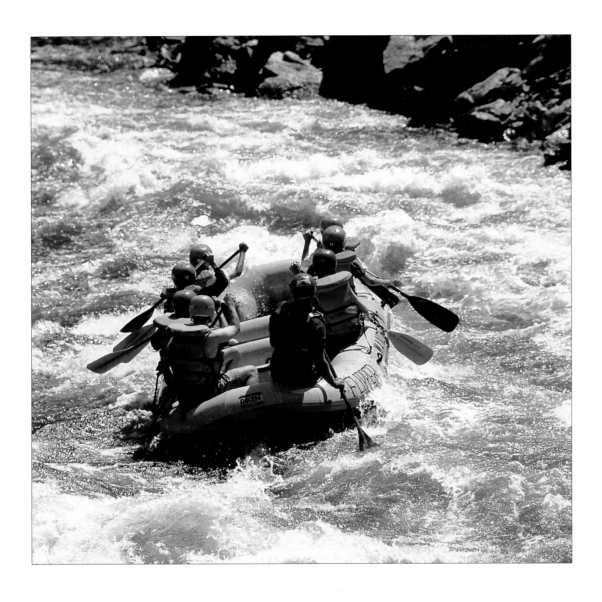

Cache la Poudre River Rafting

*F*ront Range recreation runs from mild to wild including thrilling whitewater excursions on the Cache la Poudre west of Fort Collins. This truly feisty river with 75 miles of flow is protected from dams and diversions by the National Wild and Scenic Rivers Act.

Right: Summit Lake, Mount Evans

*S*erene Summit Lake rewards visitors along the Mount Evans Scenic Byway, the motoring venture ascending the 14,264-foot-high peak which outlines the western view from Denver. Gliding through an unending spectacle of natural superlatives, the route follows the highest paved automobile road in North America.

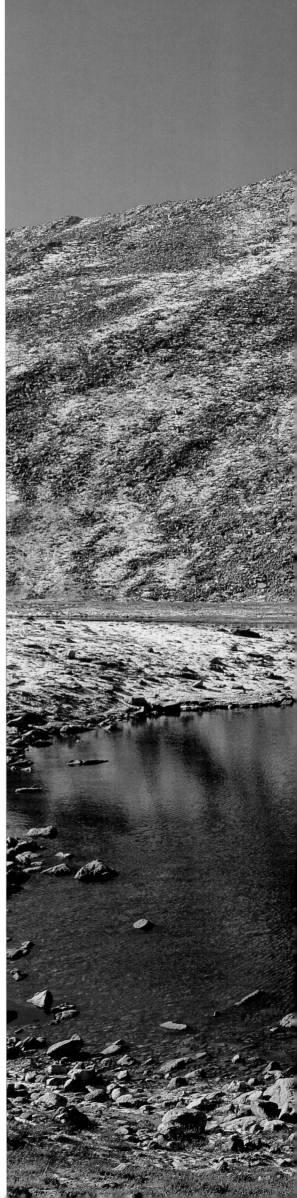

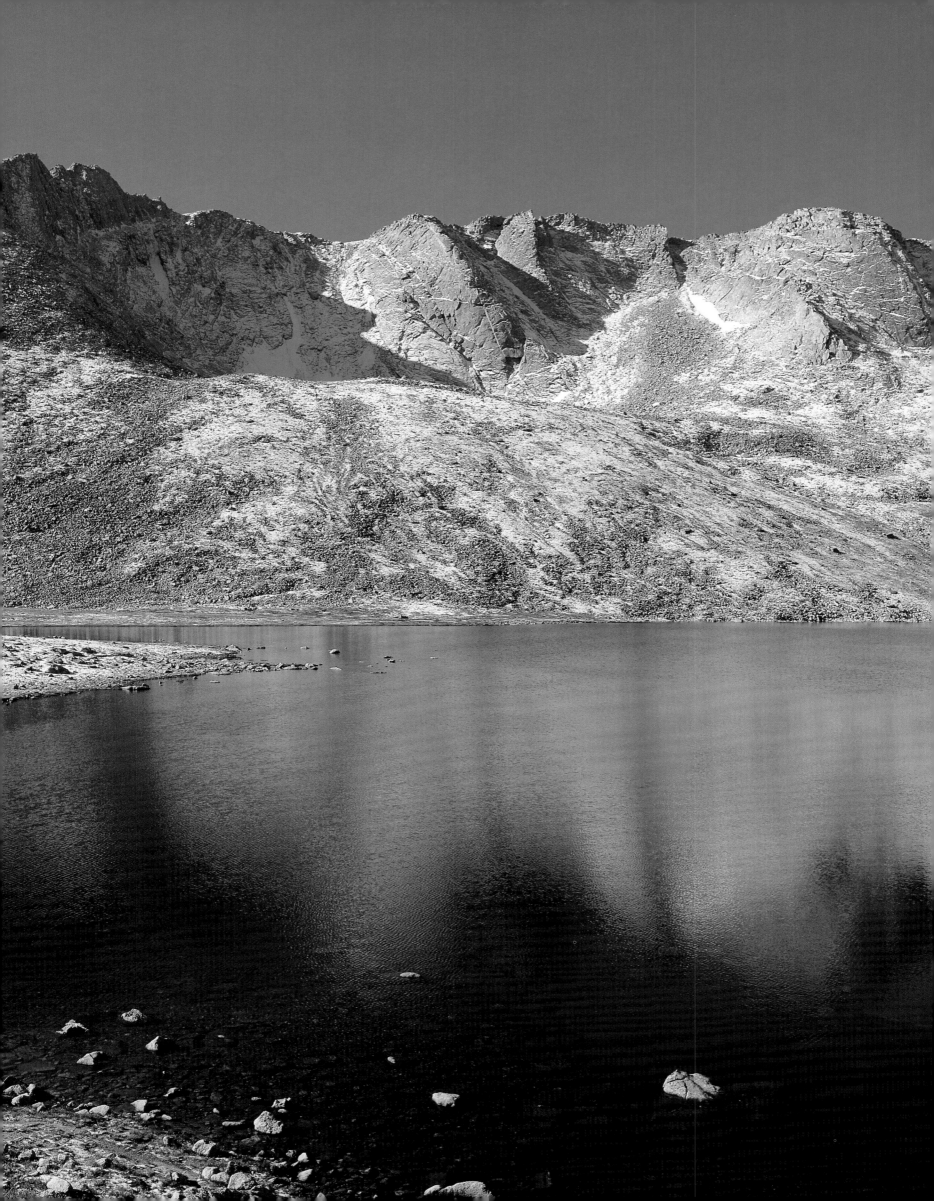

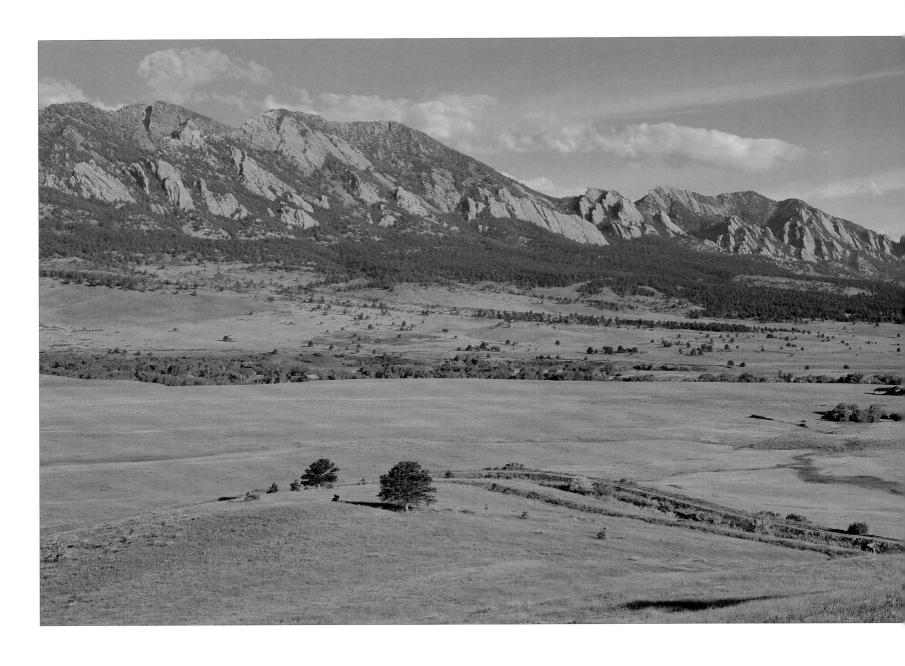

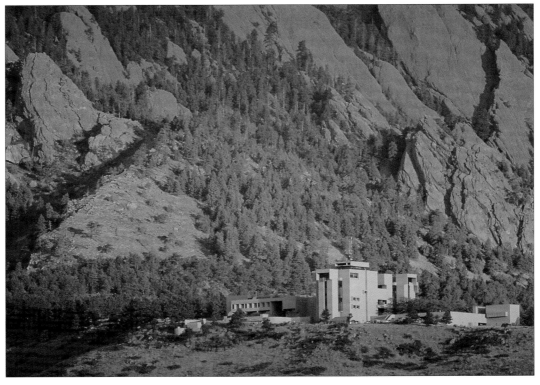

Flatirons, Boulder

*F*ew urban locales sport a backdrop more dramatic than Boulder, home to the University of Colorado. The massive sandstone formations, named the Flatirons by early pioneers, crease the northern Front Range not only with marvelous views but also with adrenaline-inducing out-of-doors opportunities.

Left: National Center for Atmospheric Research, Boulder

*H*igh aspirations aren't confined to Front Range nature enthusiasts. Located on a mesa spreading out from the Flatirons, the National Center for Atmospheric Research holds some of the world's most sophisticated weather computer systems, typifying Colorado's Front Range high-tech business profile.

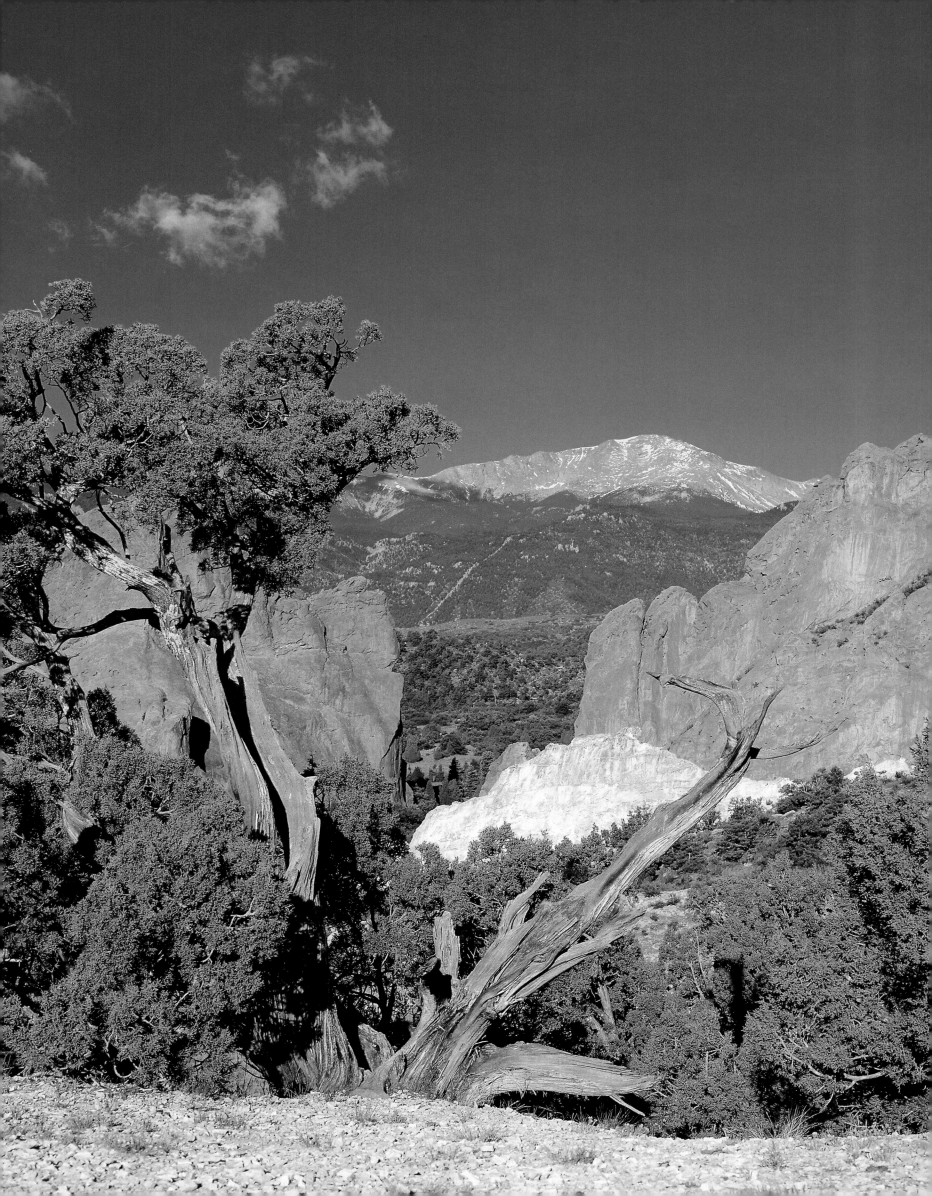

PIKES PEAK COUNTRY

*P*ikes Peak has drawn people to its impressive profile for generations. Native Americans once hunted along the foothills beneath the comforting silhouette of the "Long One." It was Lt. Zebulon Montgomery Pike, leading an expedition in 1806, who lent his name to the 14,110 foot-high peak. In 1858, Julia Archibald Holmes became the first woman on record to ascend Pikes Peak, later writing home about an experience that "fills the mind with infinitude, and sends the soul to God." A year later, thousands of prospectors seeking fast fortunes raced west with the slogan "Pikes Peak or Bust" guiding their fate.

In 1871 Civil War veteran William Jackson Palmer founded Colorado Springs on a prairie plateau due east of the picturesque peak. Palmer envisioned an elegant, resort destination—a "model of taste and refinement"—to entice well-to-do tourists to the region. His plan worked. Soon Colorado Springs flourished, touting its natural scenic wonders to the world and firmly establishing snowcapped Pikes Peak as an inspirational icon of the not-so-wild Wild West. After a trip to the summit in 1895, Katharine Lee Bates penned words which would identify Pikes Peak Country as an enduring symbol of America's abundance:

> *Oh beautiful for spacious skies,*
> *For amber waves of grain*
> *For purple mountain's majesties*
> *Above the fruited plain!*
> *America! America!*

Pikes Peak Country remains the majestic heart of a "great number of wonders," as early travel pamphlets proclaimed. Manitou Springs, named for its health-inducing mineral waters, bubbles as one of Colorado's most enjoyed family diversions. Heavenly Garden of the Gods stirs imaginations with its ruddy sandstone pinnacles. The renowned Broadmoor Hotel, accenting the foreground of Cheyenne Mountain, has welcomed guests for nearly a century. And then there is Pikes Peak itself, rising from the plains like a beckoning sentinel, its summit far more accessible nowadays, not only by hiking trail and scenic road, but also via the famous Manitou and Pikes Peak Cog Railway.

Complementing the region's time-honored amusements are attractions unique to Colorado: Royal Gorge, where the world's highest suspension bridge hangs 1,053 feet over the tumbling Arkansas River; the U.S. Olympic Complex, training ground for hundreds of gifted amateur athletes; and one of Colorado's truly beloved destinations, the architecturally-commanding campus of the United States Air Force Academy. Here at the proving ground for America's best and brightest, the Cadet Chapel's spires slice into the Colorado sky, saluting the proud spirit still burning brightly in the shadow of "Long One."

Left: Pikes Peak from Garden of the Gods

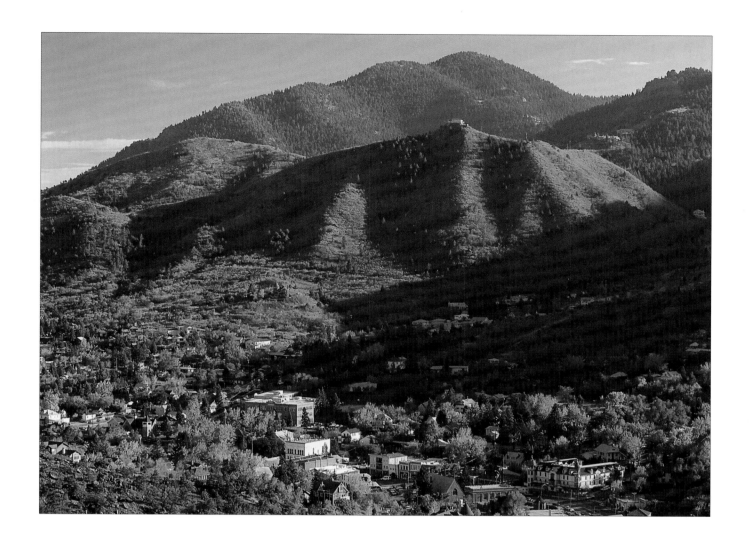

Manitou Springs

*R*esting in the foothills below Pikes Peak, Manitou Springs was known to nomadic Utes for its fine hunting and healing waters. Pioneers venturing here also favored the mineral-laden springs, so much so that by the late 1800s the area became known as the "Saratoga of the West." Today, Manitou Springs welcomes visitors as a designated National Historic District adorned with Victorian architecture and home to artists, craftspeople and charming shops.

Left: Manitou Congregational Church, Manitou Springs

*B*egun as a preaching mission in 1877, the Manitou Congregational Church is one of the oldest religious structures in Colorado.

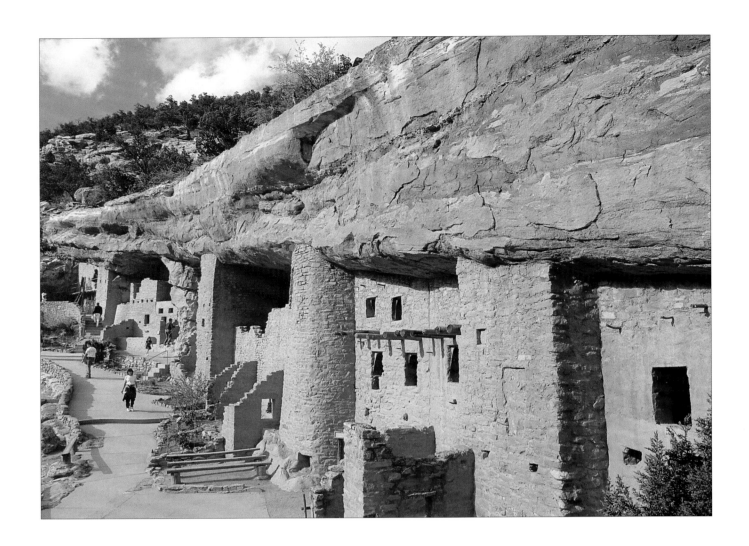

Manitou Cliff Dwellings Museum, Manitou Springs

The Manitou Cliff Dwellings Museum, tucked into overhangs of Phantom Cliff Canyon, features Ancestral Puebloan buildings reconstructed from authentic Southwestern sites that were considered too susceptible to plundering.

Right: First Falls of Seven Falls, South Cheyenne Creek

Billed as the "Grandest Mile of Scenery in Colorado," the spectacular granite spires and cliffs of South Cheyenne Canyon west of Colorado Springs are laced with a set of seven tumbling cascades. One of Pikes Peak Country's many natural wonders, Seven Falls attracts more than 300,000 visitors annually .

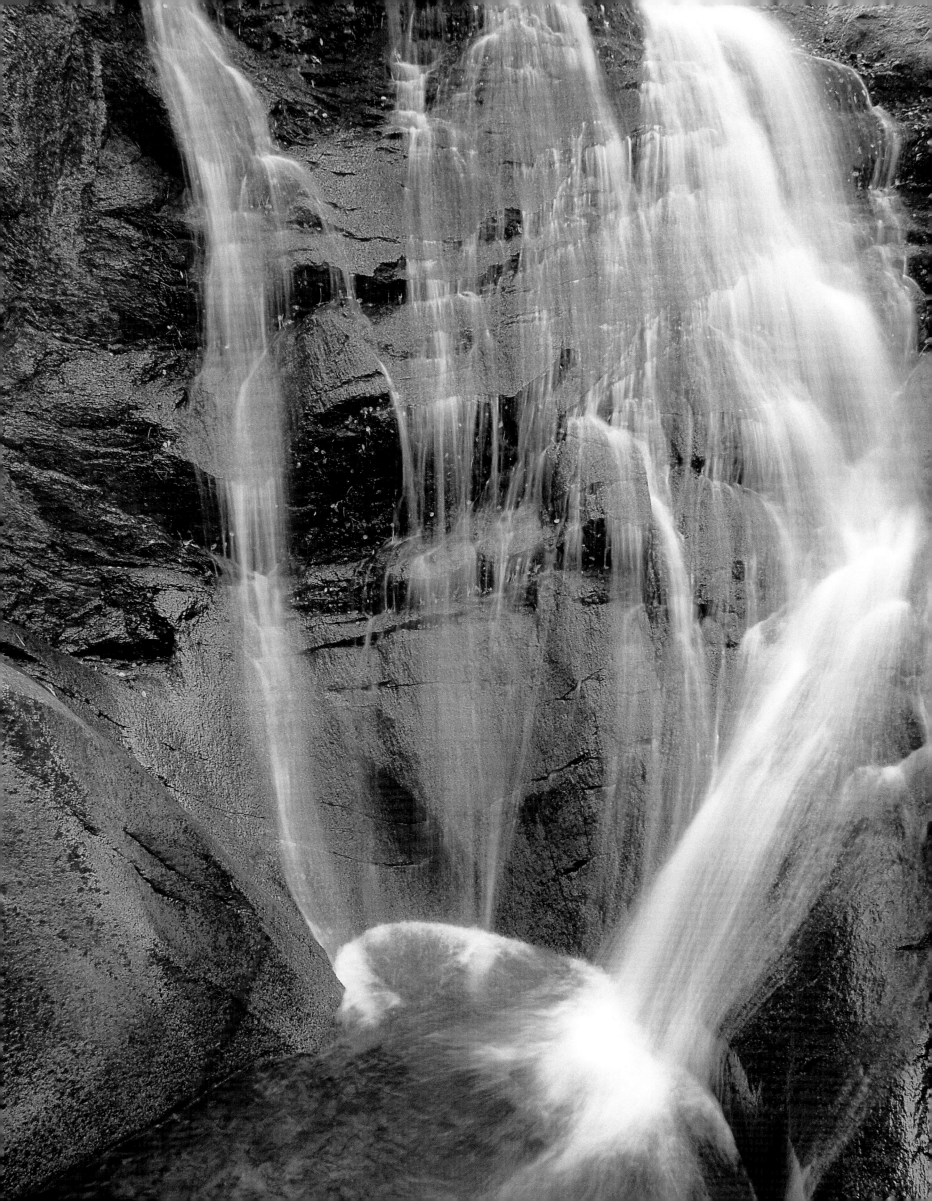

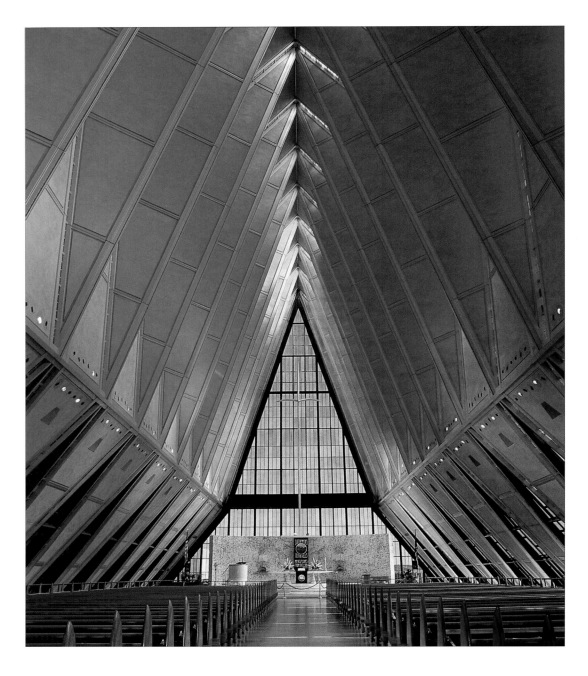

Cadet Chapel, United States Air Force Academy

*I*nside the Cadet Chapel, midday light pours through panels of tinted glass, illuminating a sanctuary to soothe both mind and spirit. The religious heart of the prestigious U.S. Air Force Academy, the chapel often inspires in visitors a sense of reverence and awe at a work wrought by humans but undeniably inspired by a greater power.

Right: Cadet Chapel, United States Air Force Academy

A summer sunset sky above the Rampart Range colors the distinctive architectural facade of the U.S. Air Force Academy Cadet Chapel. Like hands saluting heavenward, the chapel's 17 spires snap 150 feet upward, creating an inspirational sight that is both an art and architectural *tour de force*.

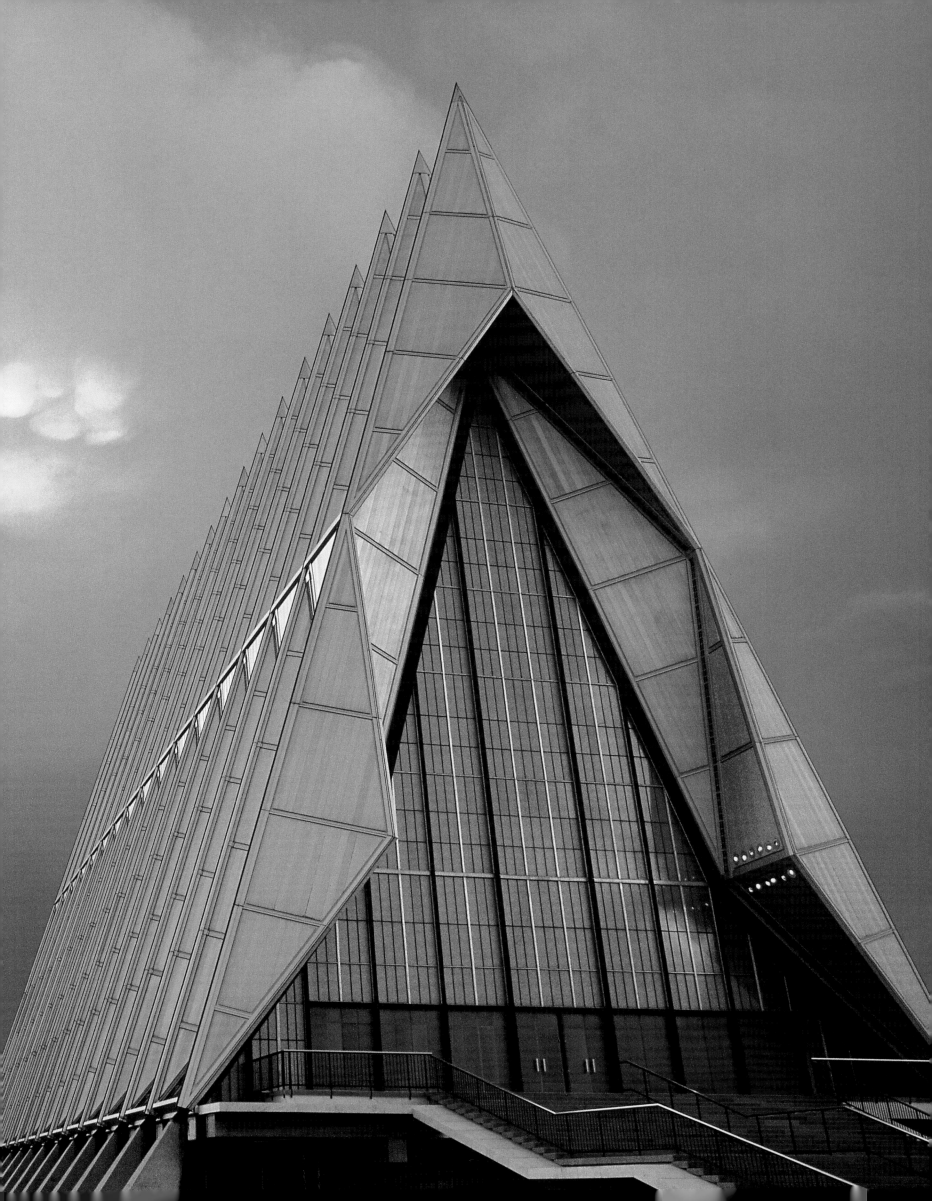

Colorado Springs and Pikes Peak

*C*olorado Springs, set on a plateau east of Pikes Peak, began as one man's vision when General William Jackson Palmer founded the city in 1871 as a resort enclave for the world's rich and famous. The town flourished, becoming Colorado's second largest city, home to important military installations and high technology businesses in addition to many tourist-pleasing attractions.

Right: Broadmoor Hotel, Colorado Springs

*T*he venerable Broadmoor Hotel, nestled against the foothills of Cheyenne Mountain, has long been a Colorado Springs centerpiece. One of the world's most highly rated hotels for accommodation, service and amenities, the Broadmoor was constructed in an Italian palazzo style in 1918 by mining mogul and entrepreneur Spencer Penrose.

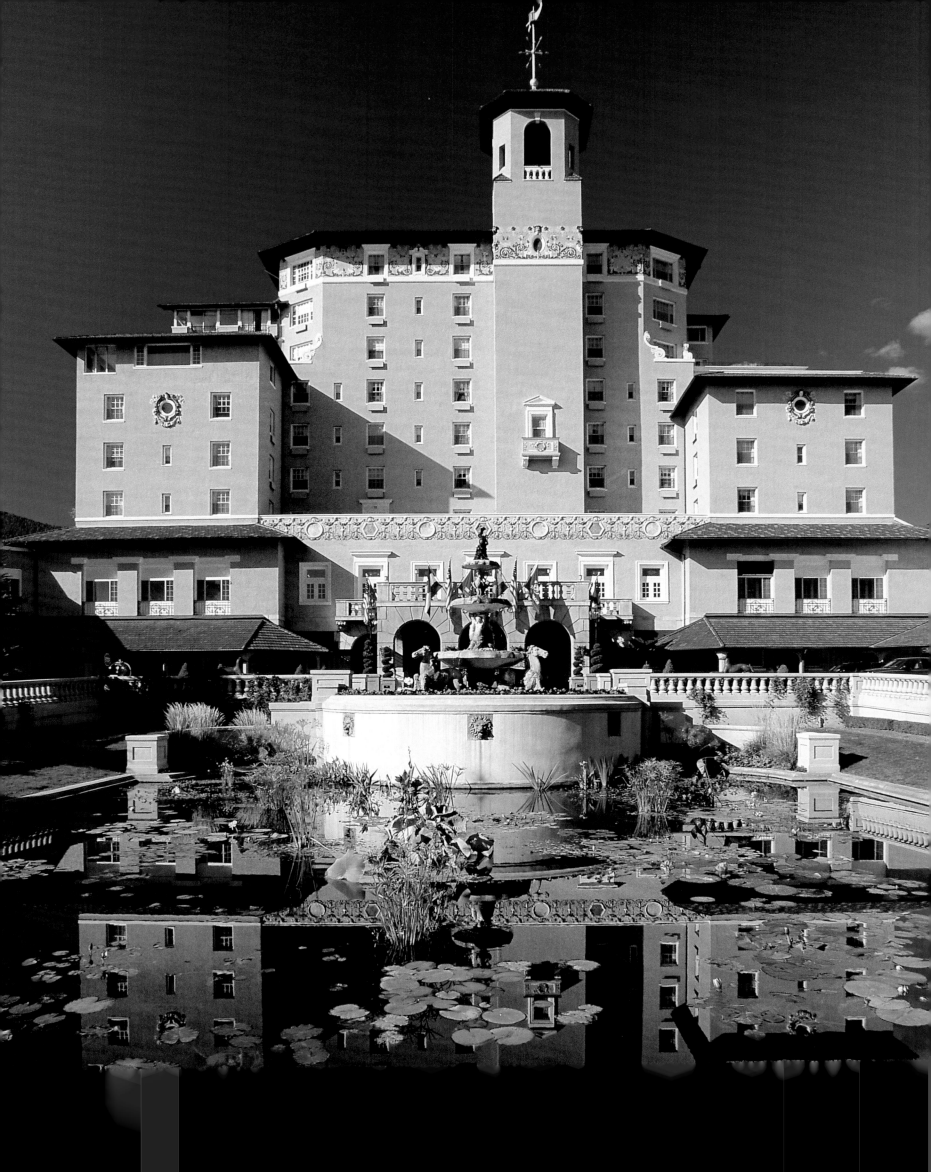

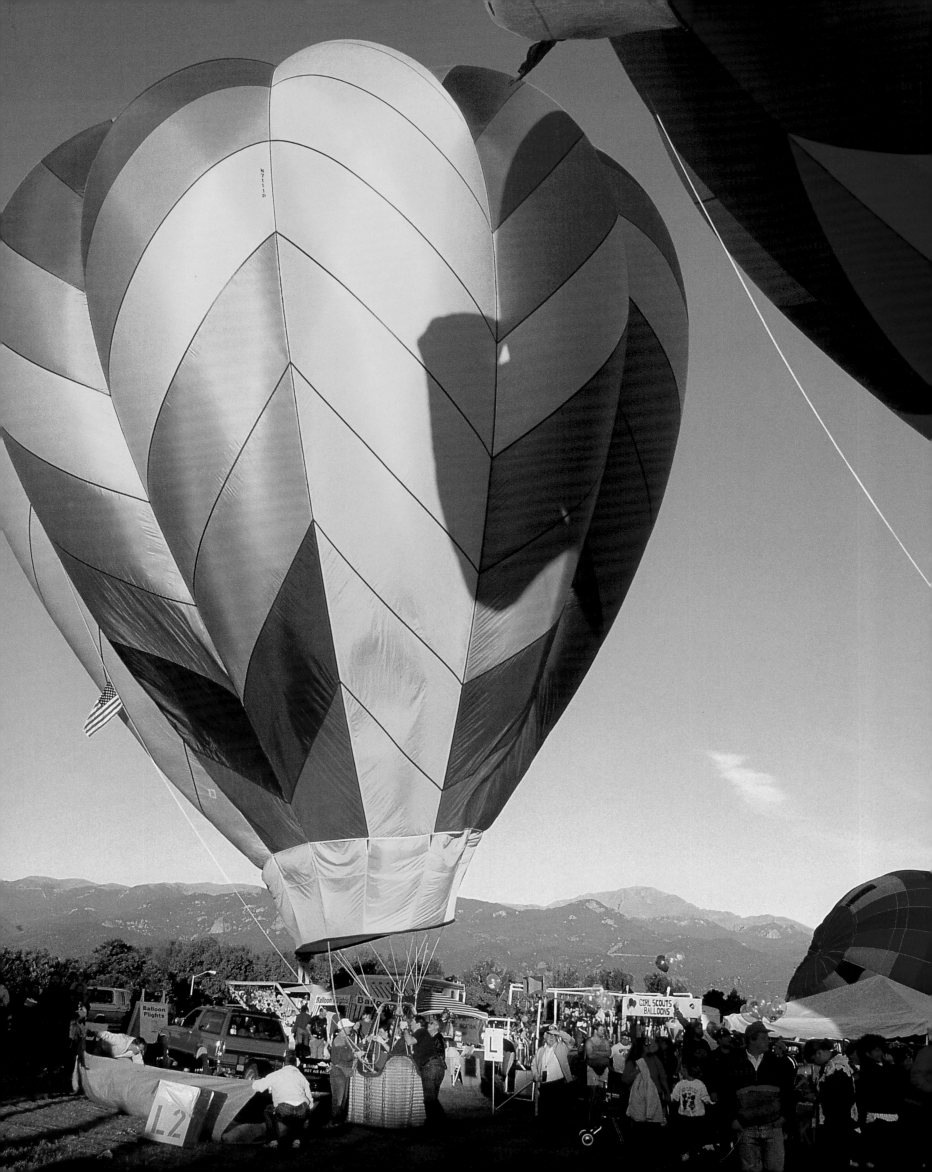

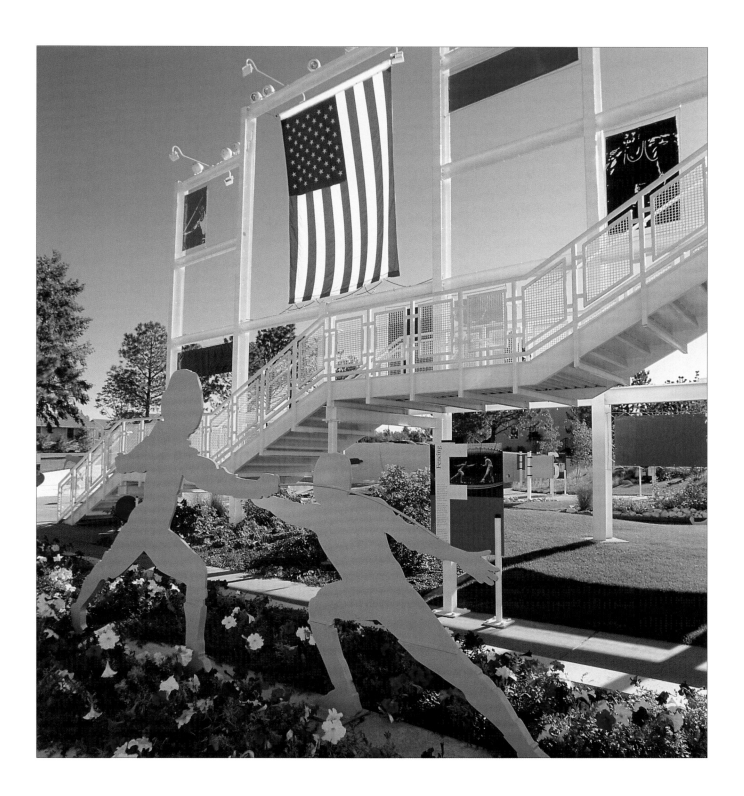

United States Olympic Complex, Colorado Springs

*T*he 37-acre U.S. Olympic Complex near downtown Colorado Springs serves as the head-quarters for the U.S. Olympic Committee and as training facilities for some 20 national amateur athletics.

Left: Balloonists with Pikes Peak

*C*olorado's annual average of 300 days of sunshine, its incredible blue skies and favorable morning winds tempt outdoor enthusiasts with many pursuits. Aficionados of fresh air and eagle-eye views love Pikes Peak Country, lifting colorful creations into the wild blue yonder.

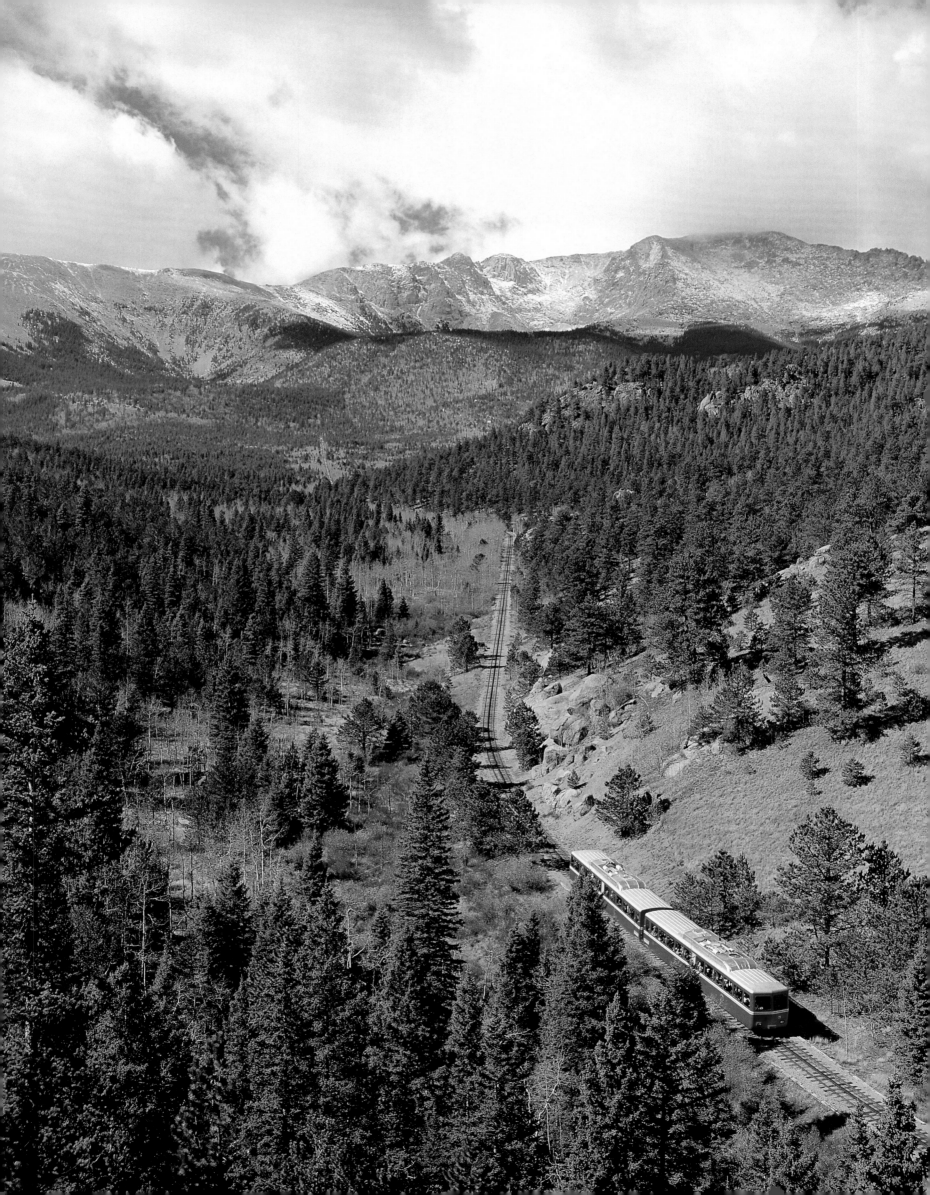

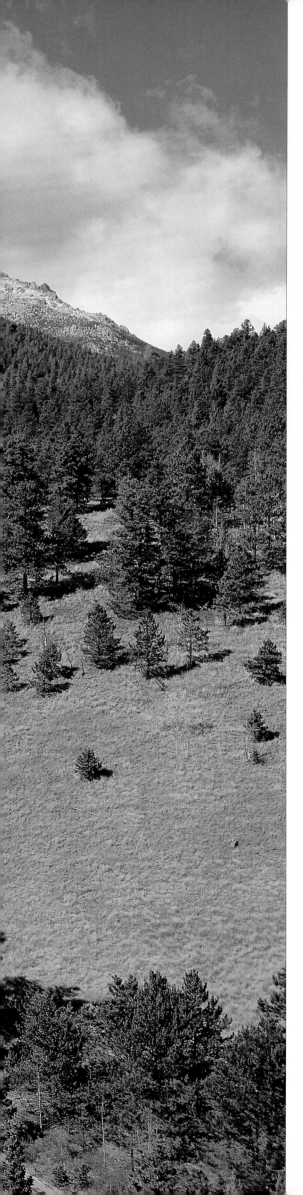

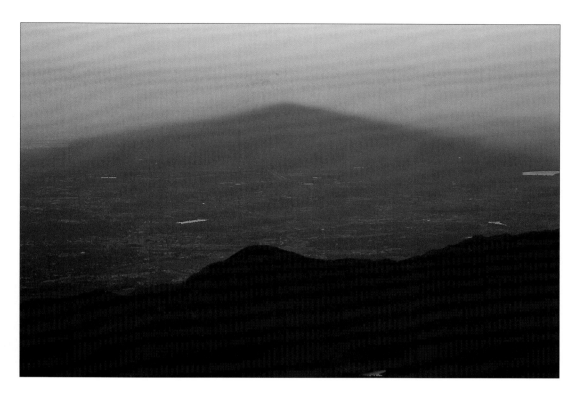

Pikes Peak Shadow

*P*ikes Peak casts an evening shadow eastward, engulfing the city of Colorado Springs. At 14,110 feet, Pikes Peak is only Colorado's 32nd highest mount, yet its dramatic location—it rises above the low-lying plains—invokes a much larger presence.

Left: Manitou and Pikes Peak Cog Railway

*P*roclaiming the scenery stunning but the journey too arduous, comfort-minded Zalmon Simmons, of Simmons Mattress fame and fortune, eased the ascent of Pikes Peak in the late 1800s by installing a Swiss-style cog railway to ratchet along the tracks to the summit. Today, the Manitou and Pikes Peak Cog Railway is still the most restful way to reach the pinnacle.

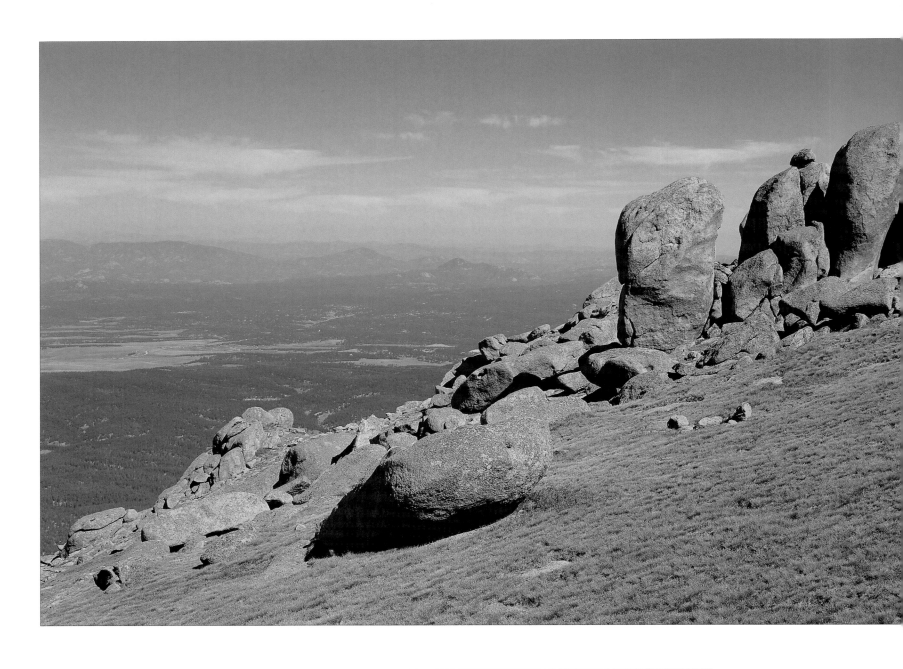

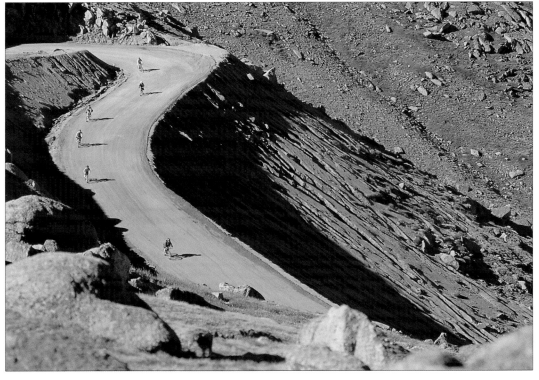

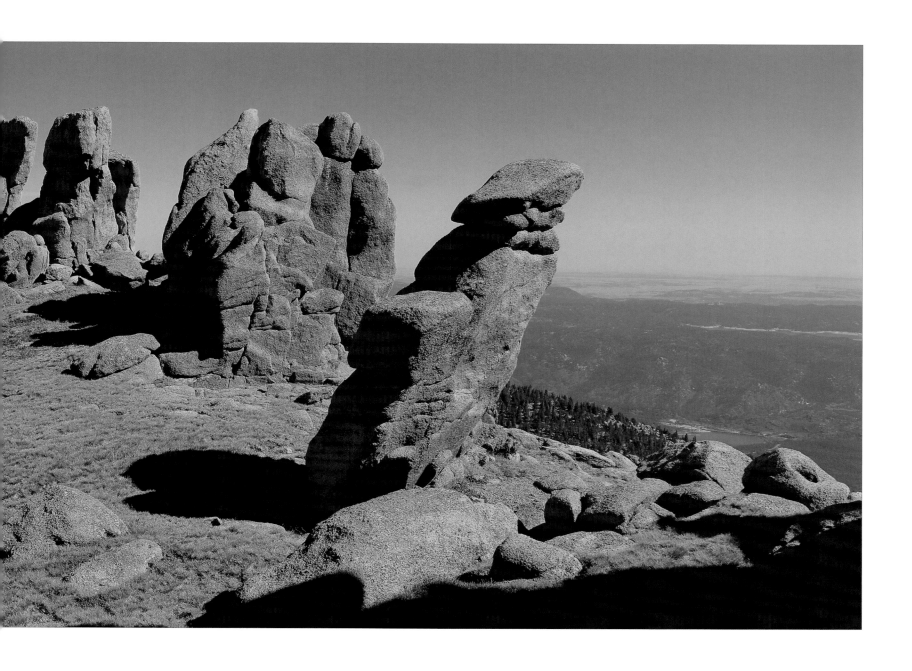

Hardrock Hoodoos, Pikes Peak

*I*n 1858, after 20-year-old Julia Holmes reached the summit of Pikes Peak, she wrote home telling of "huge rocks projecting out in all imaginable shapes." More than a century later, the enduring slopes of the great mountain continue to stir imaginations with its wind- and weather-worn monoliths.

Left: Pikes Peak Highway

*S*etting for the exciting annual Pikes Peak Auto Hill Climb, the "Race to the Clouds," the gravel track of the Pikes Peak Highway also entices bicyclists to pedal 19 miles of twisting hairpin turns and heart-pumping grades to savor truly breathtaking vistas.

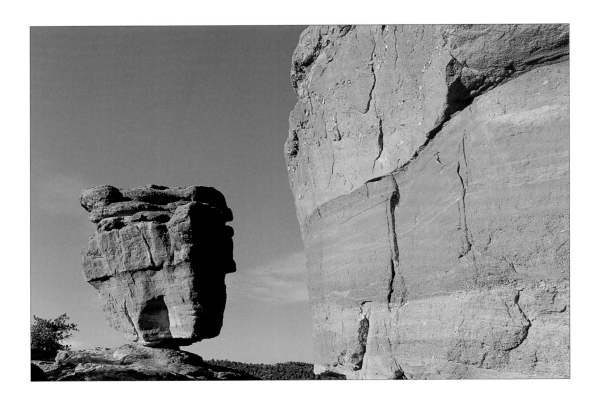

Balanced Rock, Garden of the Gods

*B*alanced Rock in Garden of the Gods, one of the park's most accessible and fascinating sandstone sculptures, appears to defy gravity, seeming to teeter on its slender rocky perch atop a windswept boulder. The city park and nature preserve features many fanciful formations with imaginative names such as "Sleeping Giant" and "Tower of Babel."

Right: Autumn afternoon, Garden of the Gods

*G*arden of the Gods National Natural Landmark encompasses 1,350 acres at the northwestern edge of Colorado Springs. Distinguished by sandstone monoliths formed millions of years ago, the uplifted sedimentary protrusions were shaped and worn by erosion over millennia into inspiring natural creations.

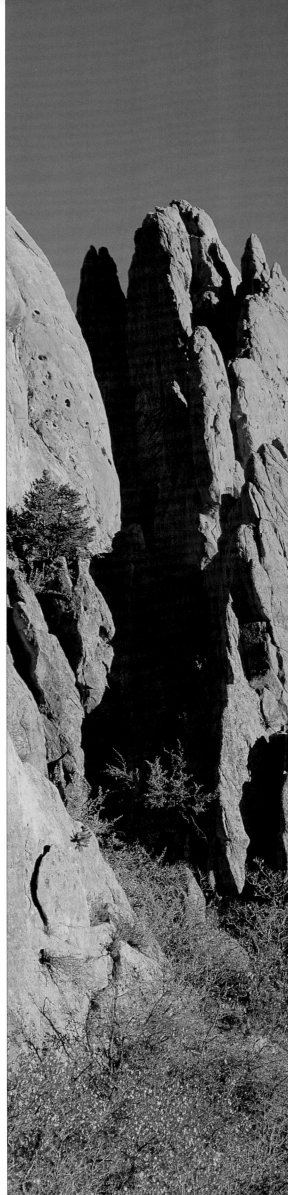

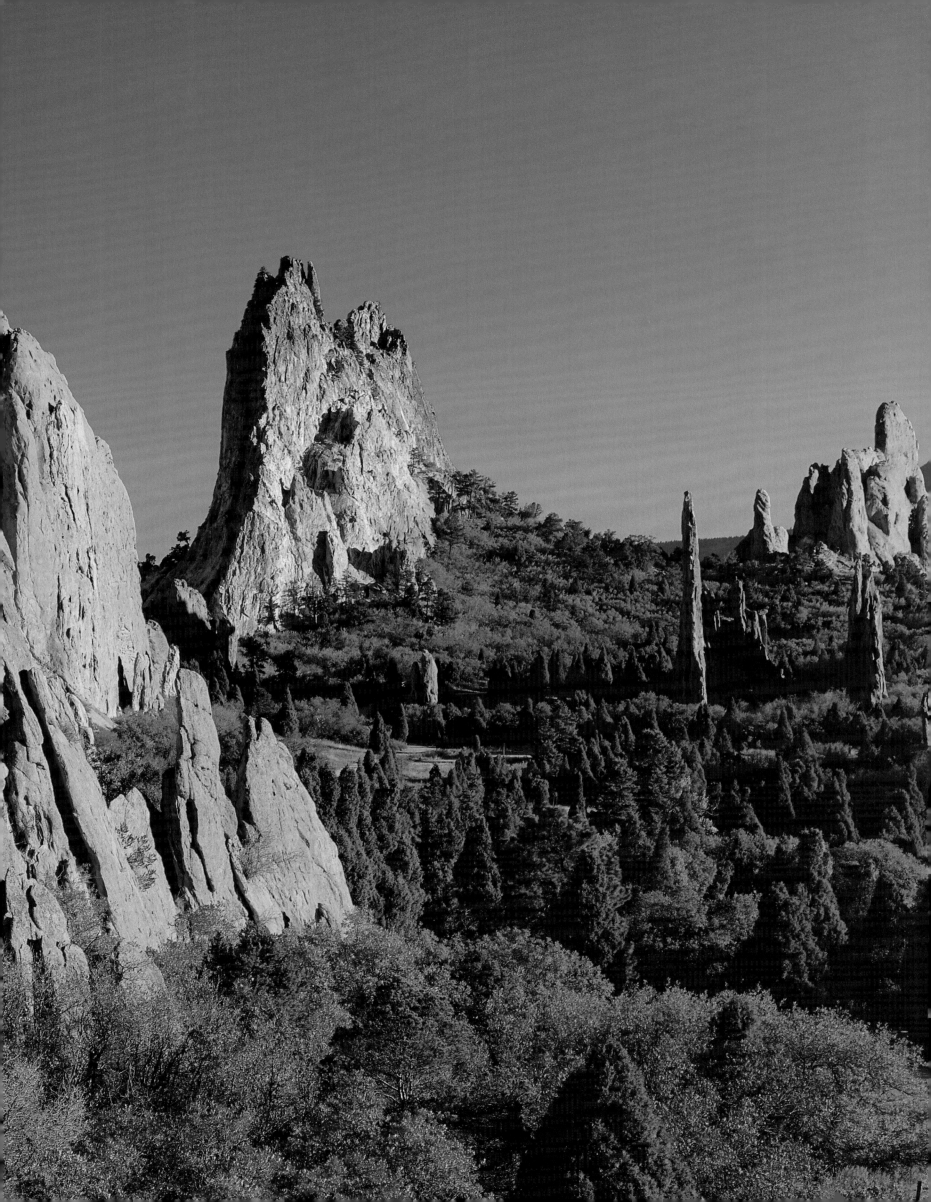

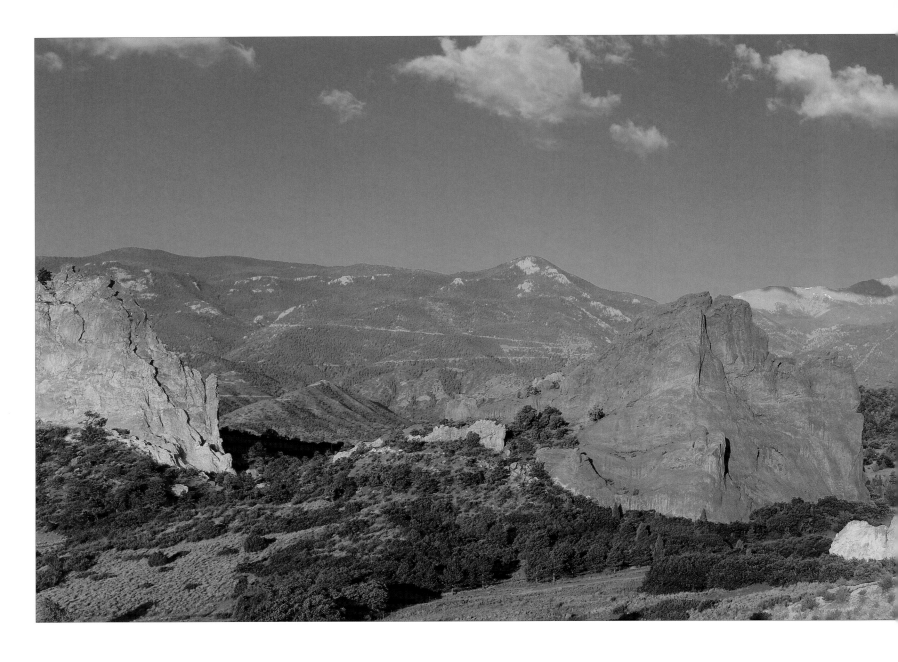

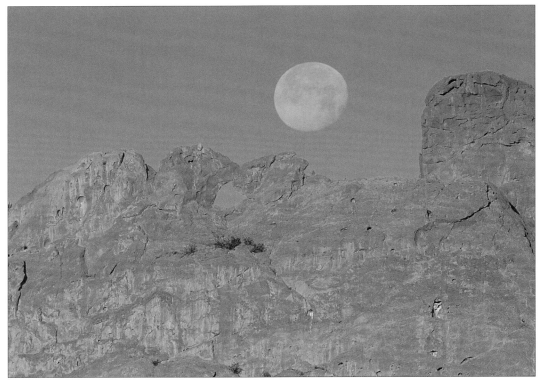

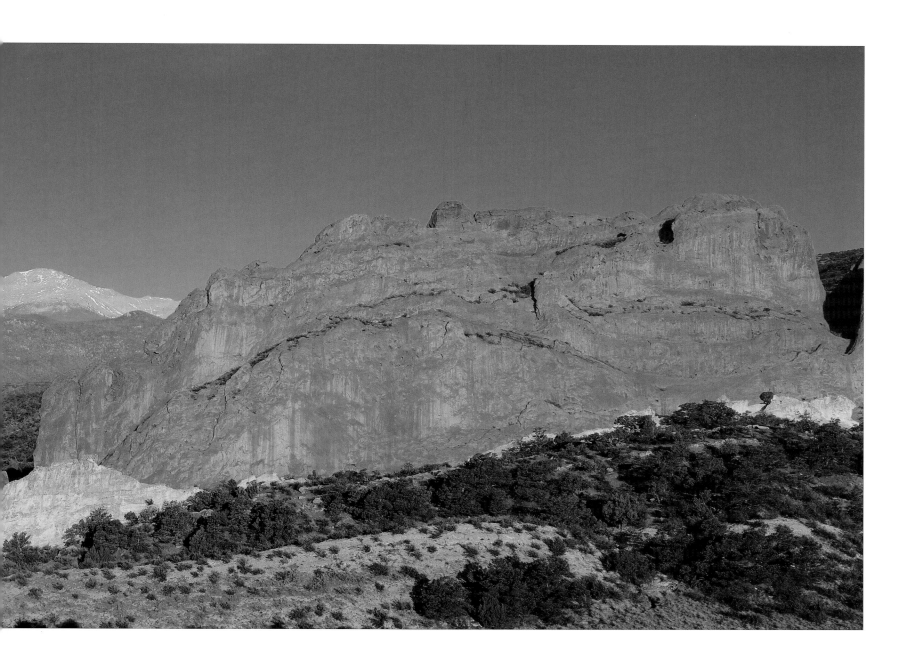

Garden of the Gods and Pikes Peak

*E*asily one of Colorado's most classic vistas, the panorama of Pikes Peak, framed by the daunting sandstone walls of the Garden of the Gods, marks the transition between Colorado's grassy prairie and the foothills of the Rampart Range.

Left: Kissing Camels, Garden of the Gods

A waning spring moon adds a sense of timeless romance to the sandstone profile, appropriately called "Kissing Camels."

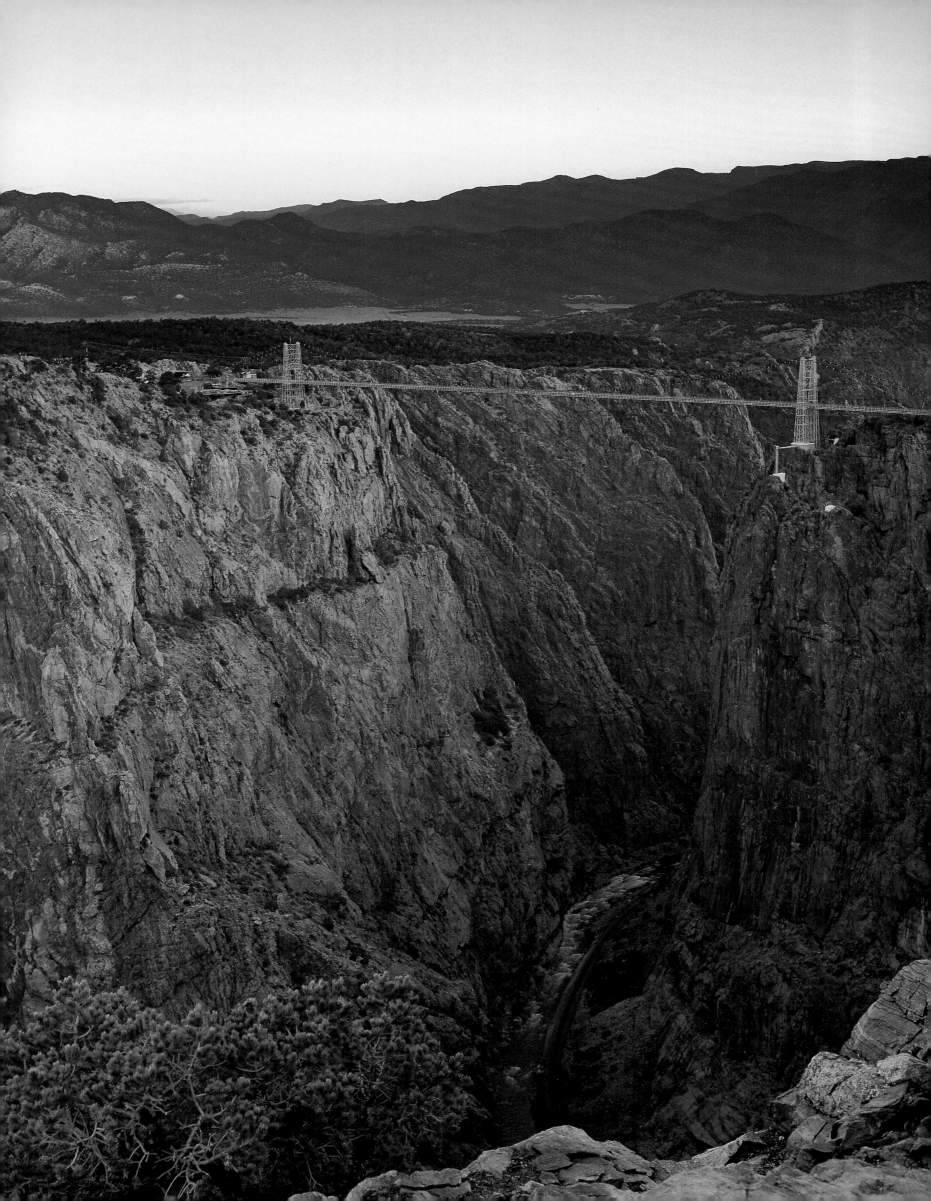

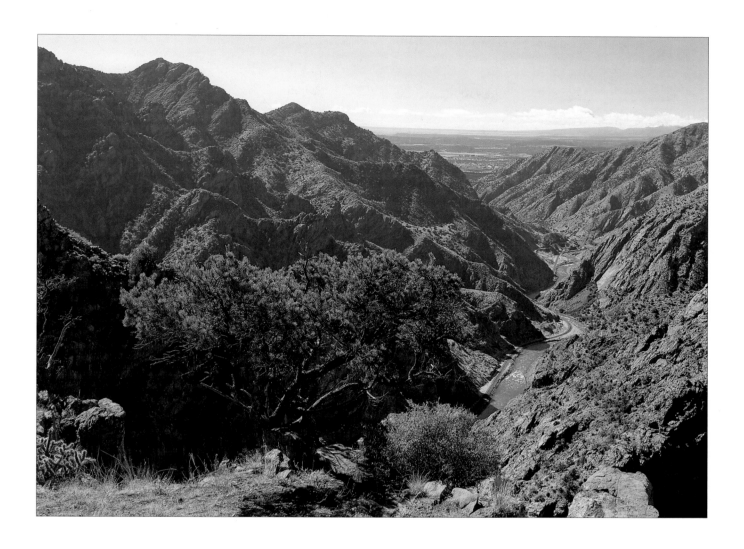

Canyon of the Arkansas River, Royal Gorge Park

*A*bove towering cliffs on a rim of high desert plateau, the smell of pinon pine and juniper complements nature's handiwork in the "Grand Canyon of the Arkansas." Steep canyon walls stretch to distant flatlands beyond Cañon City and Florence.

Left: Royal Gorge Bridge

*S*panning a thousand feet above the turbulent Arkansas River, the Royal Gorge Bridge is the world's highest suspension bridge. Completed in 1929, the steel used in its construction came from Pueblo's Colorado Fuel and Iron factories.

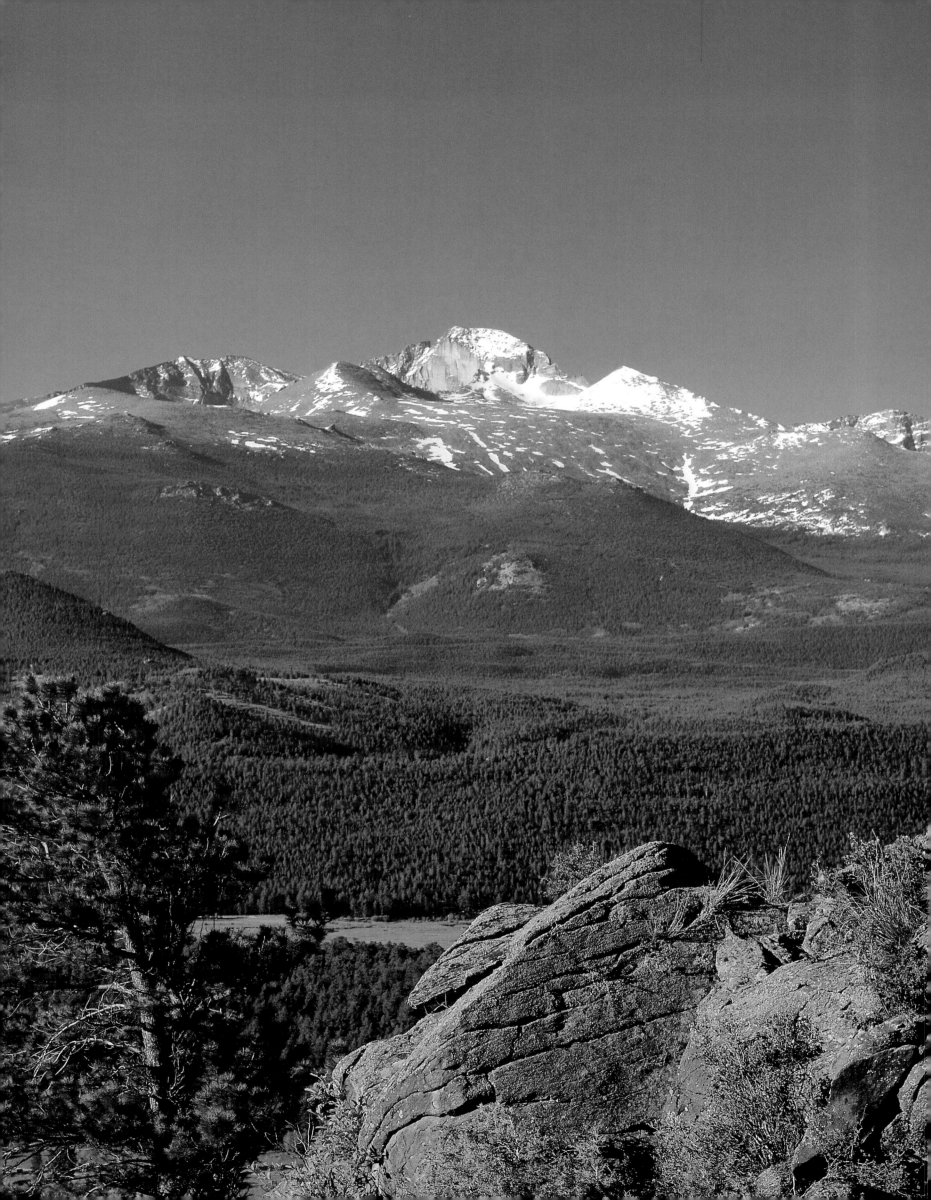

ROCKY MOUNTAINS

*C*olorado occupies the extreme southern reaches of the majestic Rocky Mountains: range after range of massif and mount staggering across the North American continent from the Canadian Yukon southward 2,000 miles to northern New Mexico. The result of eons of geological uplift, erosion and volcanic activity, the Rockies present an unparalleled natural showplace of cliffs and canyons, alpine tundra and verdant vale—perhaps nowhere better than in Colorado's magnificently diverse terrain.

Some three dozen mountain ranges—Medicine Bow, Never Summer, Rabbit Ears, Gore, Mosquito, Rampart, Ten Mile, Sawatch, Sangre de Cristo and others—traverse north to south across the middle third of the Centennial State. Tracking erratically along the their granite backbones, the Continental Divide often ignores loftier summits while defining watersheds for the Atlantic and Pacific oceans. And from mountain snows run mighty rivers—the Colorado and its tributary, the Gunnison, the North and South Platte rivers, the Arkansas, the San Juan and the Rio Grande—each contributing to the American West's most essential and important resource: water.

The Rocky Mountains *en masse* boast 54 peaks cresting over 14,000 feet in elevation, and all 54 rise in Colorado. The Sawatch Range claims the state's largest collection of "Fourteeners." The highest summit, Mount Elbert, reaches a dizzying 14,433 feet, towering high above the Arkansas River Valley and leading a parade of sky-touching titans whose company includes Mount Massive and a squad of Collegiate Peaks; Mounts Oxford, Harvard, Columbia and Yale.

In 1859, prospectors scattered across Colorado's Rockies searching for the mountains' secret hordes of gold and silver. They found them. And although only a lucky few of those tenacious miners ever struck the Mother Lode, those that did spawned great financial empires and consummated Colorado's glimmering appeal to thousands of immigrants hoping for a good life in a good land. The fledgling mining camps, which exploded into bustling frontier towns—Central City, Black Hawk, Georgetown, Leadville, Cripple Creek—became rags-to-riches icons of the American West and the American Dream.

Colorado's mountains still produce respectable quantities of precious metals and minerals, but it is the Rockies' sublime scenery and pristine wilderness which color today's dream of the American West. Internationally known for both winter skiing and snowy solitude, Colorado's high country also welcomes thousands of summer outdoor lovers seeking the natural treasures of Rocky Mountain National Park or a fortune in recreational pastimes ranging from wildlife viewing to historic rail journeys.

Left: Longs Peak, Rocky Mountain National Park

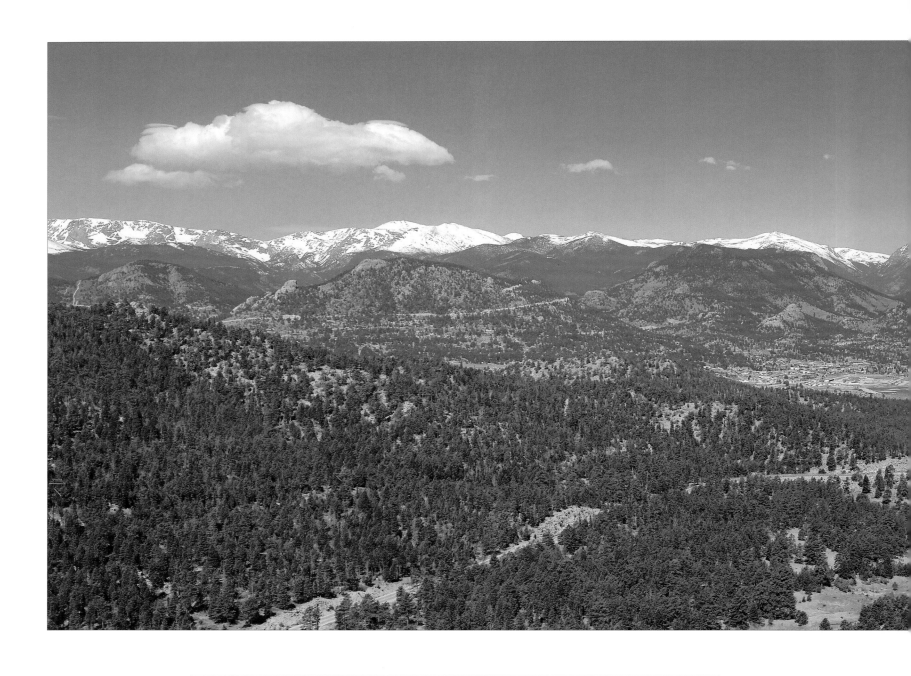

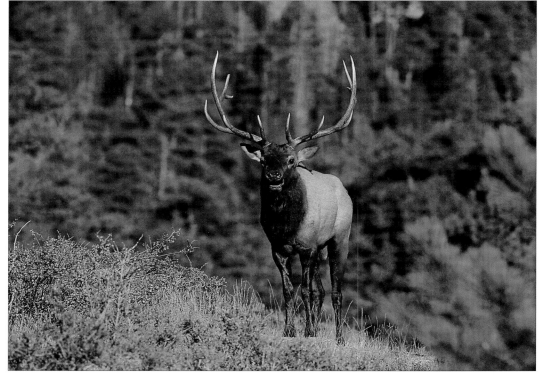

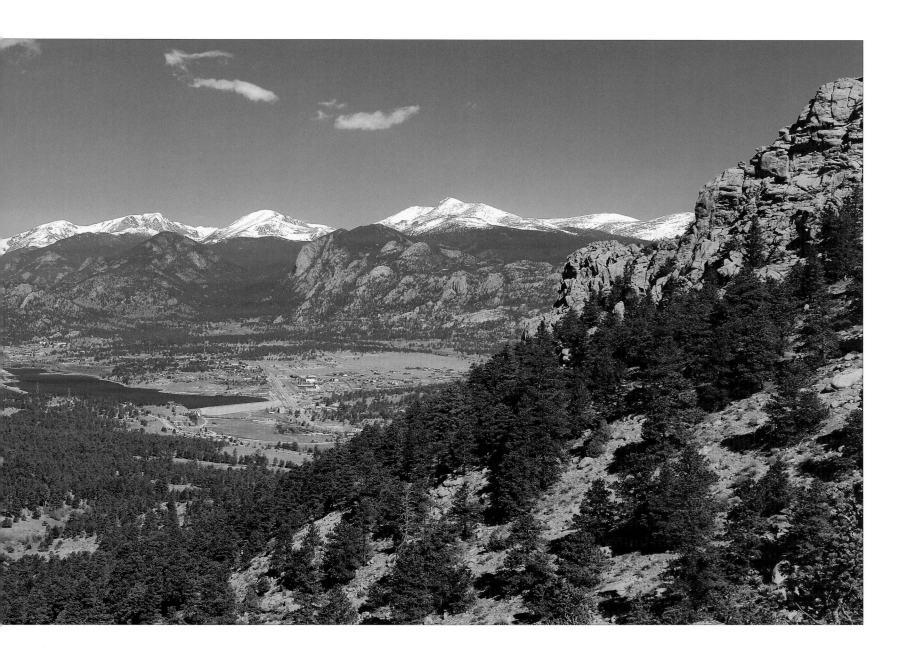

Lake Estes and Estes Park

*T*he snowcapped peaks of the Mummy and Front ranges form the backdrop to the town of Estes Park, the eastern gateway into Rocky Mountain National Park. The town's name stems from rancher Joel Estes, who along with his wife and children, settled in the area in the 1860s.

Left: Bull elk near Fish Creek, Estes Park

*W*apiti, or American elk (*Cervus elaphus*), are second only to moose in size among members of the deer family. These surefooted, hoofed mammals, or ungulates, prefer the forest's edge, feeding within easy escape to safer cover should danger appear. During the autumn mating season, bull elk fill the mountain valleys with their haunting bugling calls.

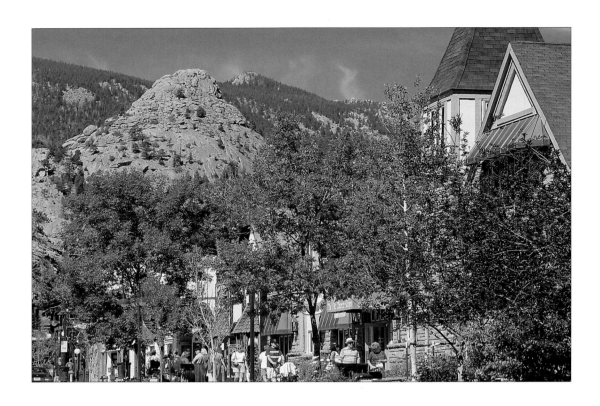

Old Man Mountain above Elkhorn Avenue, Estes Park

*E*lkhorn Avenue is the heart of Estes Park's shopping district and a testament to the community's resolve to rebuild after the disastrous Lawn Lake Flood of 1982. Today, tree-lined sidewalks welcome millions of visitors to its numerous boutiques, galleries, gift stores and eateries.

Right: Estes Park

*L*ongs Peak, the highest mountain along a divide of rocky titans, stands sentinel above Estes Park. In 1820, Major Stephen H. Long led a U.S. Army topographical expedition here, though he didn't ascend the mountain. It would take nearly 50 years before Major John Wesley Powell conquered the summit on August 23, 1868.

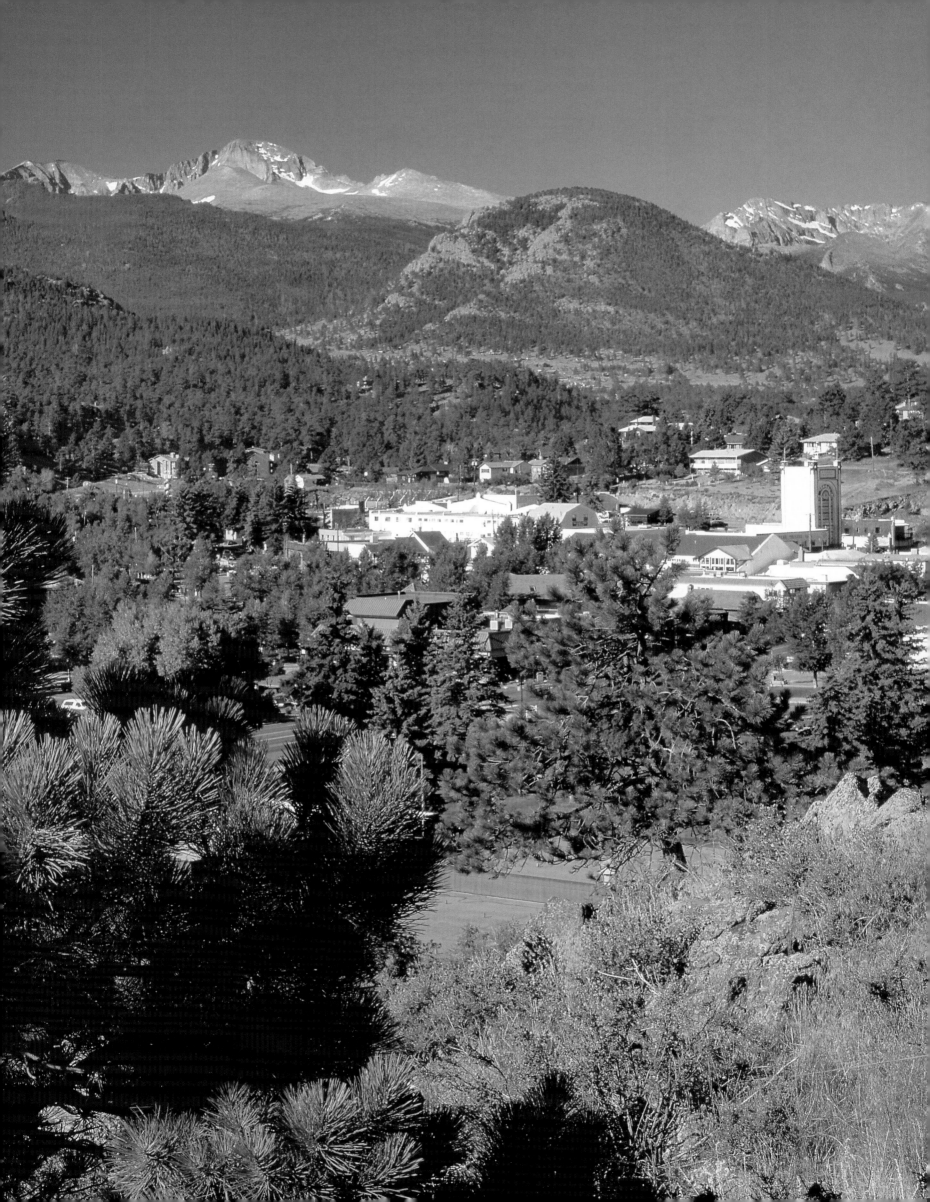

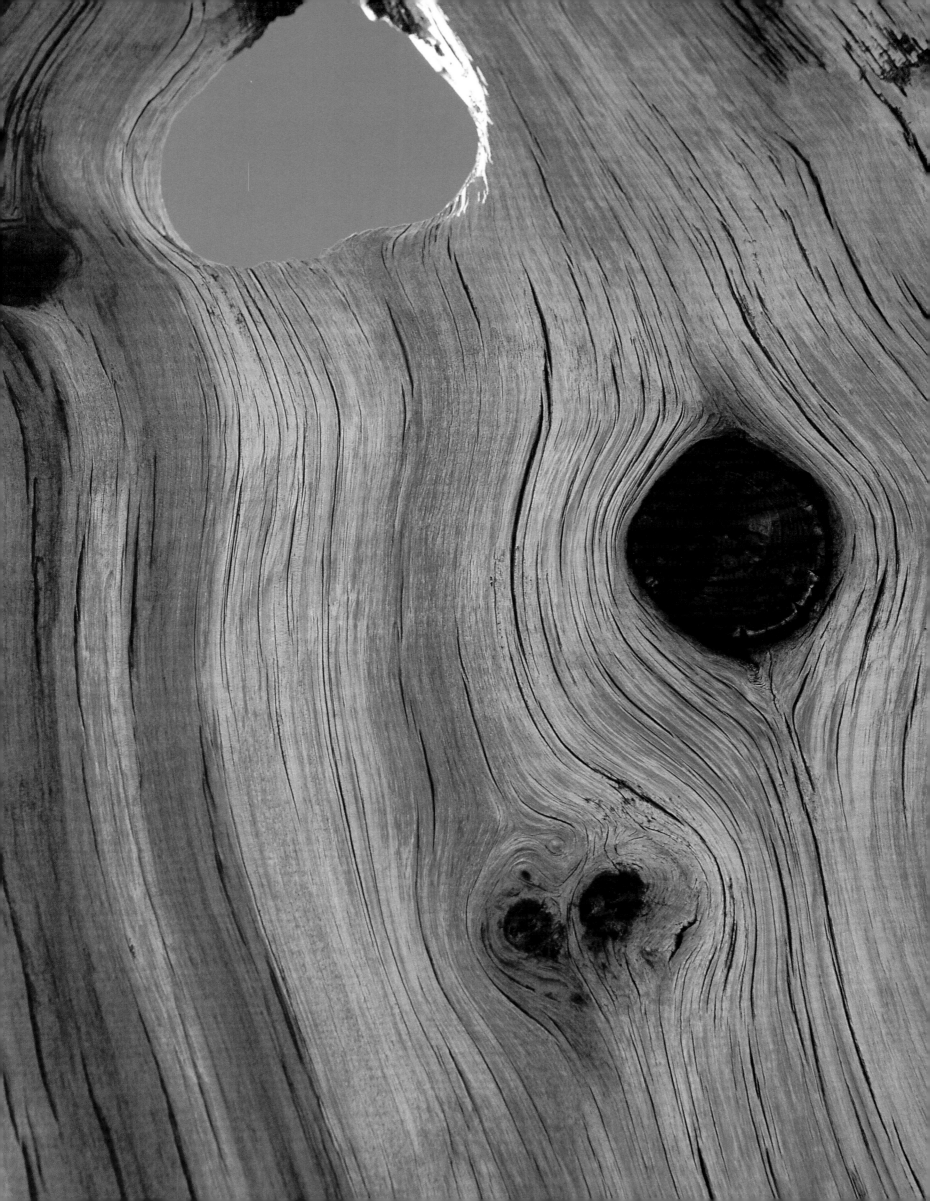

Coyote Pups, Rocky Mountain National Park

*K*nown for their eerie nocturnal howling, the wide-ranging and highly adaptable coyote (Canis latrans) typically gives birth to a litter of five to seven pups in early spring. Eight to ten weeks later, dens are abandoned and the family forages as a group until autumn before going their separate ways.

Left: Weathered pine, Mosquito Range

*O*n high-elevation, exposed mountain slopes, natural forces combine with the skill of a master woodworker to shape delightful visual treasures. A knothole opens a window to the sky in this shell of a weathered pine trunk, one of the time-worn denizens of the subalpine environment.

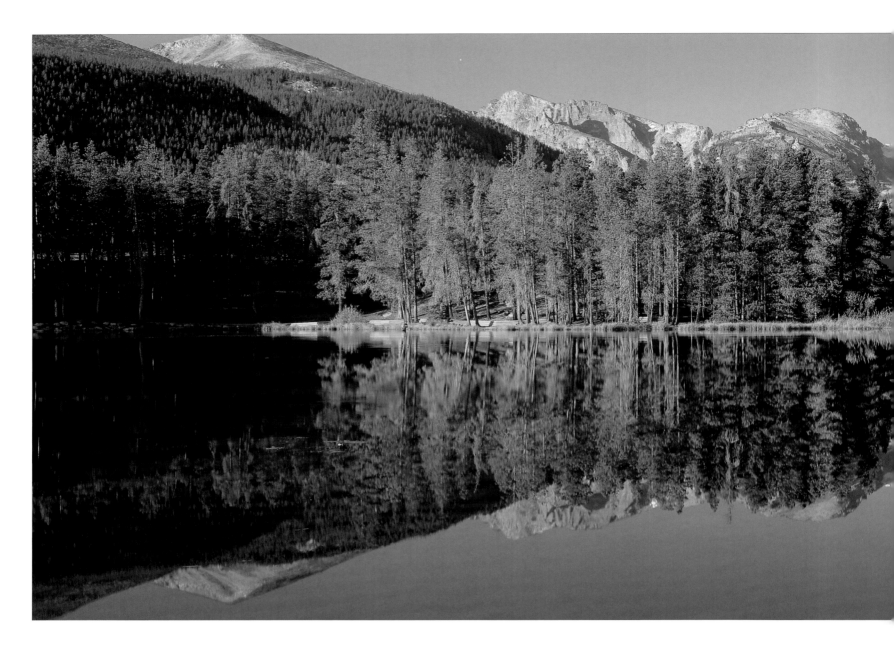

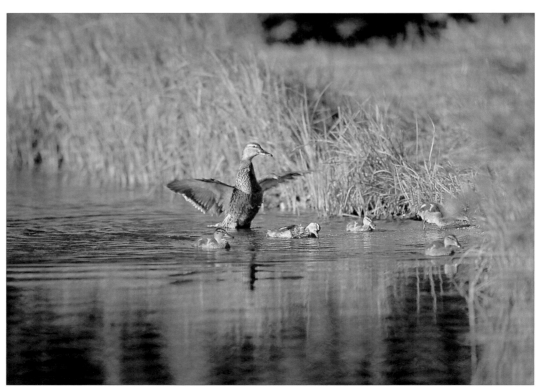

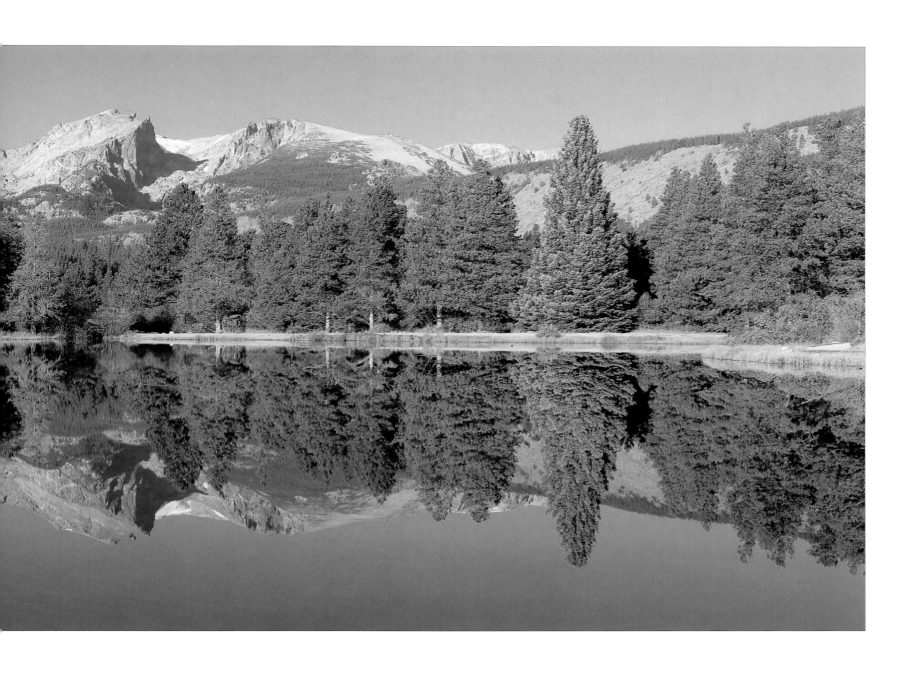

Sprague Lake, Rocky Mountain National Park

*L*ocated in Glacier Basin, Sprague Lake commands a scenic view of peaks along the Continental Divide. Pioneer Abner Sprague chose this site in the late 1800s to build a lodge, long since removed by the national park service. A lone blue spruce, Colorado's state tree, stands out among lodgepole and ponderosa pine along the lake's shoreline.

Left: Mallard hen and ducklings, Sprague Lake

*M*allards are the best-known and certainly one of the most abundant wild duck species in Colorado. In late spring and early summer mallard families feed and preen along the shores of Rocky Mountain lakes and ponds, offering entertaining natural scenes.

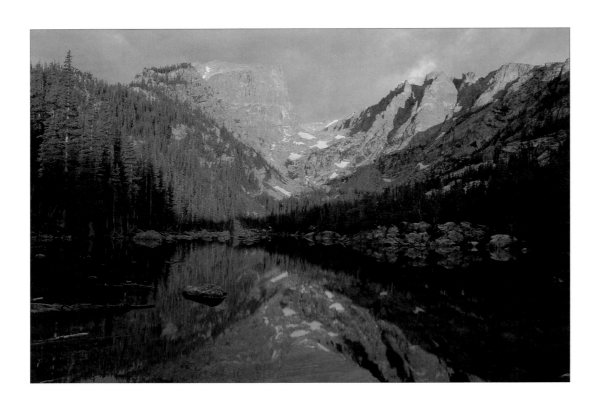

Hallett Peak at sunrise, Rocky Mountain National Park

The warm glow of a summer sunrise brightens the distinctive face of Hallett Peak and craggy arêtes on Flattop Mountain above the reflective waters of Dream Lake. One of the signature views in Rocky Mountain National Park, this vista is remarkably only a short hike from the Bear Lake parking area.

Right: Mummy Range, Rocky Mountain National Park

Blooming golden banner brightens a meadow along the Big Thompson River in Moraine Park. Expansive mountain grasslands called "parks" were formed by the scouring forces of glaciers. Over time the receding ice left rocky ridges known as moraines which in turn trapped water, creating lakes and ponds. Slowly filling with sediment, the natural reservoirs eventually became lush meadows.

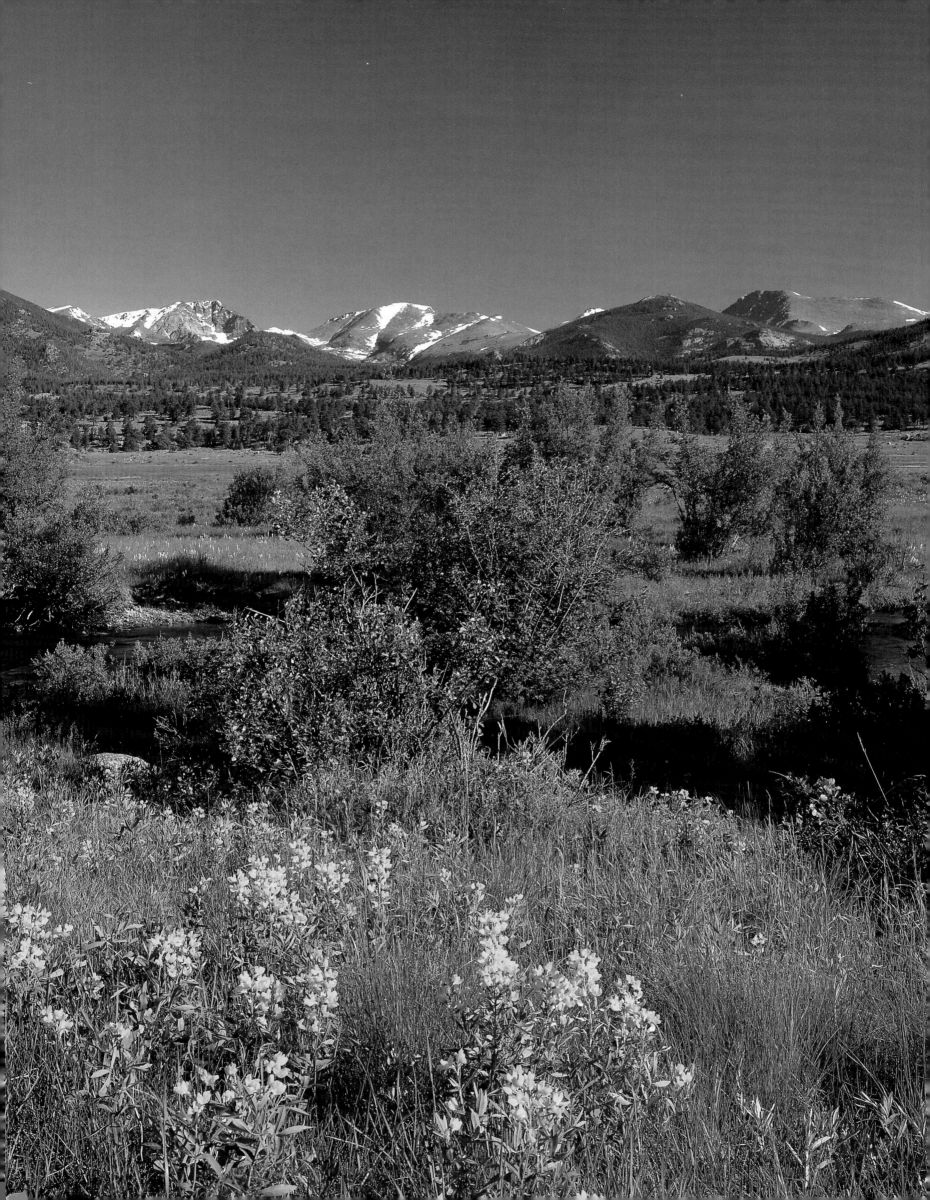

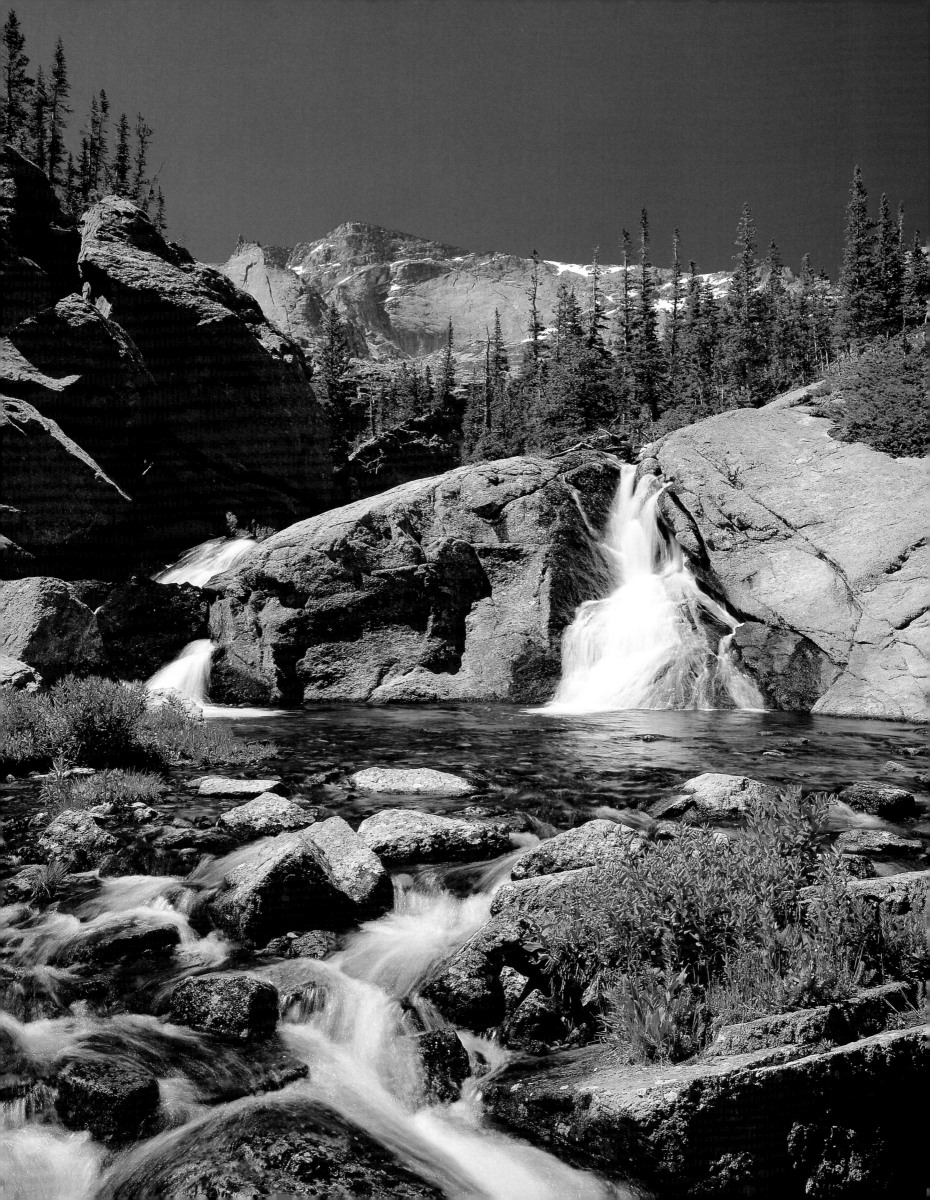

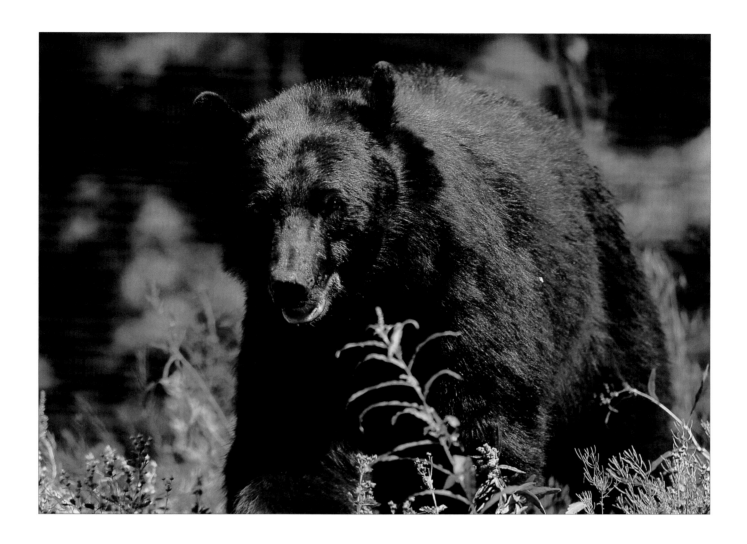

Black bear, Roosevelt National Forest

*W*eighing between 200 and 500 pounds, the black bear (*Ursus americanus*) inhabits the forested high country of Colorado's Rocky Mountains. Although termed "black," black bears' coloration may indeed vary from dark brown to cinnamon. Not true hibernators, black bears enter a lethargic, sleepy state in winter known as dormancy, usually denning under natural shelters such as rocks, trees, or even in deep snows. Females (sows) breed only in alternate years, bearing one to four cubs in January.

Left: Glacier Creek, Rocky Mountain National Park

*S*prightly Glacier Creek tumbles over granite outcroppings in Glacier Gorge, displaying the timeless sculpting action which water—whether in liquid form or as solid ice—has had on the Rocky Mountain landscape.

Fall River Pass, Rocky Mountain National Park

*S*unset enhances a skiff of snow carpeting the alpine tundra high atop Fall River Pass. Here the Rocky Mountain National Park Alpine Visitor Center and Trail Ridge Store are situated at the terminus of Old Fall River Road—an adventurous, 11-mile "motor nature trail" completed in 1920.

Right: Alpine Sunflowers, Continental Divide

*H*igh in the Rocky Mountains, in a land above treeline, the climate is similar to the Arctic. Short summers bring a dazzling array of dwarfed wildflowers, painting the harsh and fragile landscape with a flourish of intense color.

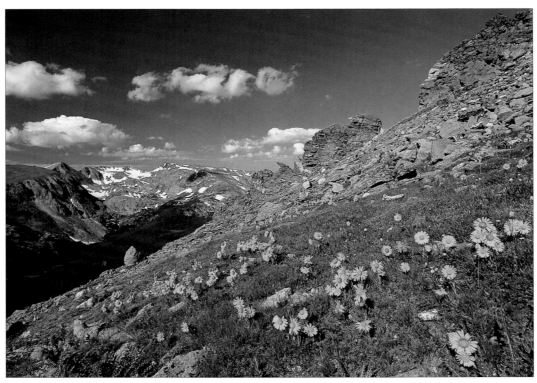

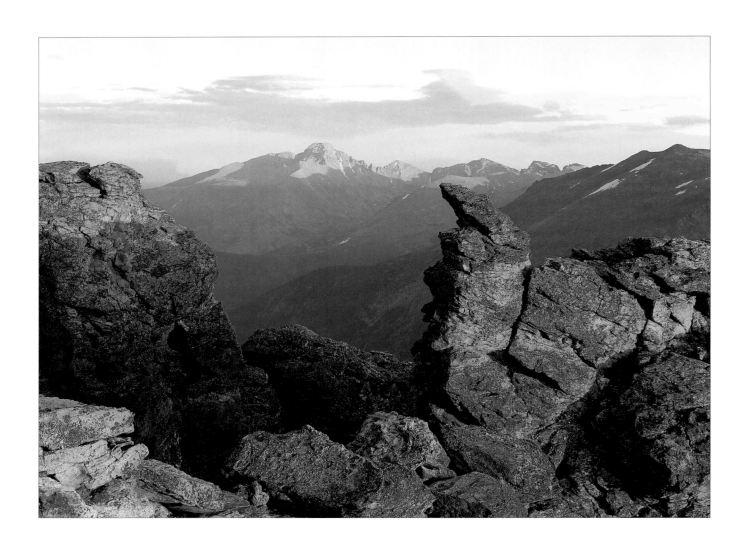

Longs Peak from Rock Cut, Rocky Mountain National Park

*S*itting astride the Continental Divide, Rocky Mountain National Park encompasses 415 square miles of jagged peaks, evergreen forest, open meadows and alpine tundra—truly the crown jewel of Colorado's Rocky Mountains. Within the park's boundaries, 60 mountains exceed 12,000 feet in elevation and cresting above them all at 14,255 feet is majestic Longs Peak. Dramatic views of Longs Peak are seen from Trail Ridge, a rolling section of alpine tundra accessible by auto via Trail Ridge Road—one of the highest paved highways in North America.

Right: Fresh Snow and Winter Sun, Rocky Mountain National Park

*L*ong midday shadows testify to the winter season's shorter days and accent the powdery, glistening snow blanketing Colorado's Rocky Mountain subalpine forests.

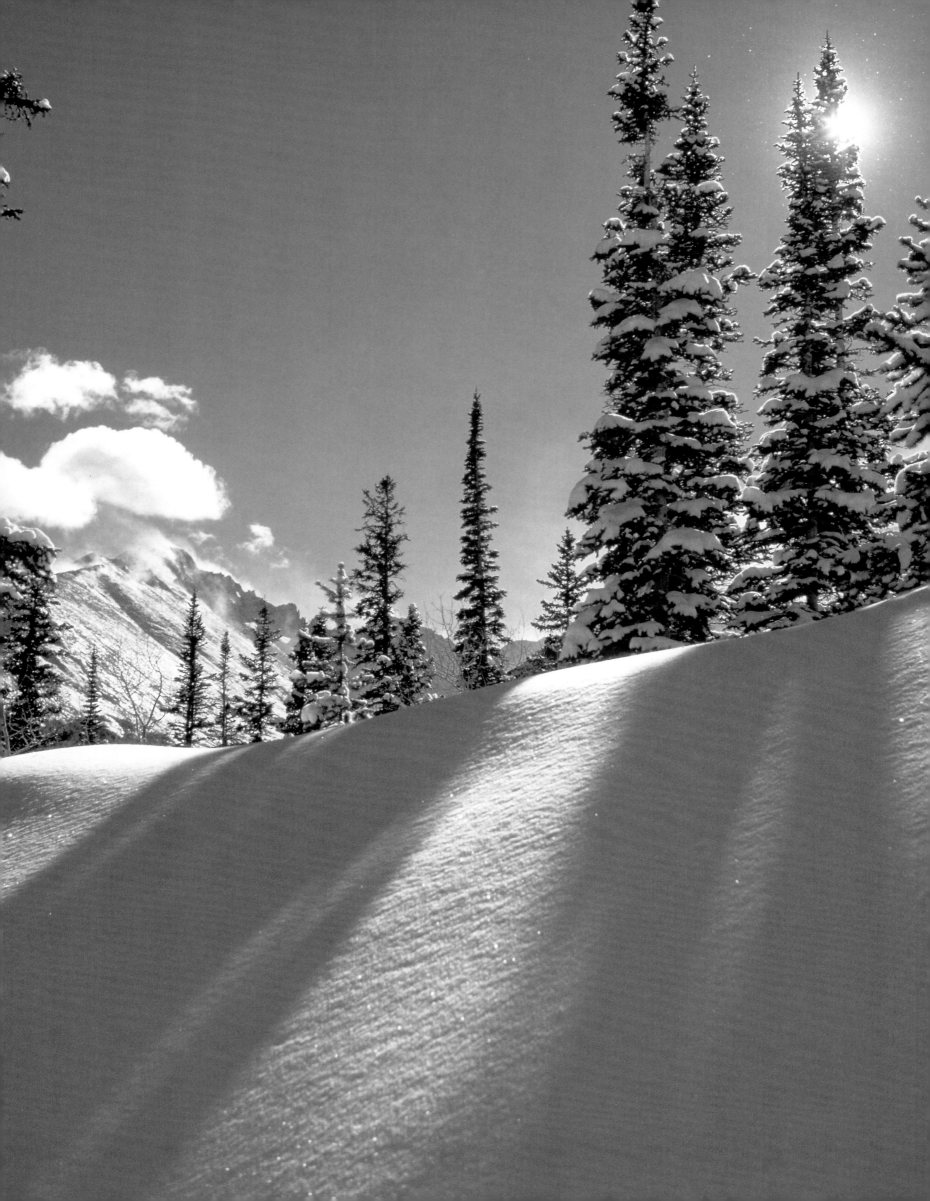

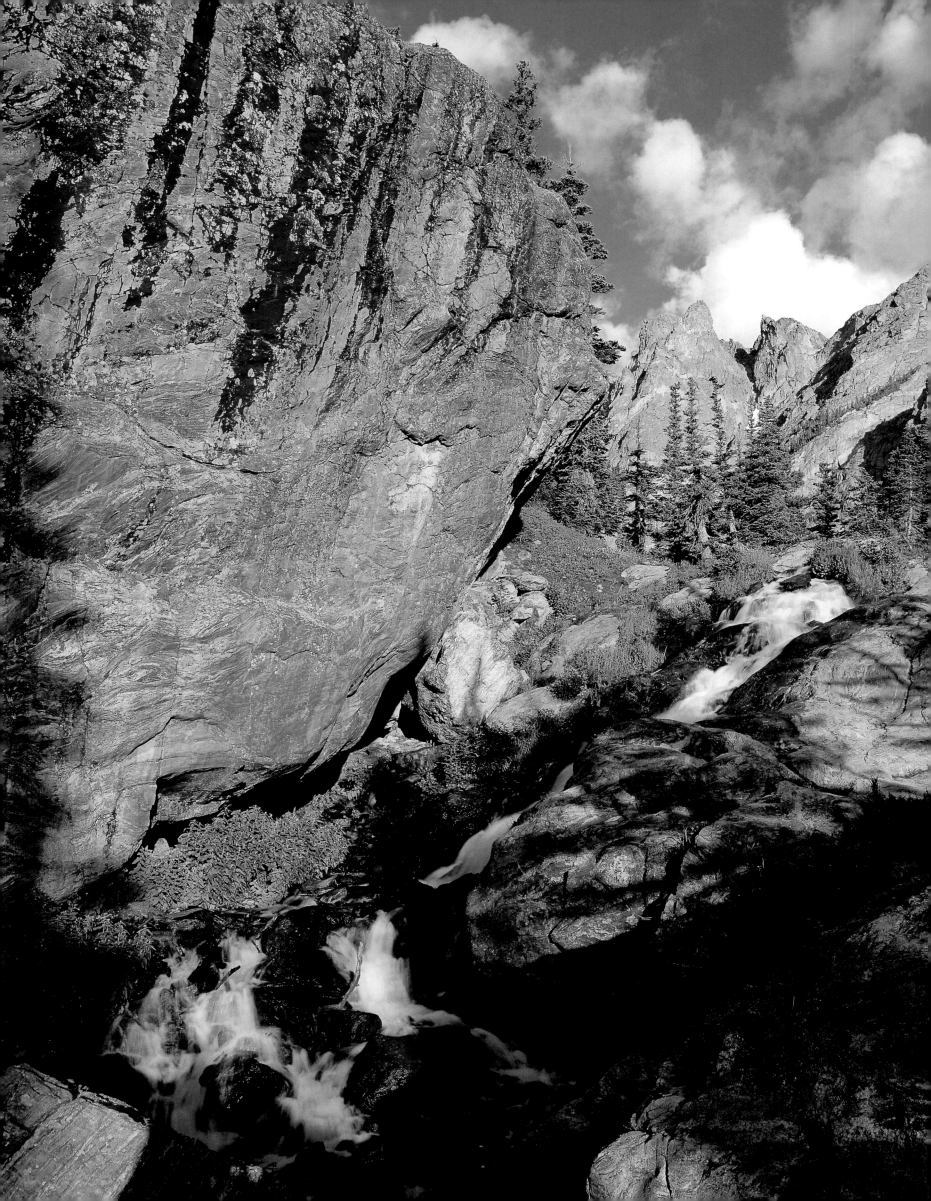

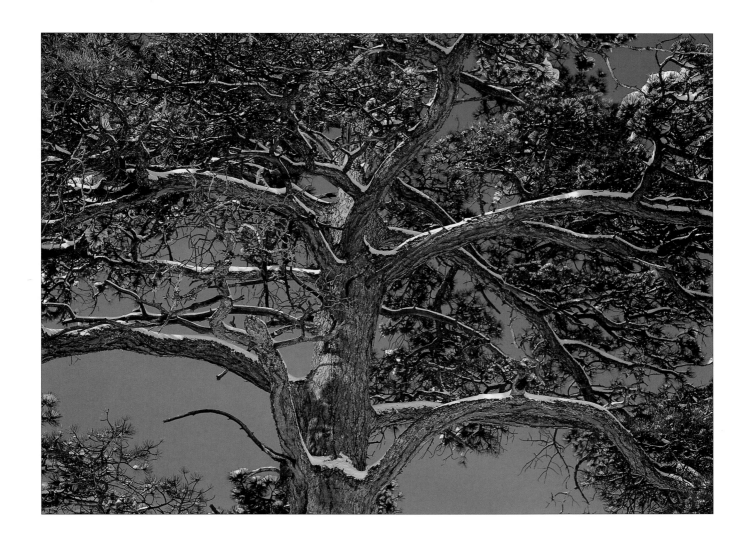

Ponderosa pine branches and spring growth

*P*onderosa pine (*Pinus ponderosa*), characterized by its ruddy-red bark, are sun-lovers, preferring south-facing mountain sides. Among the Rockies' largest conifers, the stately giants grow to heights of over 100 feet with trunk diameters reaching three feet.

Left: Tyndall Creek, Rocky Mountain National Park

*P*ick any trail in Colorado's high country and invariably, there will be delightful natural surprises at every turn, such as this lichen-covered anvil of glacier-sculpted granite that seems to defy gravity as it leans precariously above Tyndall Creek.

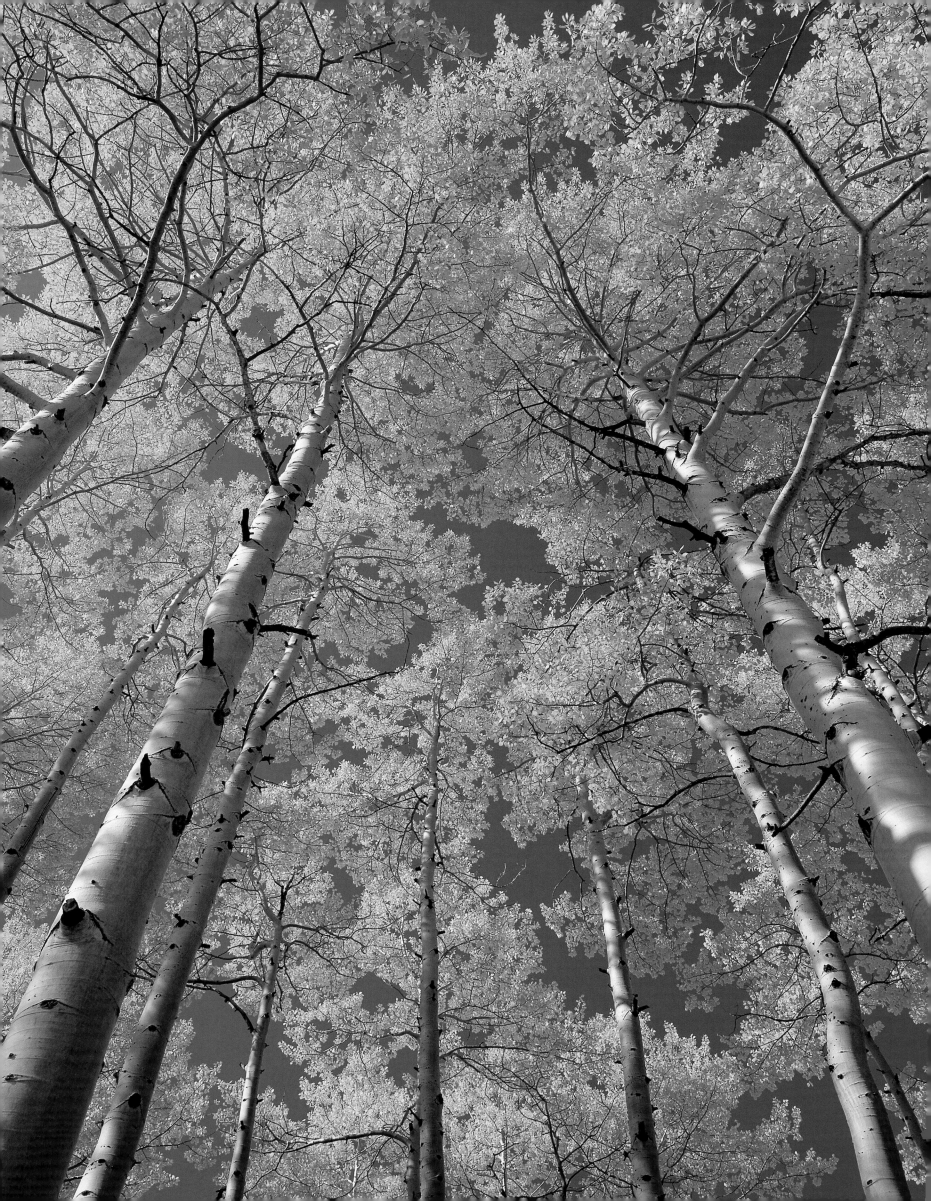

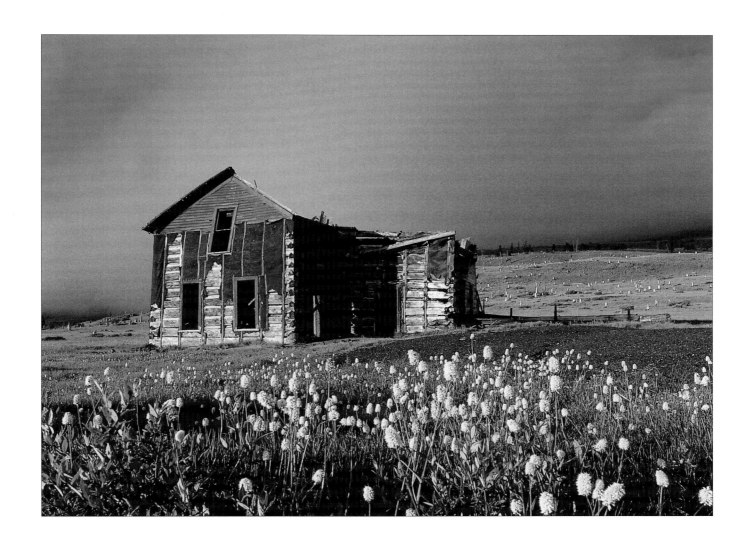

Timeworn homestead, Boreas Pass

\mathscr{R}elics of clear-cut subalpine forest and long-forgotten dreams are brightened by a meadow festooned with long-stemmed bistort high in the Rocky Mountains outside Breckenridge.

Left: Autumn aspen

\mathscr{A}utumn in Colorado's Rocky Mountains is symbolized by golden-hued groves of quaking aspen (*Populus tremuloides*), so named because their leaves quiver in the slightest breeze. Come late September and into October, entire mountainsides glow fire-bright with this remarkably tall, straight and colorful member of the willow family.

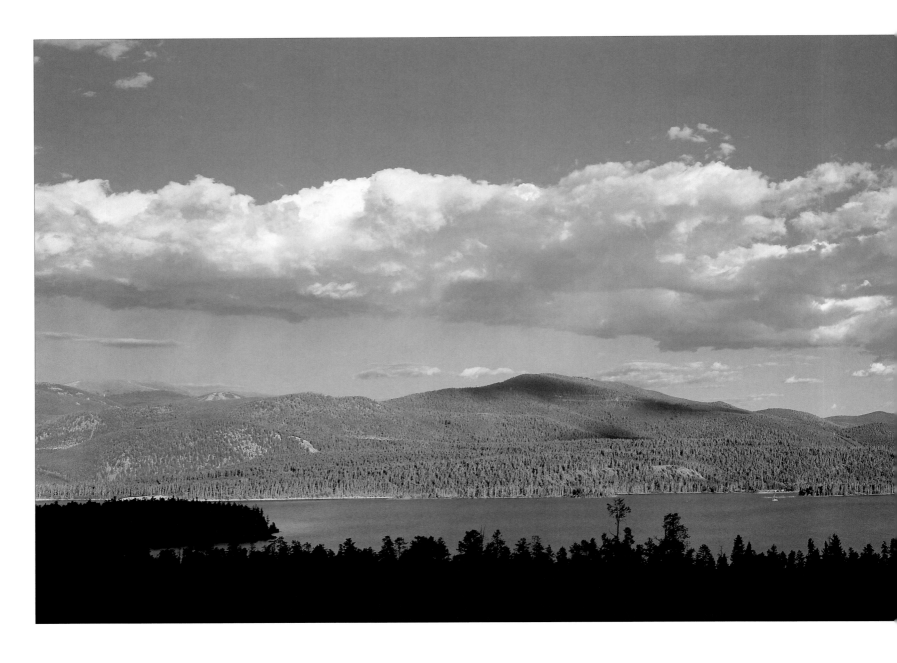

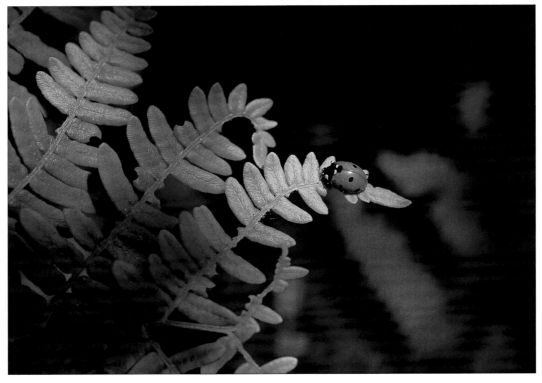

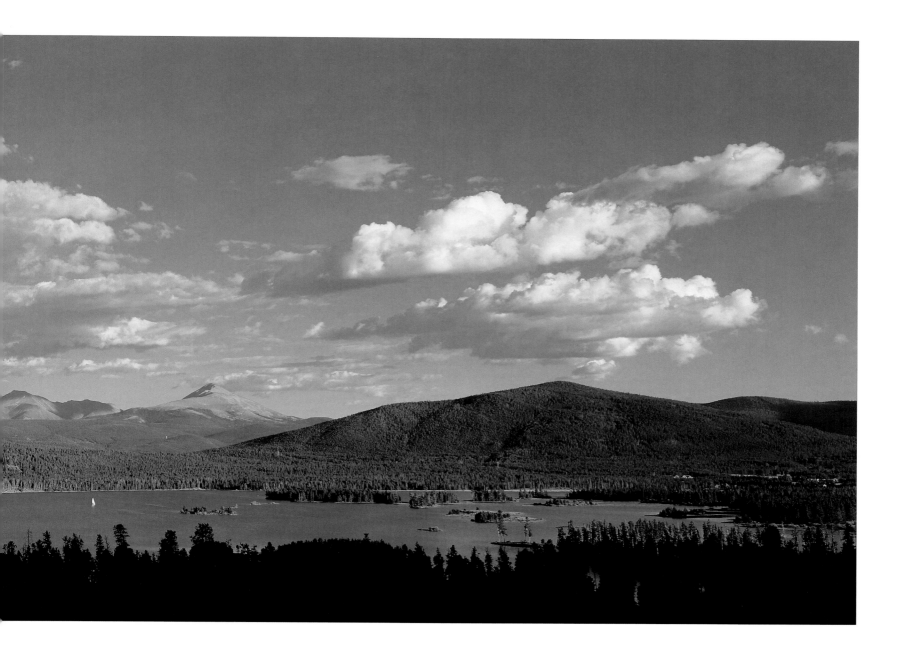

Dillon Reservoir, Summit County

*W*ind-tossed cumulus clouds drift above Dillon Reservoir and Arapaho National Forest near the towns of Frisco and Dillon. The Summit County area anchors the Rockies' reputation as recreation central for outdoor enthusiasts. Streams, lakes and trails welcome visitors into fresh mountain air to enjoy hiking, horseback riding, fishing, kayaking, mountain biking or sailing.

Left: Ladybug on fern

*W*herever spring and summer blossom, tiny ladybugs seem to be nearby, even in Colorado's high country. Considered nature's exterminators for their gastronomic delight in insect pests and their eggs, ladybugs are a humble, yet important, piece of the Rocky Mountain ecosystem.

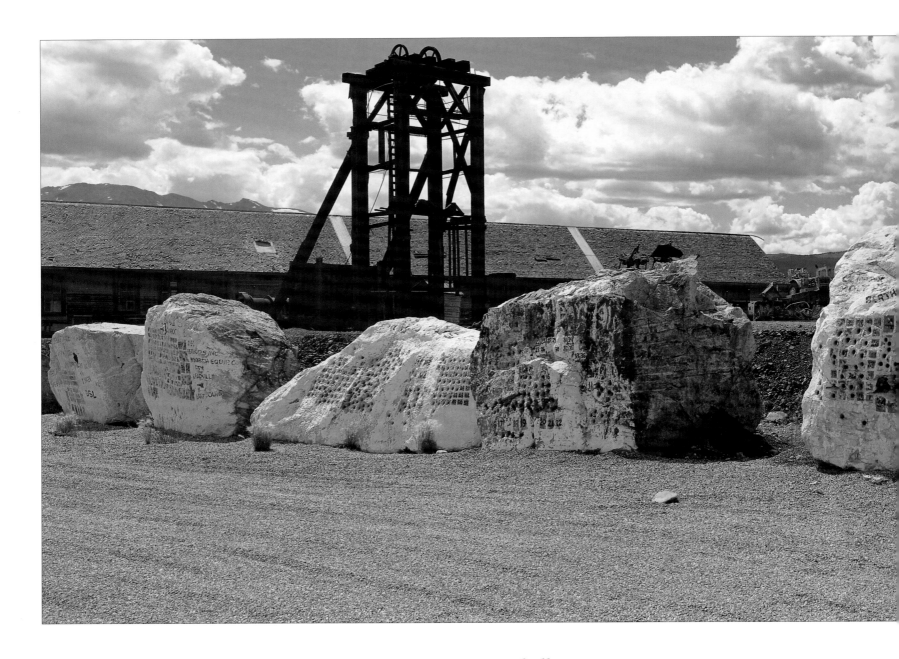

Mining memories, Leadville

*H*uge granite blocks, bearing the marks of jackhammer contests, line a street in Leadville, America's highest-elevation incorporated city at 10,430 feet. During its heyday in the late 1800s, the thin-aired "Cloud City" was also one of Colorado's "Silver Queens," turning many dirt-poor miners into overnight millionaires.

Right: Great Sand Dunes National Monument and Preserve

A dusting of spring snow frosts the rippling ridges of Great Sand Dunes National Monument and Preserve, an area with 30 square miles of shifting sands rising mirage-like from the San Luis Valley at the base of the Sangre de Cristo Mountains.

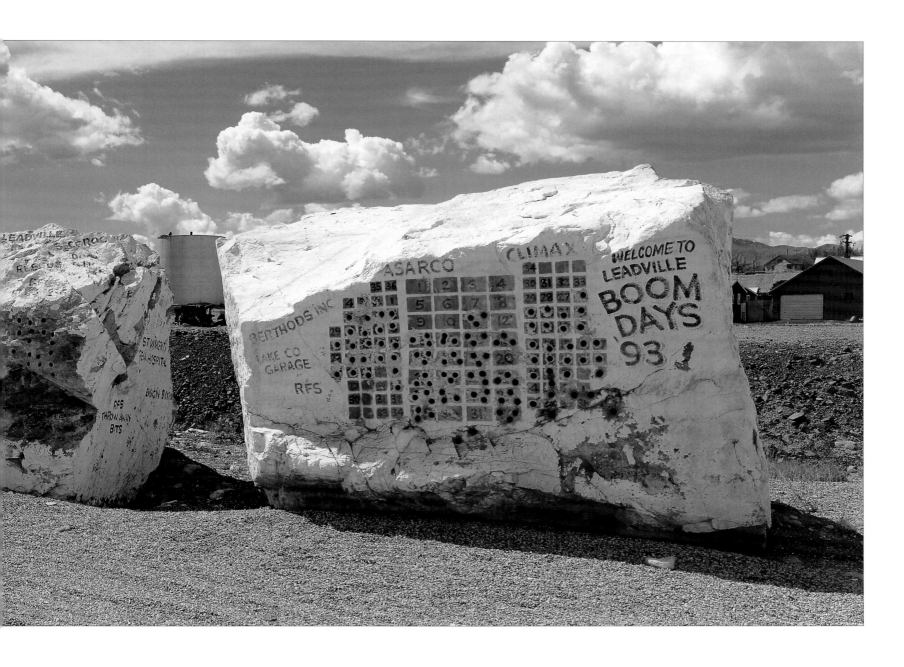

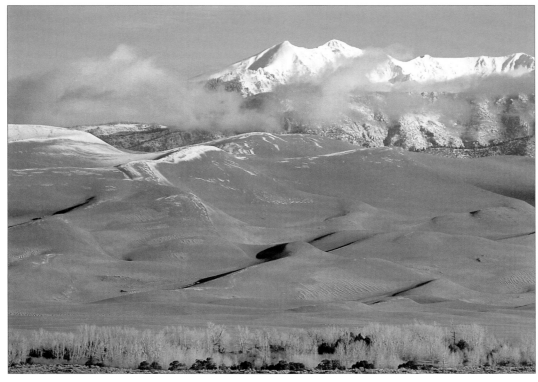

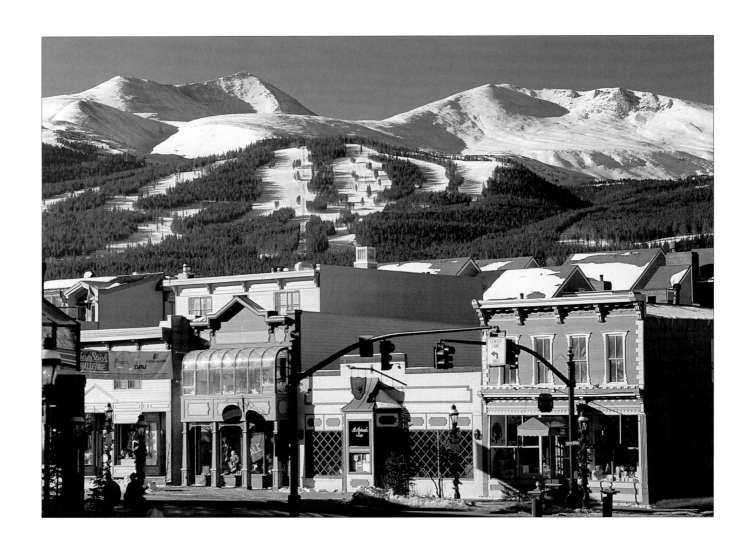

Breckenridge and the Tenmile Range, Summit County

*A*t an elevation of 9,600 feet, Breckenridge nuzzles up against the simply-named mountains of the Tenmile Range—Peaks 7, 8, 9 and 10. The mountain community combines colorful Victorian architecture with world-class downhill schussing at Breckenridge Ski Resort.

Right: Georgetown Loop Railroad atop Devil's Gate Viaduct

*T*he Georgetown Loop, once part of the Colorado and Southern Railway, chugs along restored track between the historic districts of Georgetown and Silver Plume. Surmounting the nearly eight percent grade up to Silver Plume, early engineers crafted "Devil's Gate Viaduct," which corkscrews nearly 100 feet above and across narrow Clear Creek Canyon.

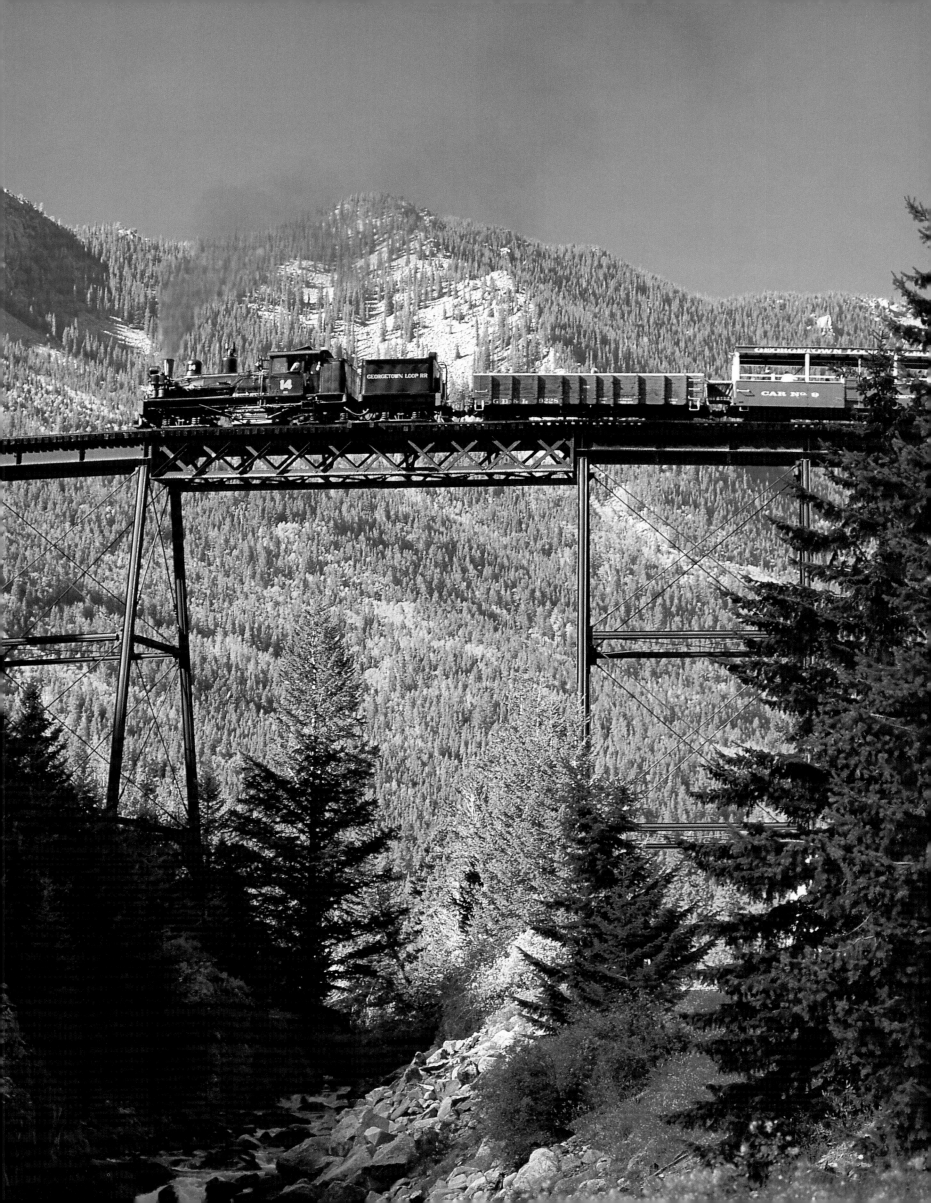

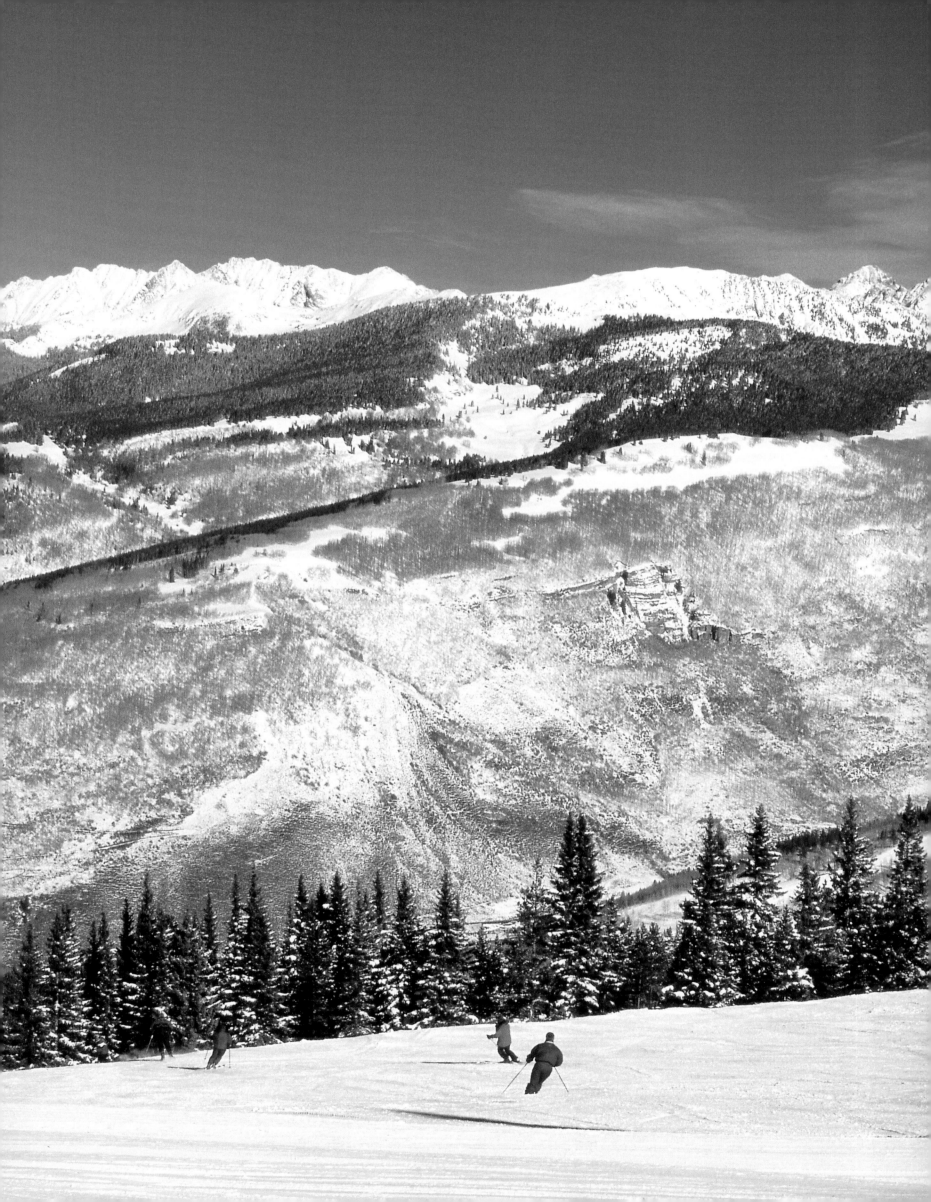

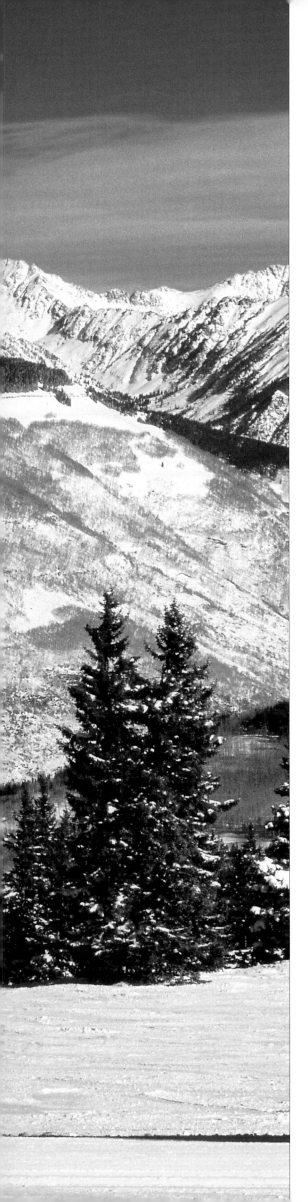

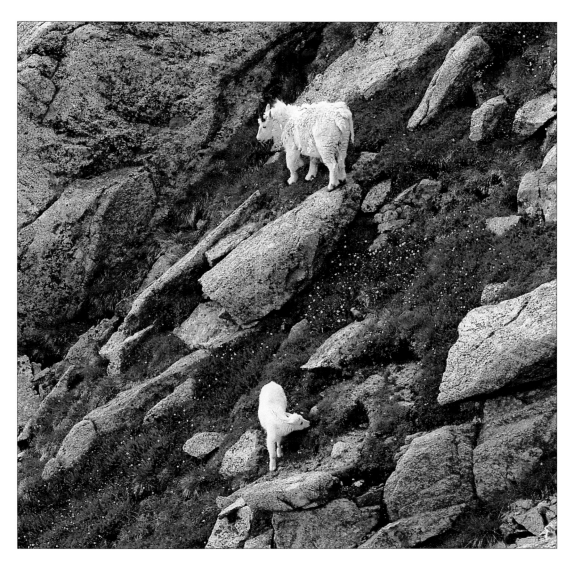

Mountain goats on Mount Evans

Mount Evans, a Colorado "Fourteener" rising above Arapaho and Pike national forests is an ideal location at which to view wildlife such as these mountain goats (*Oreamnos americanus*) easily negotiating the steep alpine slopes. The Mount Evans Scenic Byway climbs 14 miles through spectacular scenery including bristlecone pine forest and windswept tundra, affording visitors a rare mountain experience accessible by automobile.

Left: High on the ski slopes of Vail

Colorado's winter recreation reputation is as sparkling as the reliable "champagne powder" snow which seasonally blankets the state's alpine resorts. Vail, the world's largest ski area, annually hosts millions of visitors, including many celebrities, who favor its luxurious accommodations, excellent restaurants and expansive slopes.

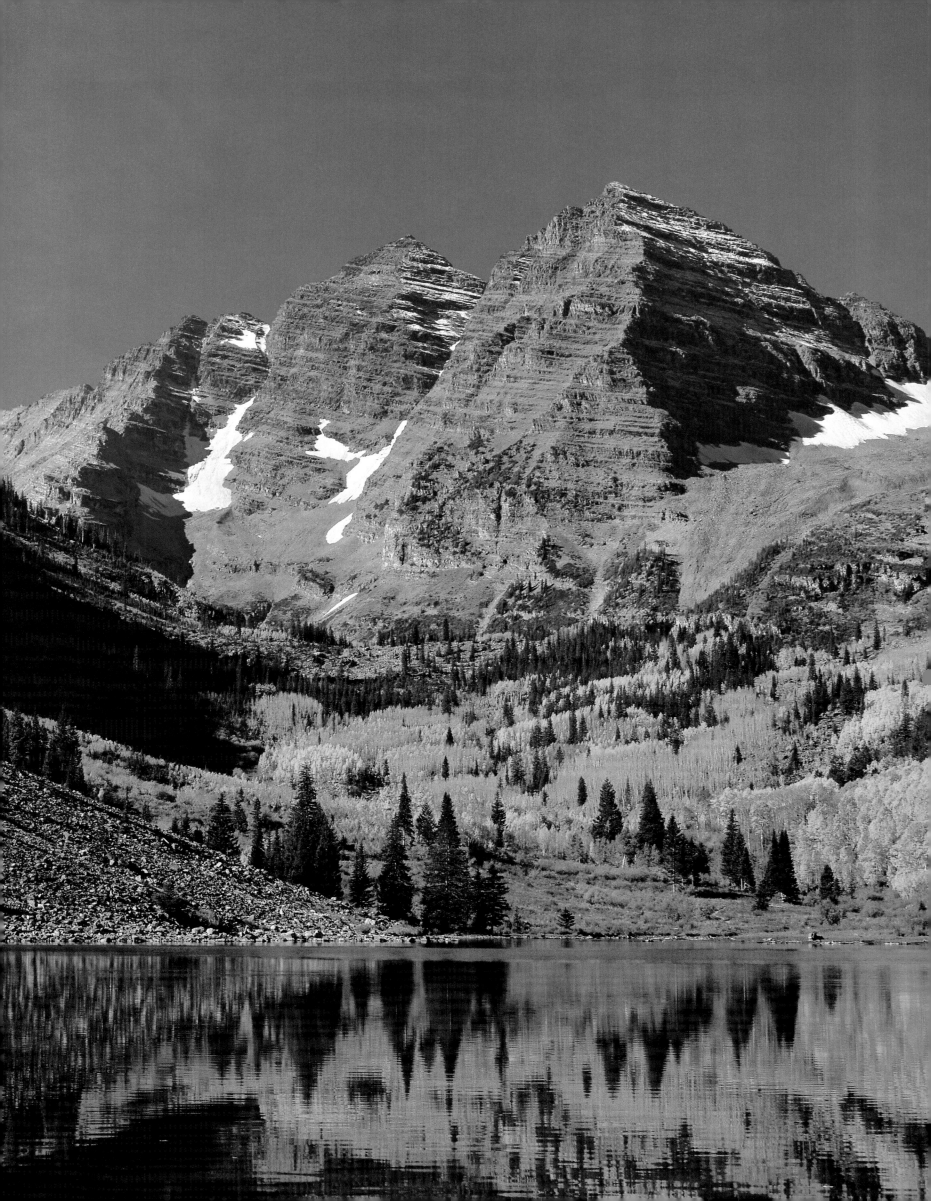

WESTERN SLOPE

*W*est of the Continental Divide and covering close to a fifth of Colorado's landscape, the Western Slope is as stunningly beautiful as it is geographically unique. Here, the vast Colorado Plateau descends from the alpine heights of the Rocky Mountains into weathered uplifts—extended ridges, coxcomb peaks and broad mesas—rimmed with cliffs separated by verdant river valleys giving way to high desert. At times rugged, sometimes unforgiving, yet always beguiling, the Western Slope is a place for all who cherish the great outdoors.

And there is much to love. Sitting astride the northern border of Utah and Colorado, Dinosaur National Monument reveals rumpled badlands incised by deep gorges where significant dinosaur fossil discoveries have revealed much about the earth's Jurassic past. Outside Grand Junction, the region's principal city, the Colorado National Monument is the state's own Grand Canyon in miniature, featuring yawning canyons and massive sandstone protrusions. Southeast, beyond Grand Mesa, at 53 square miles one of Colorado's most expansive plateaus, the vertiginous Black Canyon of the Gunnison National Monument holds mile upon mile of raging river choked between 2,000-foot-high walls of dark gneiss and schist streaked with pink granite. Farther westward in alpine vales and river valleys nestle some of Colorado's signature mountain towns: Aspen, Crested Butte, Redstone and Glenwood Springs.

Given the territory's challenging environment, the Western Slope was Colorado's last frontier. Not until the 1880s were the Utes finally, and unmercifully, displaced from their traditional homeland. By then prospectors were setting up camps, railroads were chugging west, and farmers and ranchers were harnessing the water-wealth of the Colorado and Gunnison rivers, opening the floodgates for agricultural progress. Cultivating grain and produce, in addition to keeping cattle well pastured continues to be a lifestyle legacy of the Western Slope's wide-open-spaces appeal.

One need not venture far on the Western Slope to be surrounded by grassy meadows, irrigated fields, orchards, and even vineyards: some of the state's most bountiful acres. Sparse in population yet a land of plenty, Colorado's far West is as intimately shaped by its remarkable landscape as by its heritage of resilient Coloradans who came to live the true spirit of the American West.

Left: Autumn at Maroon Bells, White River National Forest

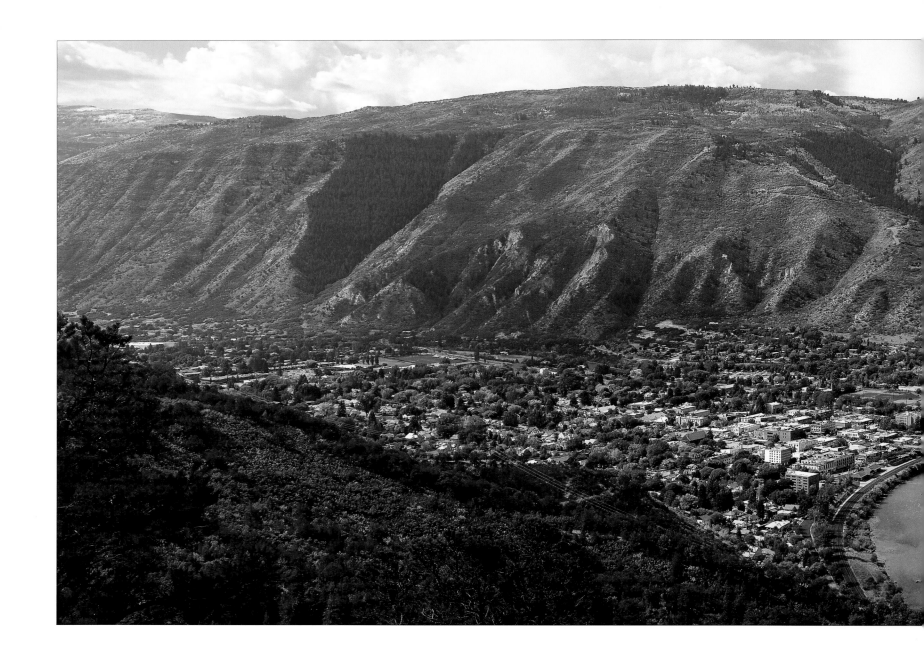

Glenwood Springs and the Colorado River

*R*eclining in a broad valley where the Roaring Fork River merges with the mighty Colorado River, Glenwood Springs is one of the Western Slope's most unassuming cities. This, despite the fact that the town is home to the famous Glenwood Hot Springs with the world's largest swimming pool, as well as having the honor of holding the final natural hot springs resting spot of gunfighter John "Doc" Holliday.

Right: The Colorado River, Glenwood Canyon

*W*est of Glenwood Springs the Colorado River plunges into Glenwood Canyon, embarking upon a spectacular 13-mile course wriggling through steep cliffsides of rust-colored granite some 570 million years old.

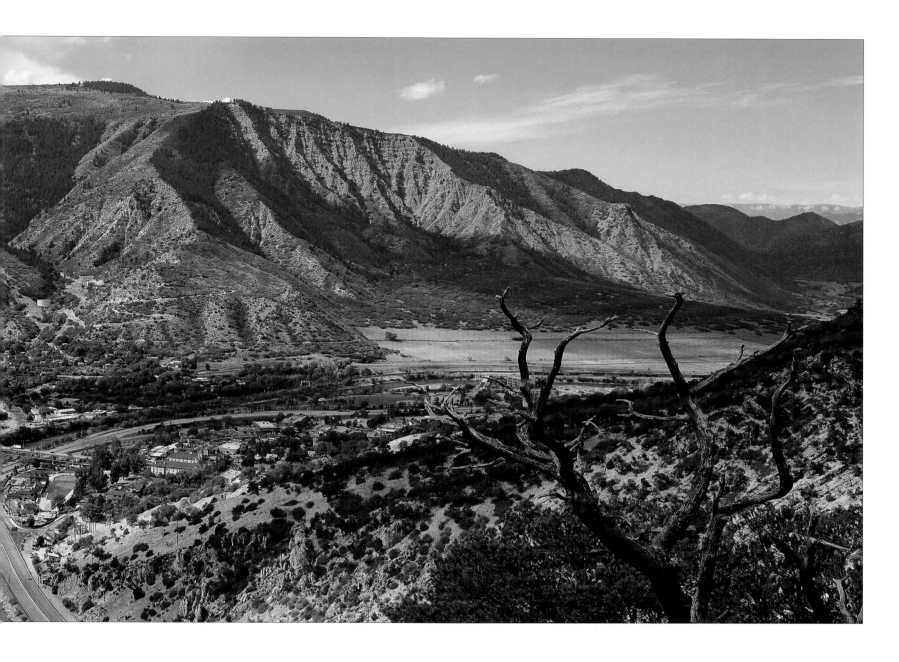

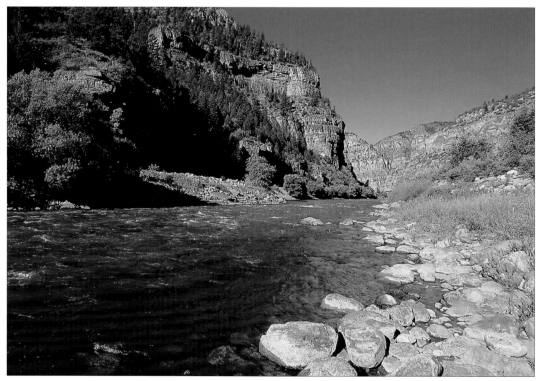

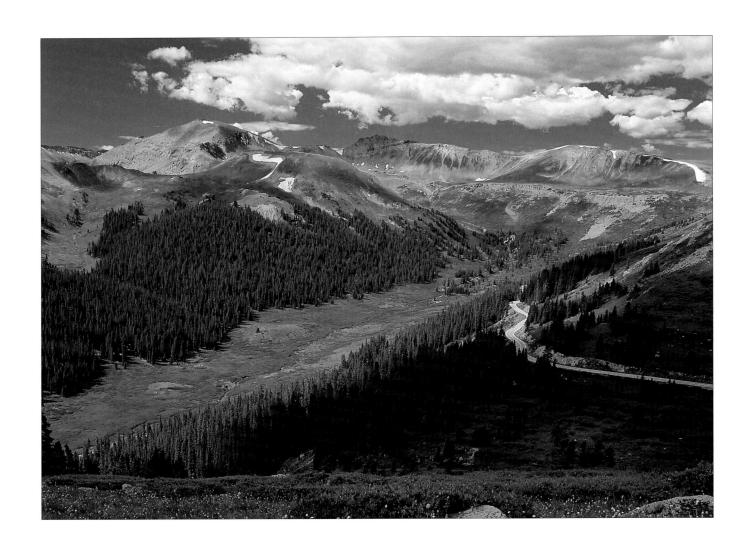

Mountain Boy Gulch near Independence Pass, Sawatch Range

Colorful Colorado is truly evident amid the peaks of the Sawatch Range. Derived from a Ute word meaning "water at the blue earth," this is the Centennial State's loftiest collection of mountains. In all, the range boasts more than a dozen "Fourteeners," among them the state's two highest, Mount Elbert (14,433 feet) and Mount Massive (14,421 feet).

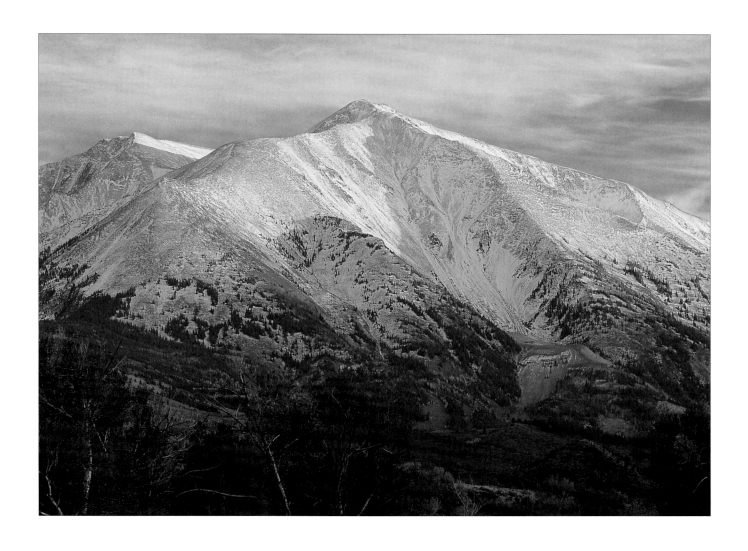

Mount Sopris at Sunset, White River National Forest

A pyramid-shaped sentinel of the Western Slope, Mount Sopris commands a view above the junction of the Roaring Fork and Crystal rivers. Its name comes from Captain Richard Sopris, who in 1860, while leading an exploring party, became one of the first white men to soak in the now famous mineral hot springs so prevalent in the area.

Overleaf: Crystal Mill, White River National Forest

W ithin the White River National Forest once stood the tiny mining community of Crystal. Not much remains of the town today, yet the Sheep Mountain Tunnel Mill, better known as the "Crystal Mill," is maintained by volunteers as an enduring symbol of Colorado's heritage. The station harnessed the power of tumbling Rock Creek to create pressurized air and water for nearby mines.

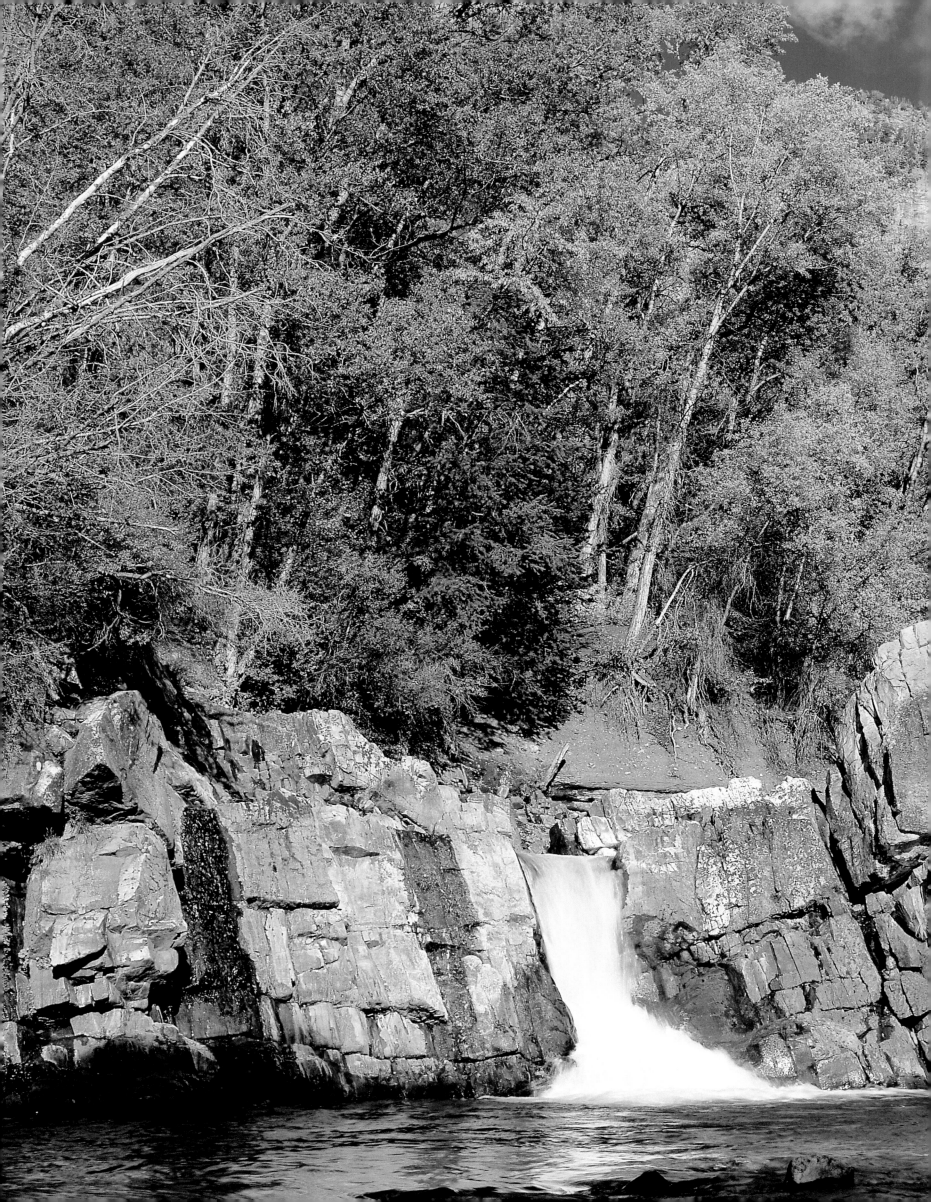

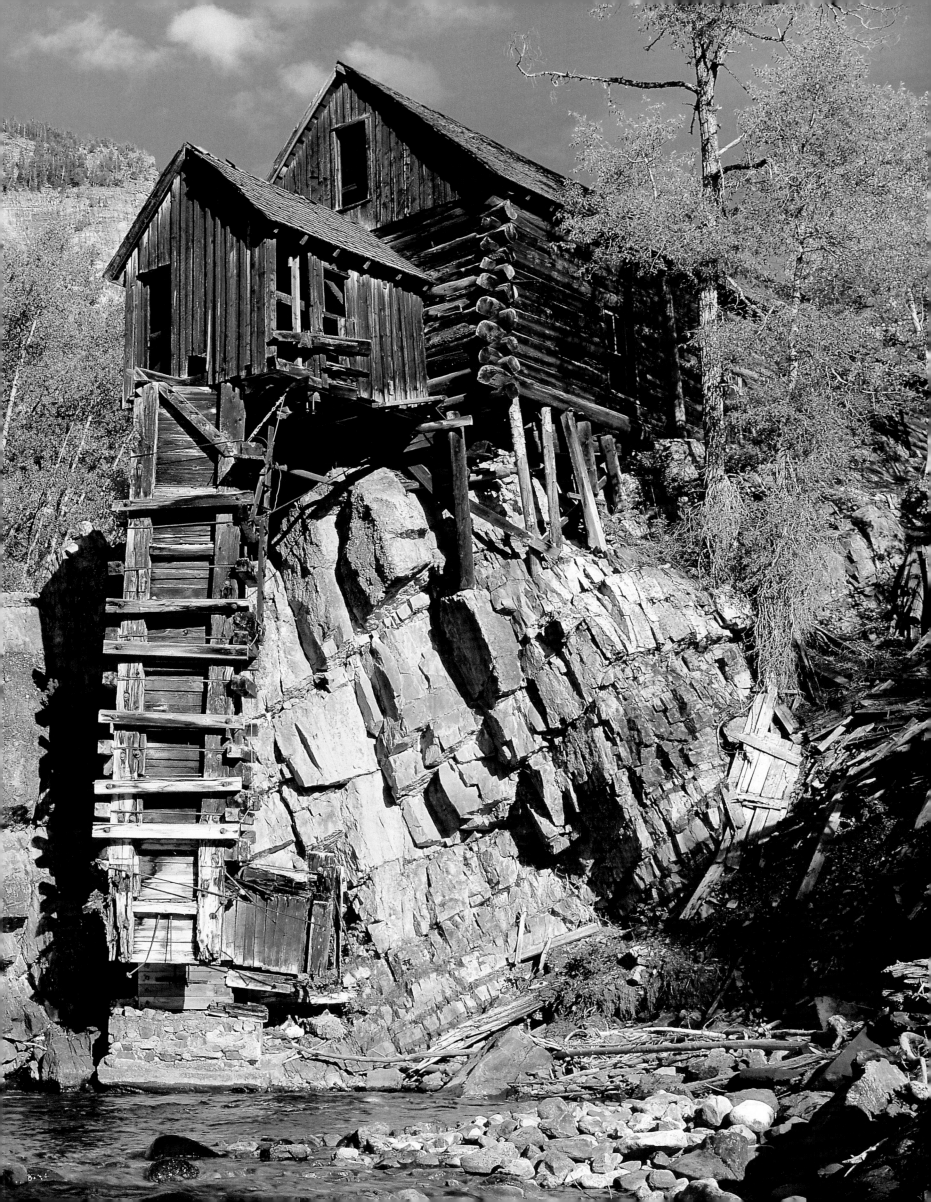

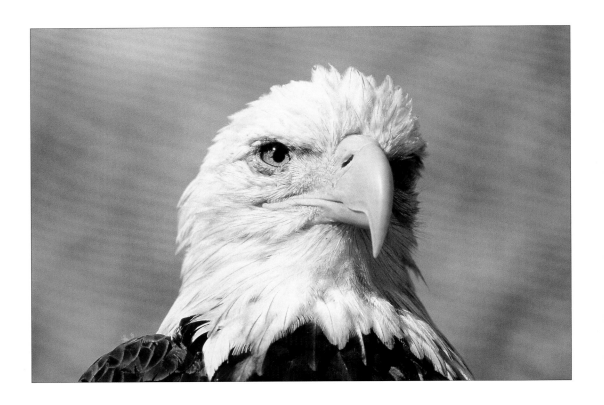

Bald eagle

*W*ith its proud visage, the bald eagle (*Haliaeetus leucocephalus*), never fails to incite respect and awe. Once endangered, America's national bird has made an exciting comeback in Colorado.

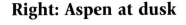

Right: Aspen at dusk

*D*uring the 1880s, Aspen was one of Colorado's "Silver Queens," rivaling Denver as the Centennial State's most influential city. The silver crash of 1893 dimmed Aspen's glimmer until the 1940s when its glittering winter snowfall attracted the interest of ski developers. Now a premier resort destination, Aspen sparkles with modern amenities while retaining its Victorian charm.

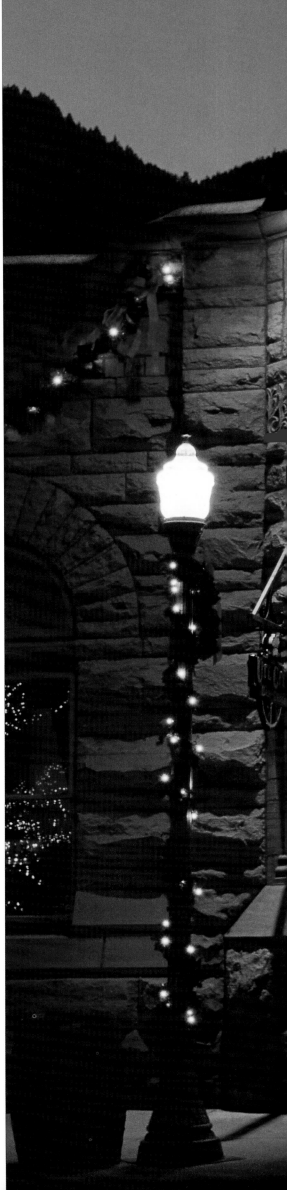

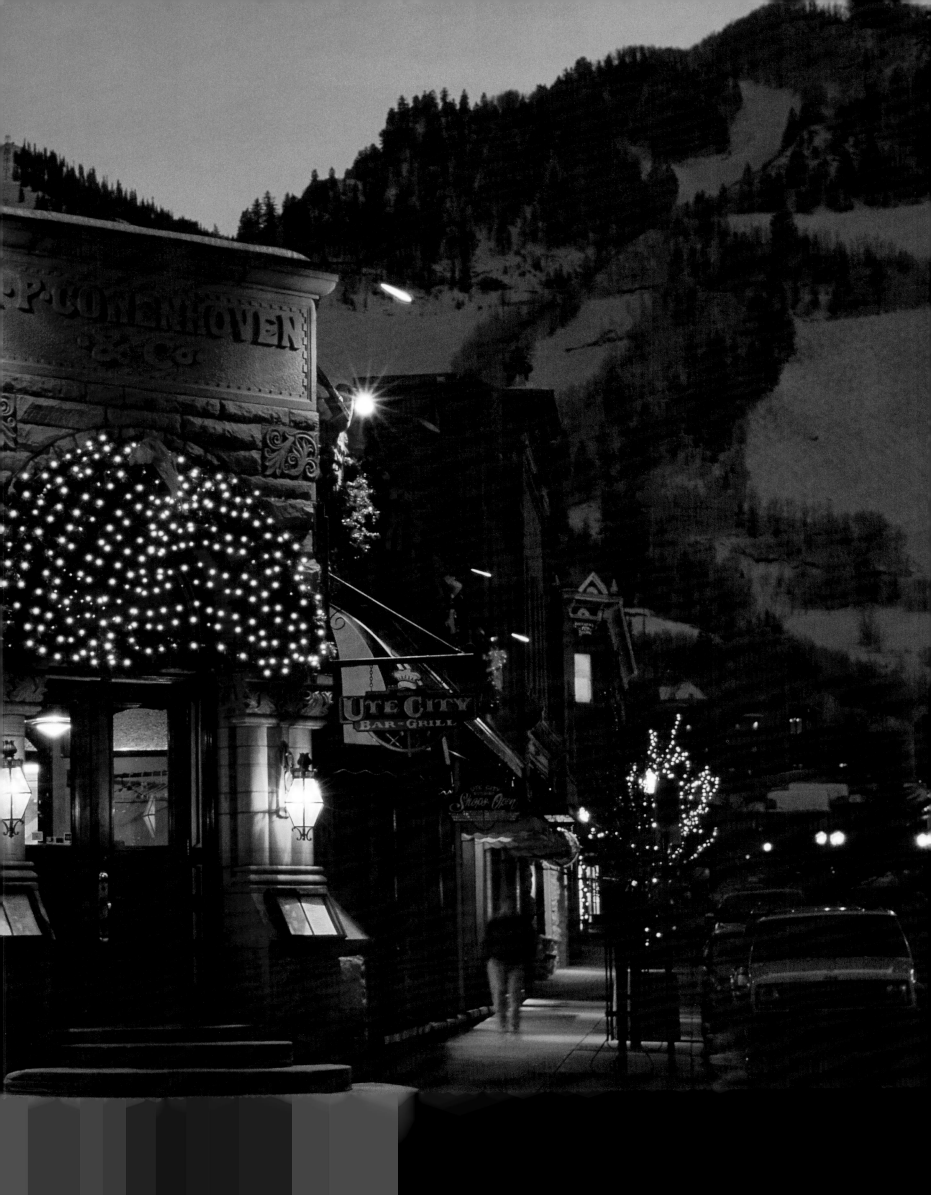

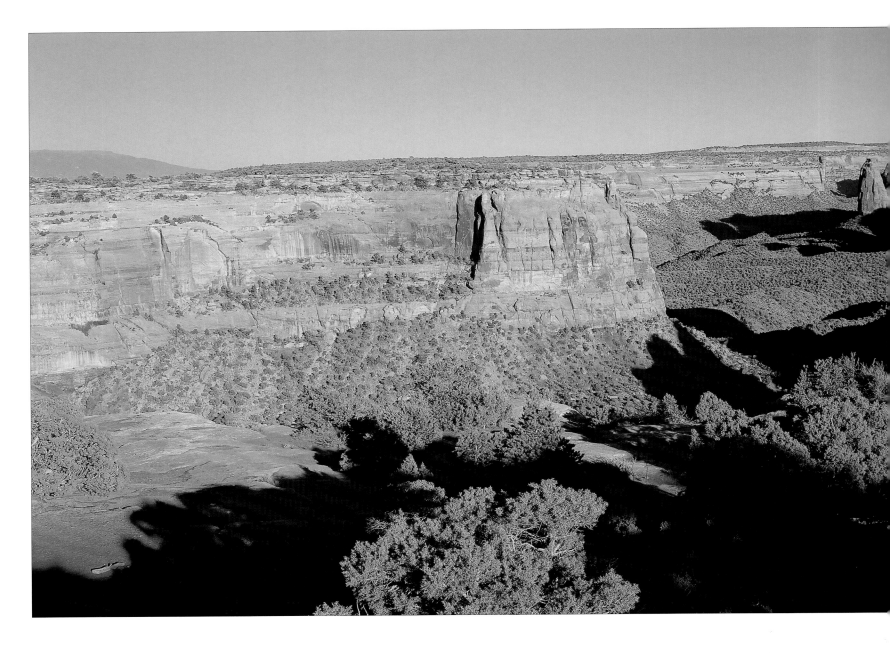

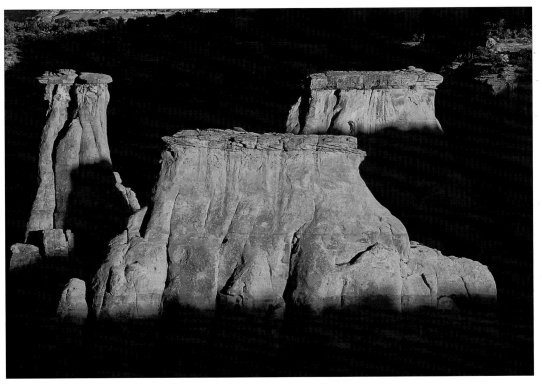

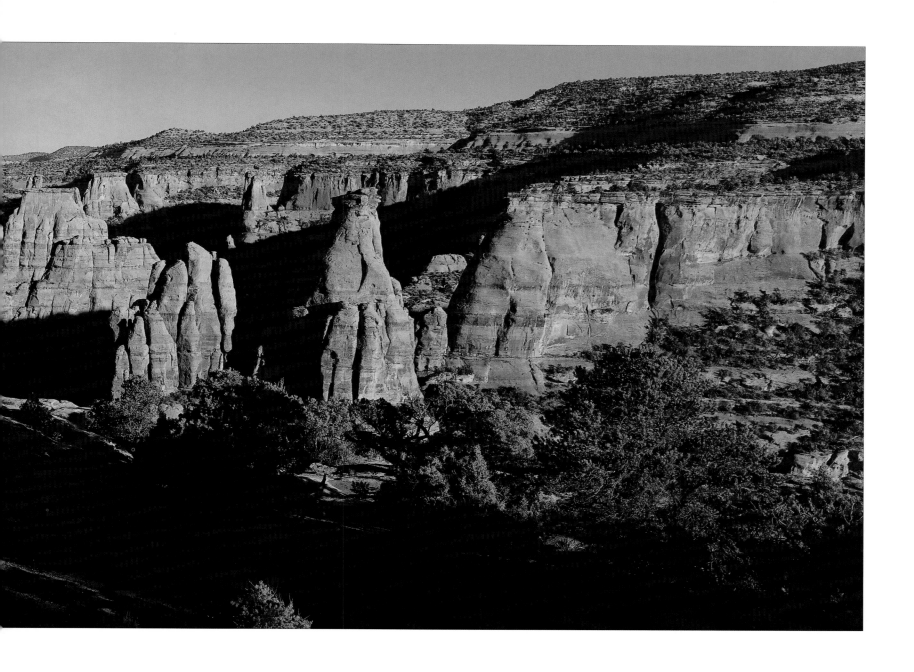

Monument Canyon, Colorado National Monument

\mathscr{C}olorado National Monument rises above the Grand Valley of the Colorado River within sight of Grand Junction. Occupying the northern edge of the Uncompahgre Plateau, the preserve is a place of cliffs, mesas and chasms layered in ruddy sandstone dating from the age of dinosaurs.

Left: Monument Canyon, Colorado National Monument

\mathscr{A}mid sweet-smelling juniper and piñon, evening shadows creep up the shapely sandstone pinnacles of the Colorado National Monument. The forces of wind and water still incessantly wear away at the pebbly surfaces of these monolithic glimpses into Colorado's geologic past.

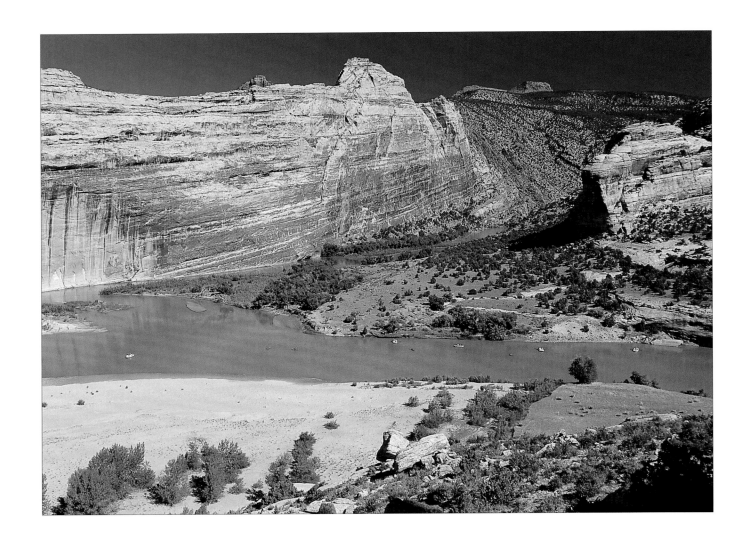

Steamboat Rock at Echo Park, Dinosaur National Monument

At the confluence of the Green and Yampa rivers beneath Steamboat Rock, placid waters entice kayakers and rafters to drift along blissful currents to the sandy beach at Echo Park in the heart of Dinosaur National Monument. Located in Colorado's extreme northwest corner, the monument's 300 square miles of stark and remote wilderness is well known for its abundance of fossilized dinosaur remains.

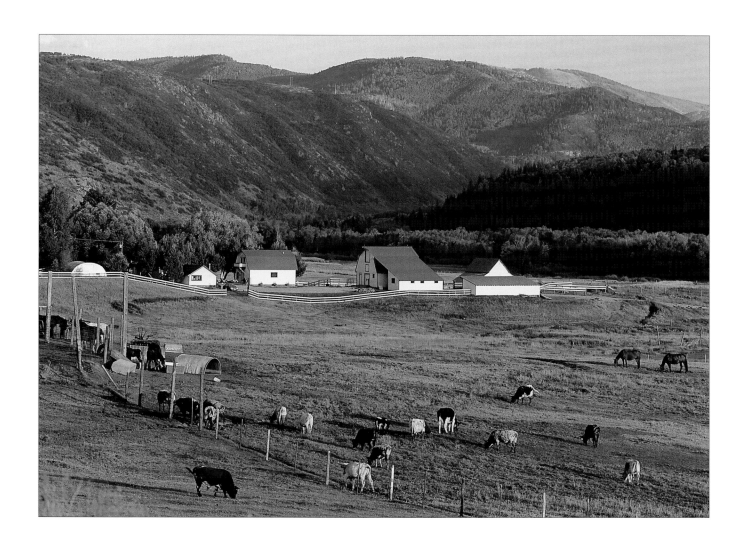

Ranchland along the Elk River north of Steamboat Springs

*B*egun as a quiet agricultural community in 1885, Steamboat Springs evolved into "Ski Town U.S.A." Located in the Yampa River Valley and bubbling with soothing mineral waters, the town named for the percolating waters which sounded like a steamboat's chug has maintained its ranchland roots while hosting outdoor enthusiasts with a variety of contemporary winter and summer recreational opportunities.

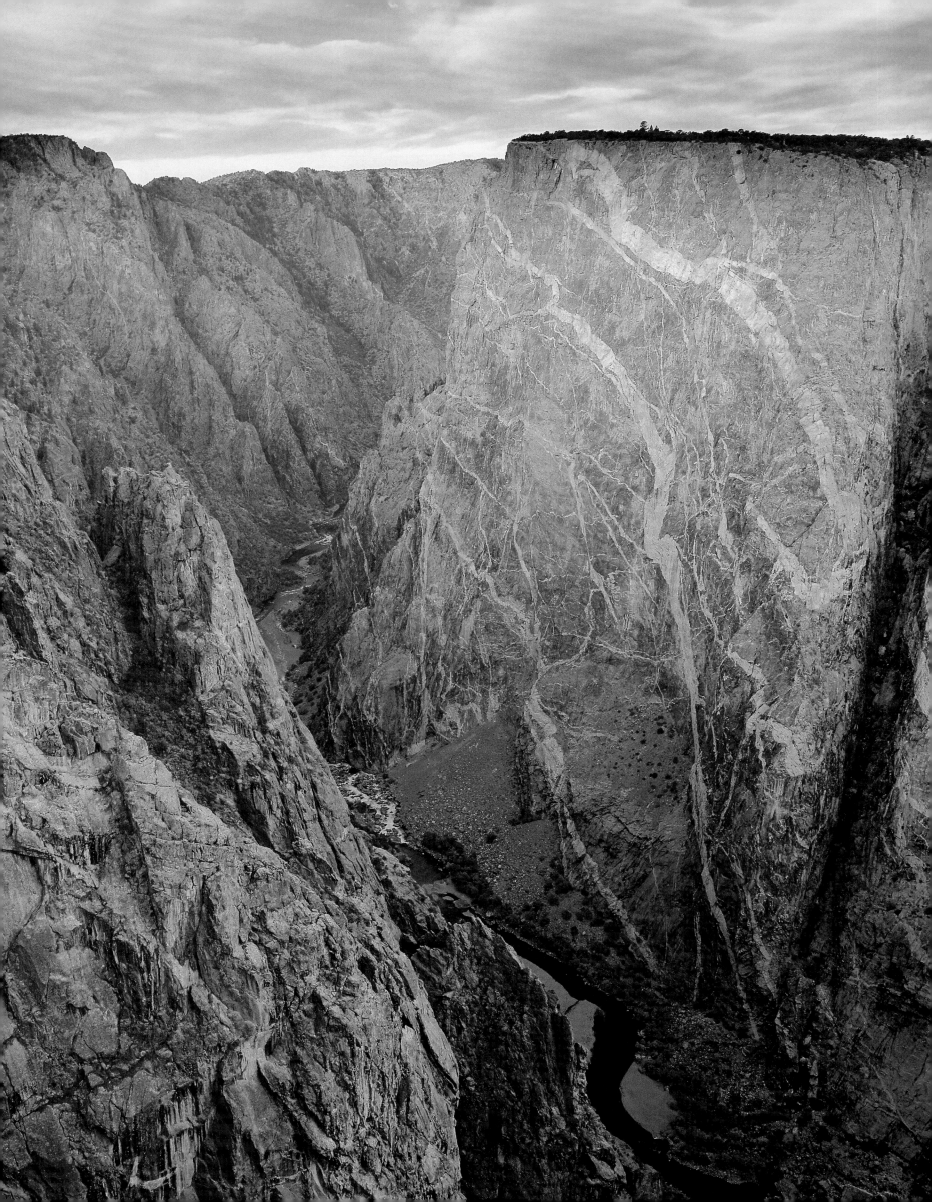

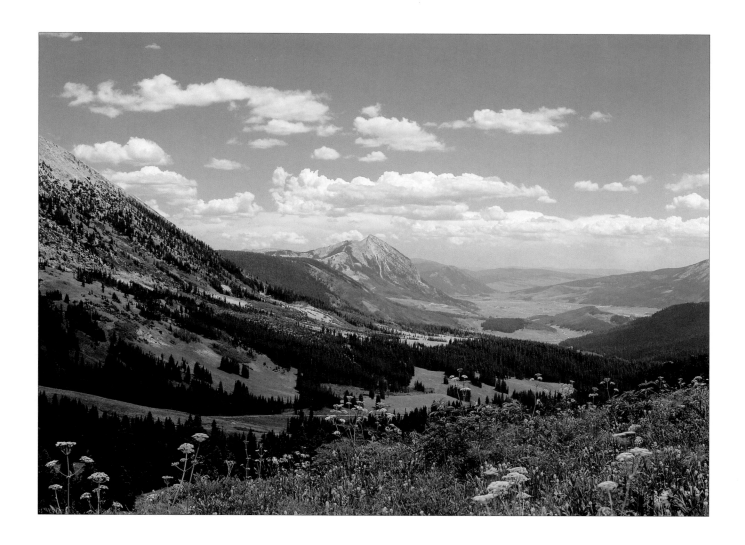

Slate River Valley from Anthracite Mesa, Gunnison National Forest

*S*ituated at the edge of the Slate River Valley 30 miles north of Gunnison, the historic mining community of Crested Butte retains its historic mining-town ambiance while showcasing top-notch skiing and mountain biking.

Left: Painted Wall, Black Canyon of the Gunnison National Park

*"O*ne of the most spectacular gorges in the United States," is how park service representative Roger Toll described the Black Canyon of the Gunnison in 1932. A year later, President Herbert Hoover declared the most stunning 12 miles of the narrow chasm a national monument. Adorned with streamers of pink granite, the Painted Wall rises 2,200 feet above the Gunnison River, making it Colorado's highest vertical cliff face.

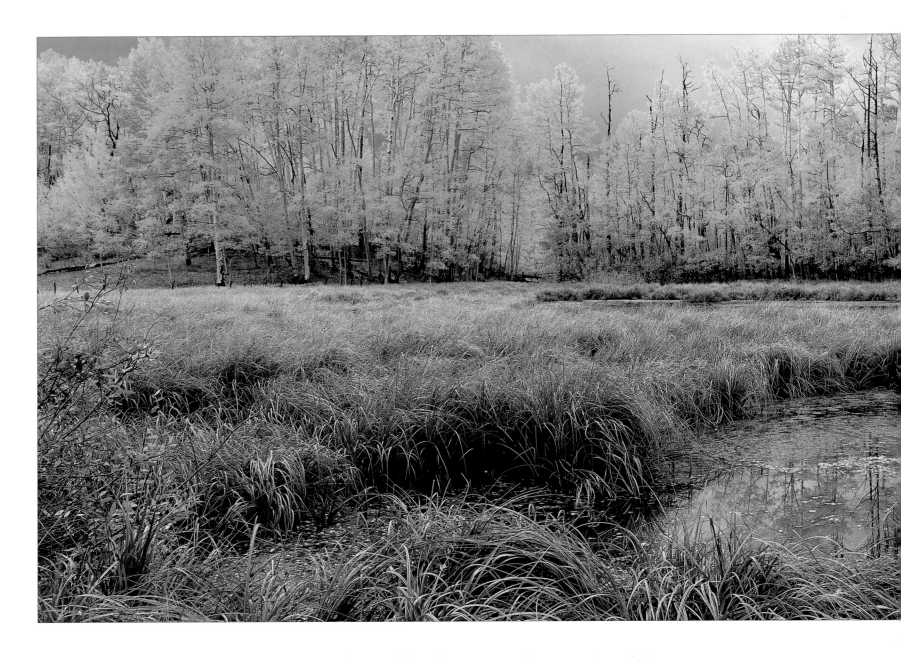

Autumn aspen and marshland, Uncompahgre National Forest

*C*olorado boasts three national parks, seven national monuments and historic sites, 48 wilderness reserves, 42 state parks and recreation areas, and nearly 14 million acres of national and state forests. Havens for a diverse sampling of flora and fauna, these wildlands form Colorado's enduring image of the "Wild West."

Right: West Elk Loop, Gunnison National Forest

*T*he West Elk Loop Scenic and Historic Byway offers some of Colorado's best fall color as the route climbs along a 31-mile stretch of graveled road to Kebler Pass before dropping down to parallel Coal Creek as it descends into historic Crested Butte.

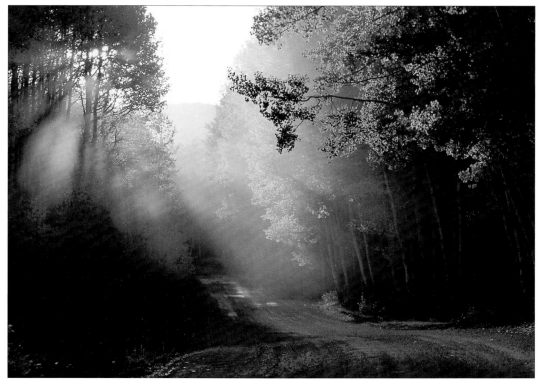

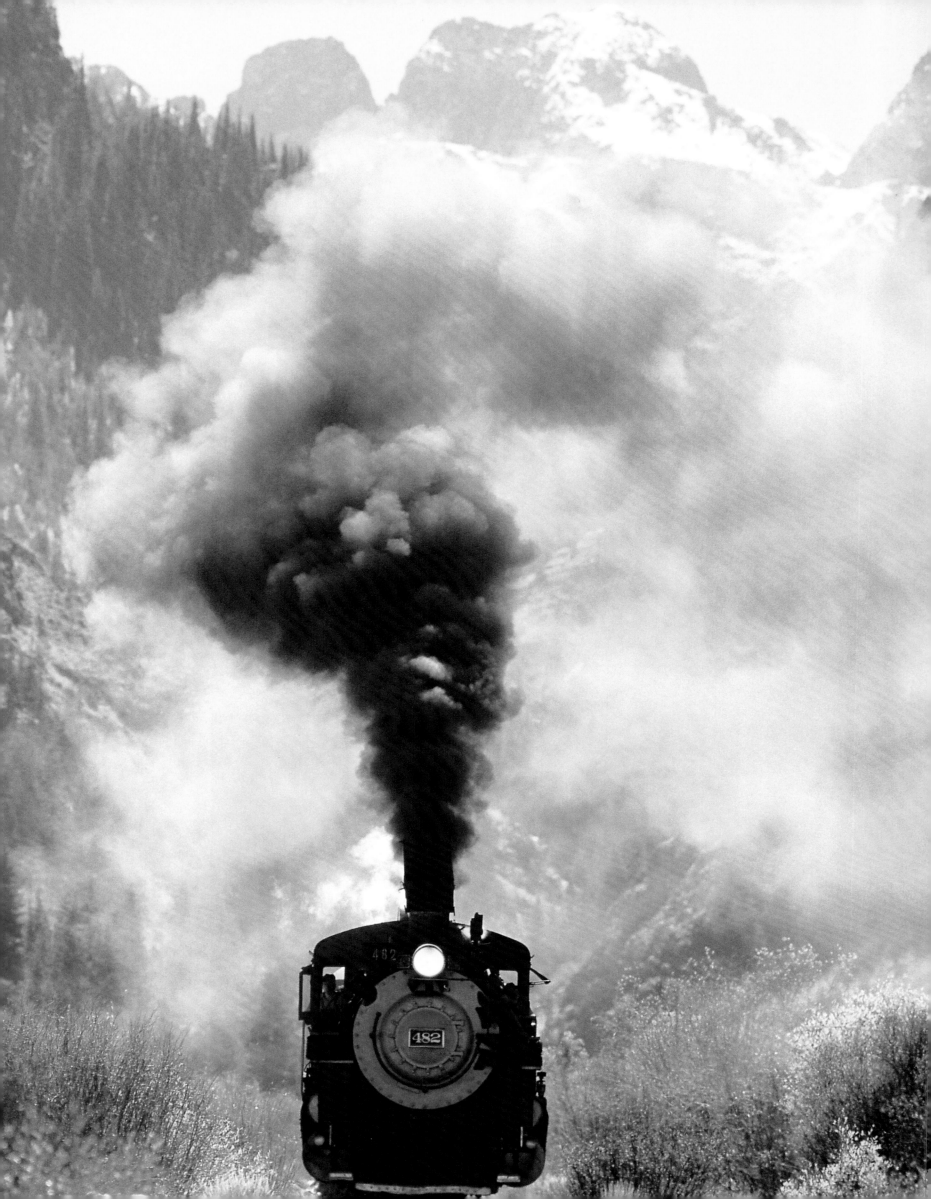

FOUR CORNERS

*I*n southwestern Colorado, a region known as the Four Corners, the rumpled San Juan Mountains define a territory of awe-inspiring terrain crafted by fire and ice. Formed from volcanic eruptions followed by eons of massive glaciation, red-hued mounts and snow-mantled peaks rise like an island amid the Uncompahgre Plateau and Gunnison River drainage flowing southward into the high desert bordering Utah, Arizona and New Mexico—the only place in America at which four states intersect.

Long ago this was the land of the Ancestral Puebloans who dwelled here for a thousand years until the 13th century, when they mysteriously abandoned their magnificent, multi-storied cliff dwellings. The remains of those extraordinary stone structures are still visible today at Mesa Verde National Park, a UNESCO World Heritage Site and the only national park dedicated to the work of humankind. The lure of gold and silver found prospectors combing the San Juans by the late 1800s. Those intrepid souls weren't disappointed; the land proved rich in precious metals, spawning mining camps which became the San Juan's principal communities.

Exploring Four Corner's history serves as only a start for prospecting an abundance of outdoor recreational activities—hiking and backcountry camping in the Weminuche Wilderness; downhill skiing at world-renowned Telluride; whitewater rafting on the feisty Dolores, Animas, and Rio Grande rivers; and thrilling rail journeys aboard Colorado's best-known excursion train, the Durango and Silverton Narrow Gauge Railroad. Crisscrossed by a patchwork of old mining routes, the San Juans are perhaps best loved for some of the nation's most rewarding off-road driving adventures. The town of Ouray, known for its mineral springs and nicknamed the "Gem of the Rockies," is the sparkling epicenter for several classic four-wheeling excursions.

For travelers who prefer more easy-going driving, the Four Corners also delivers four of Colorado's finest highway trips. The Silver Thread Scenic and Historic Byway connects the quiet towns of South Fork and Creed with Lake City traversing three high mountain passes. Farther west, the Alpine Loop serves up a vertiginous route through ore-laden terrain, crossing alpine vistas and rolling past numerous ghost towns. The Trail of the Ancients circumnavigates a path through the San Juan River Valley, taking in Hovenweep National Monument and Mesa Verde National Park. Finally, the incomparable San Juan Skyway passes four wilderness areas as it follows a 236-mile loop corralling Ouray, Telluride, Cortez, Durango and Silverton. So exceptionally beautiful is the tour that it was also named as one of the few U.S. Scenic and Historic Byways, bringing national acclaim to a brilliant archipelago of mountains, which are steeped in history, and seemingly boundless with nature's splendor.

Left: The Durango and Silverton Narrow Gauge Railroad

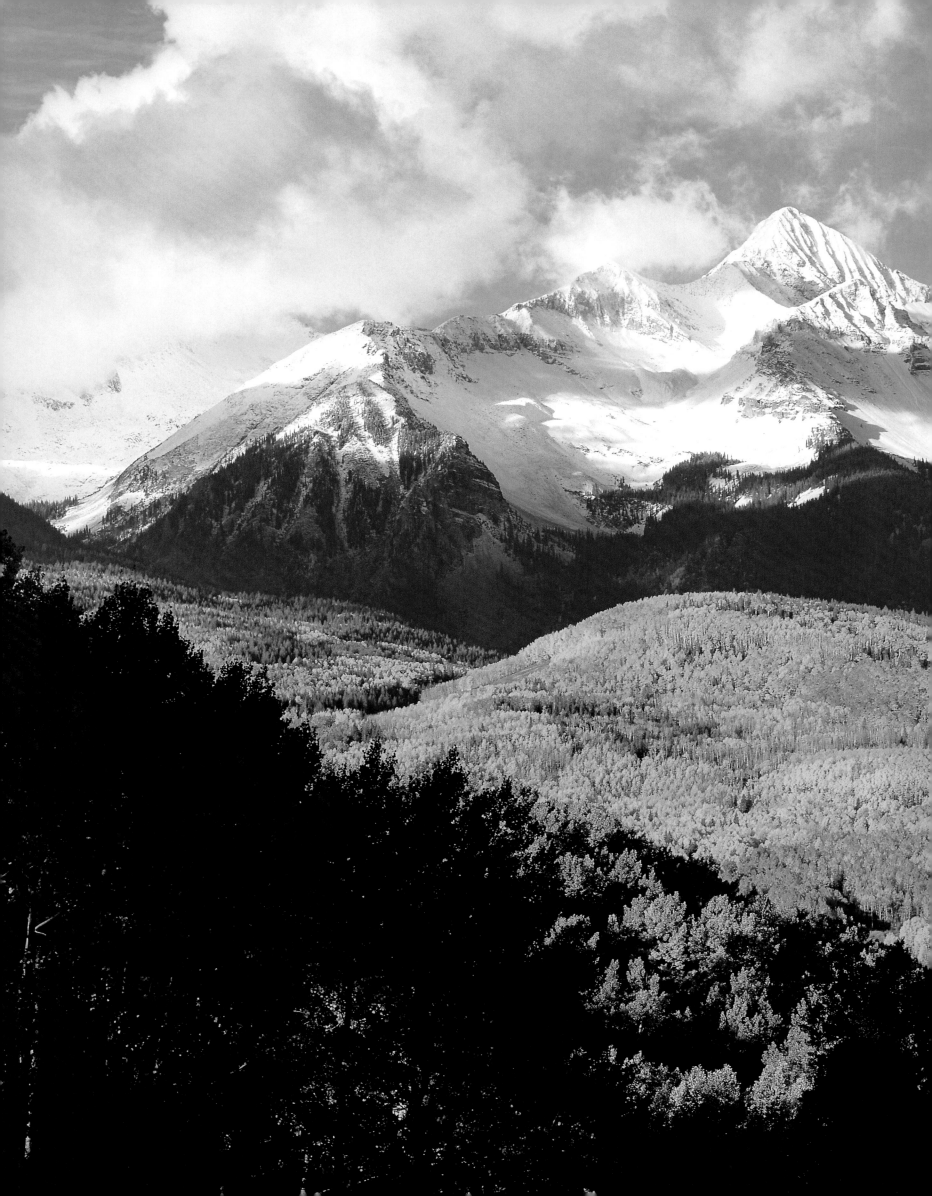

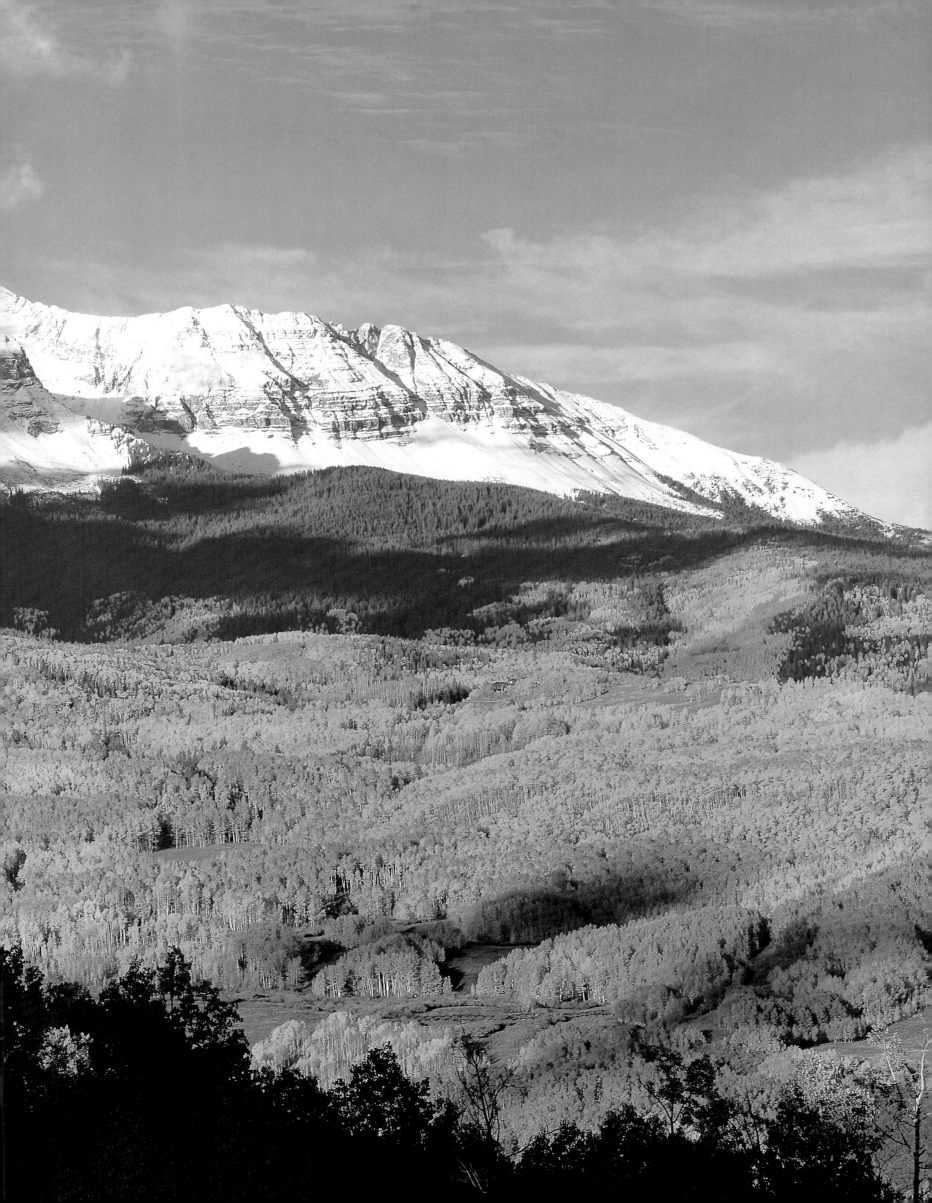

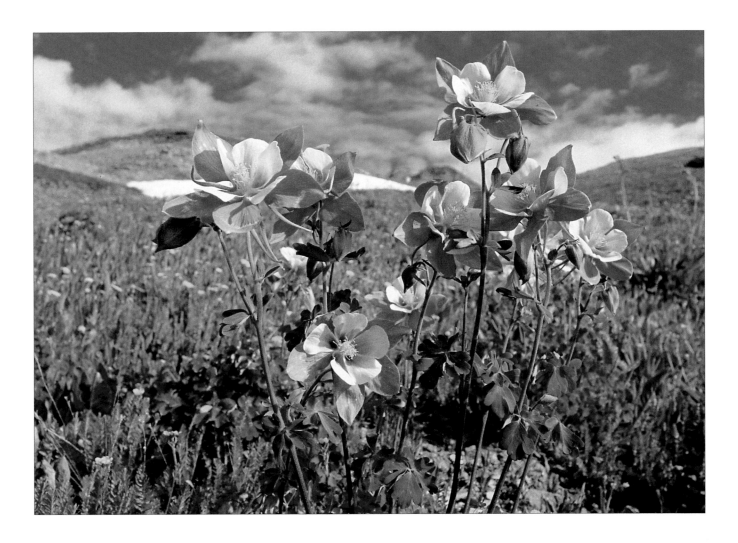

Rocky Mountain Columbine, Uncompahgre National Forest

*D*eclared the state flower on April 4, 1899, the Rocky Mountain Columbine (*Aquilegia coerulea*) was selected for its emblematic Colorado colors—blue for the sky, white for snow, and yellow for gold. Before the creation of protected public lands, columbines were eagerly picked by early sightseers, severely depleting its natural reproduction. Today, however, the showy beauty flourishes throughout Colorado's high country.

Previous pages: Snowcapped Wilson Peak, San Miguel Mountains

*W*ilson Peak anchors a trio of 14,000-foot-plus summits in the San Miguel Mountains southwest of Telluride. Sliced by the boundary line of the Lizard Head Wilderness—a backcountry region unifying sections of the Uncompahgre and San Juan National Forests—the peak is one of Colorado's signature mountain scenes.

Right: Wildflower wonderland, San Juan Mountains

*I*n summer, the steep mountain meadows of the San Juan Mountains burst with a swaying symphony of Colorado's colorful, and prodigious, wildflowers. Rich in precious minerals, these rugged and isolated mountains lured prospectors by the droves whose imprint remains not only in quaint Victorian towns such as Ouray, but also in a complex of old mining roads and ghost towns which delight four-wheeling enthusiasts.

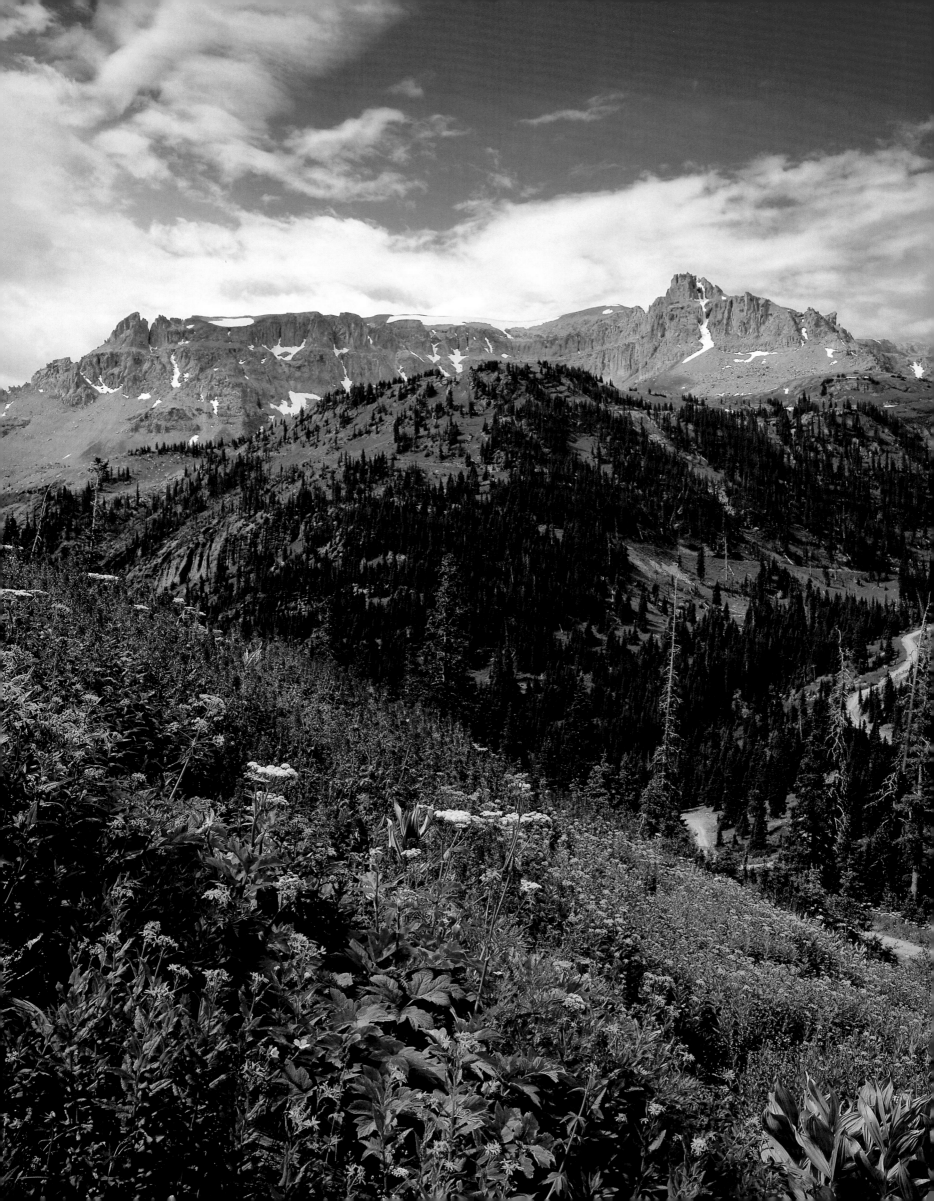

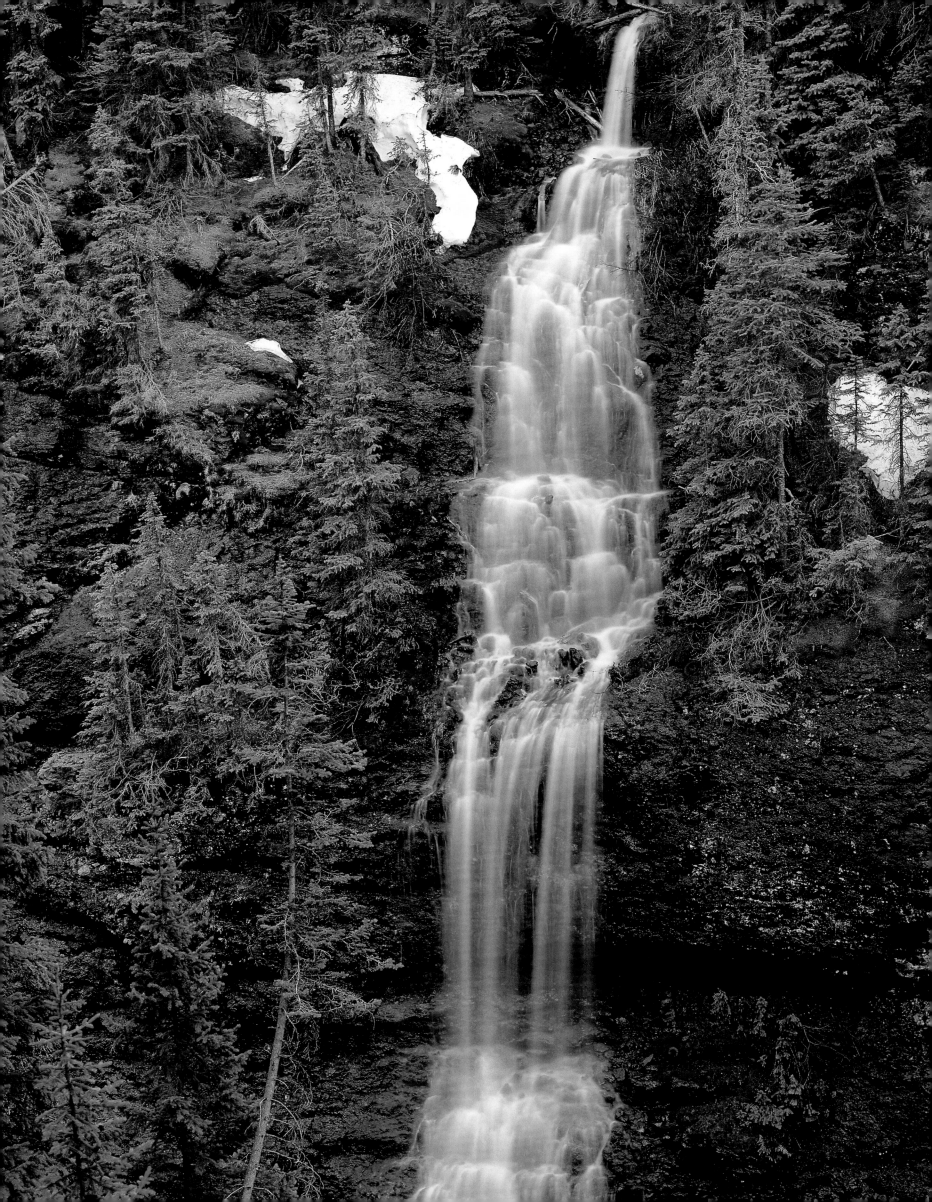

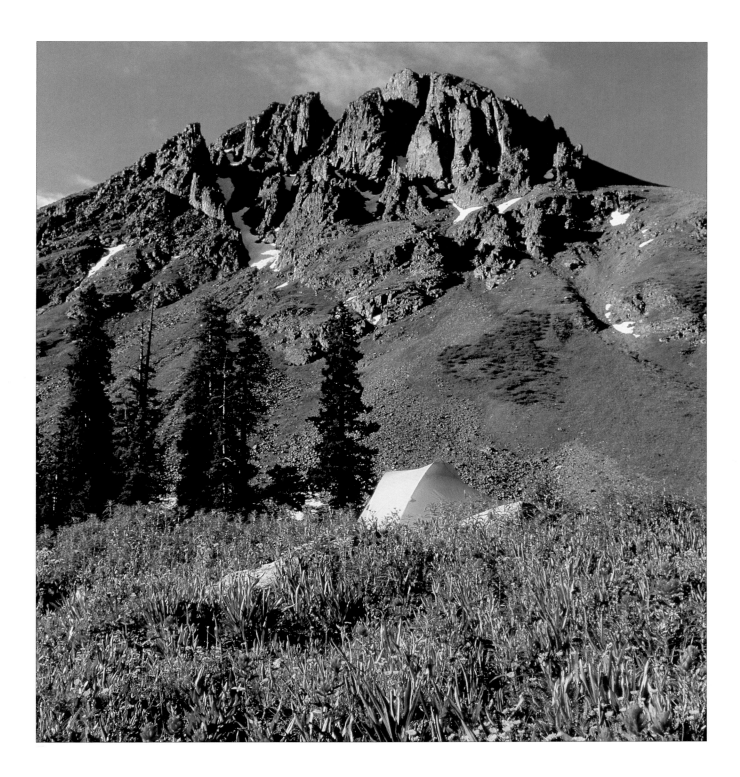

Yankee Boy Basin, Uncompahgre National Forest

*T*hroughout the remote San Juan Mountains opportunities for outdoor recreational activities seem almost endless, from hiking and camping to riding historic rails to summiting 14,000-foot-high peaks.

Left: Waterfall, Uncompahgre National Forest

*S*pilling from the San Juan Mountains, streams and rivulets give birth to several of Colorado's prized rivers—the San Juan, the Animas, the Uncompahgre, the San Miguel, the Dolores—all wild and wonderful. Arguably some of the most stunning scenery in America, powdery snow blankets the landscape for more than five months of the year, fueling the West's most important natural resource—pure Rocky Mountain water.

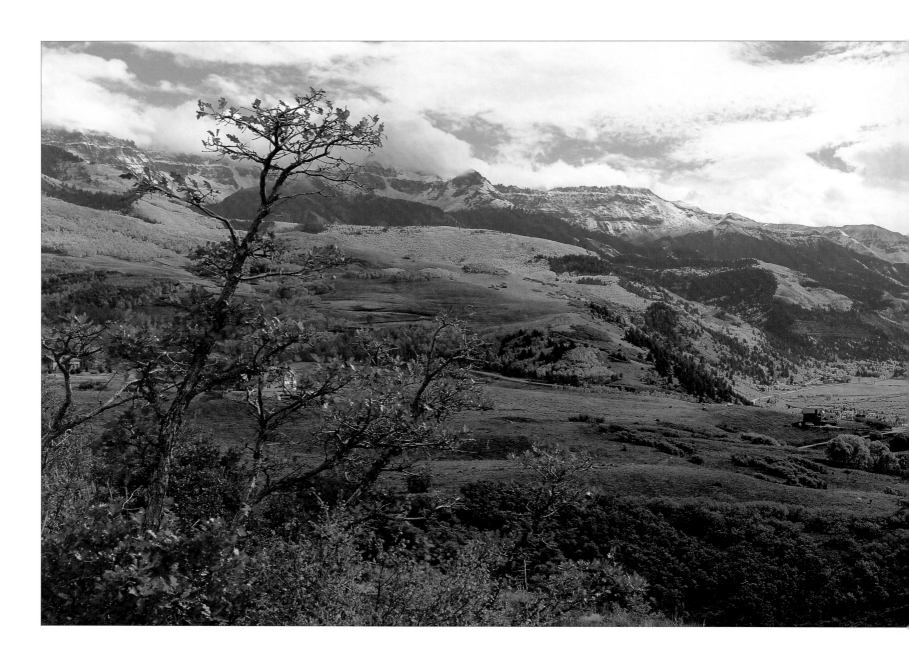

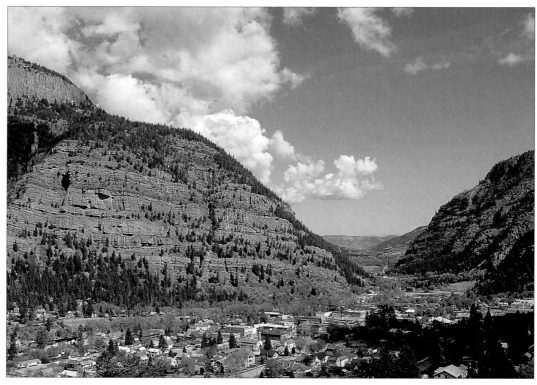

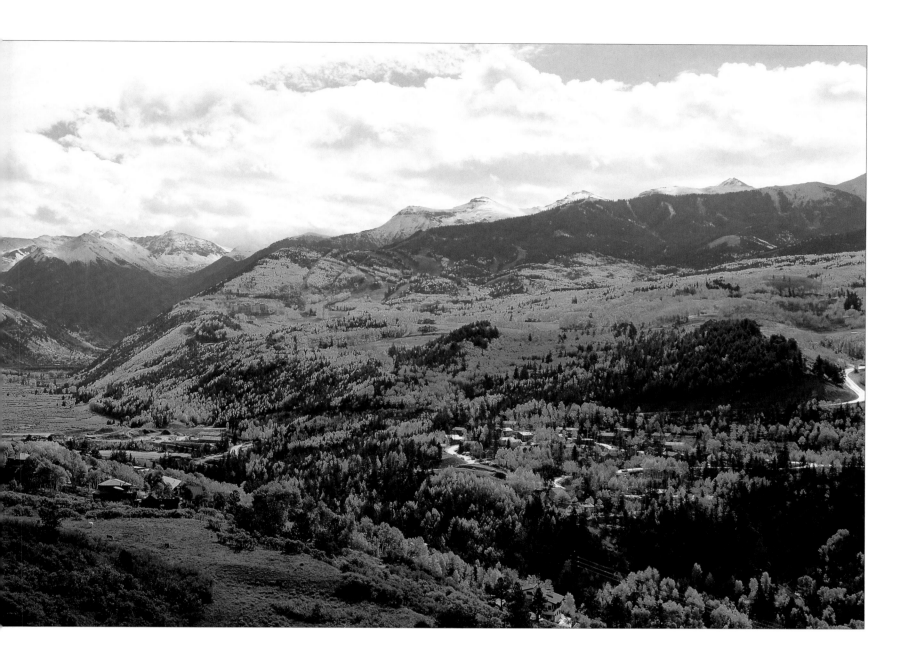

San Miguel River Valley Near Telluride

*B*reathtaking vistas greet travelers in the San Miguel River Valley as it approaches Telluride. Tucked into a box canyon with the towering San Juan Mountains on three sides, Telluride—out-of-the-way and quaintly Victorian in appearance—is one of Colorado's most celebrated towns. Named for gold-bearing tellurium ore, Telluride thrived as a mining enclave long before it became a popular ski resort and summertime event center renowned for film and music festivals.

Left: Ouray, Uncompahgre River Valley

*O*uray, located at the head of the Uncompahgre River Valley, is nicknamed the "Switzerland of America." Its name, however, is purely Native American, stemming from the respected Ute chief, Ouray, who negotiated treaties with the U.S. government during the late 1800s.

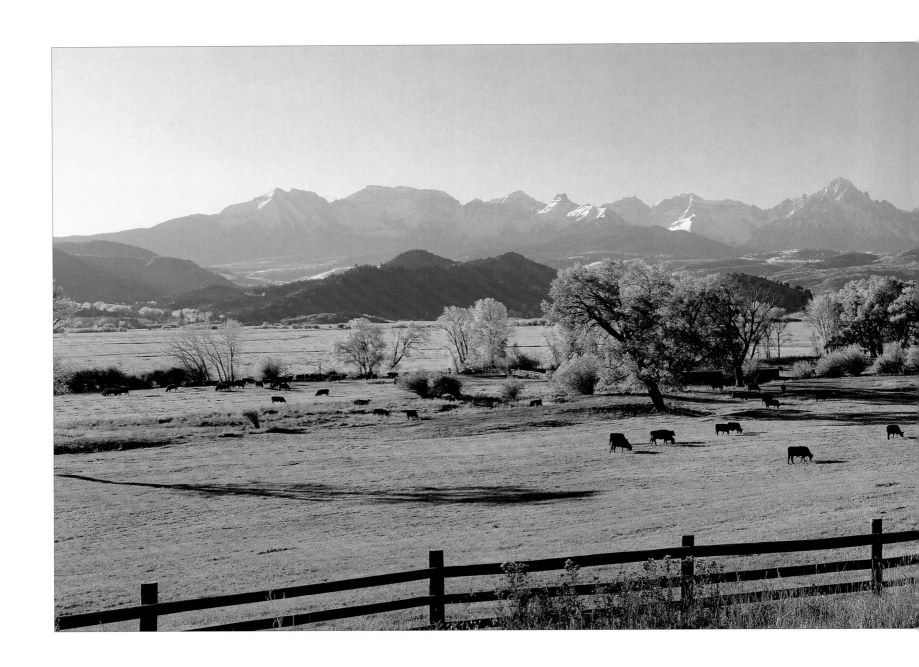

Sneffels Range near Ridgway, San Juan Mountains

*B*lending the ambiance of the true West with the majesty of the mountains is the promise of The San Juan Skyway, a scenic driving route running west-southwest from Ridgway. Scattered blue mesas of piñon and juniper, the towering lines of snowcapped peaks, streams edged with cottonwood groves, and rolling meadows dotted with contentedly grazing cattle bestow a wealth of visual pleasure.

Right: Horses, Rio Grande County

*R*eintroduced to the "New World" by Spanish explorers in the 16th century, horses quickly became an icon of the West and of Colorado, beloved by Native Americans for their battle prowess and valued by settlers for their tireless service in accomplishing the daily tasks of ranching.

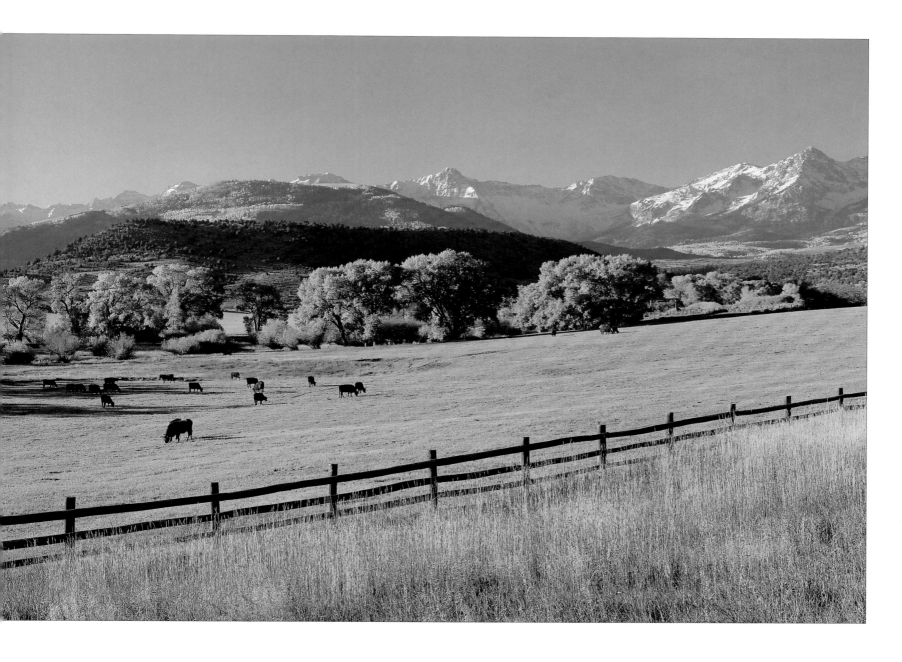

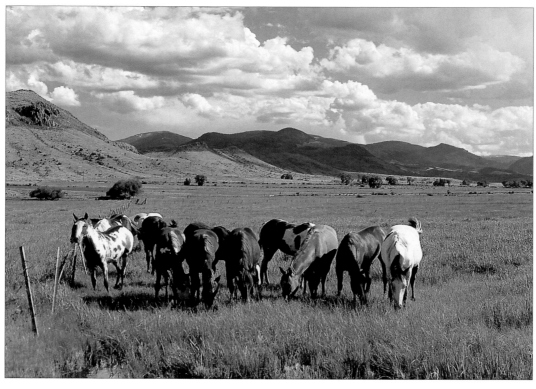

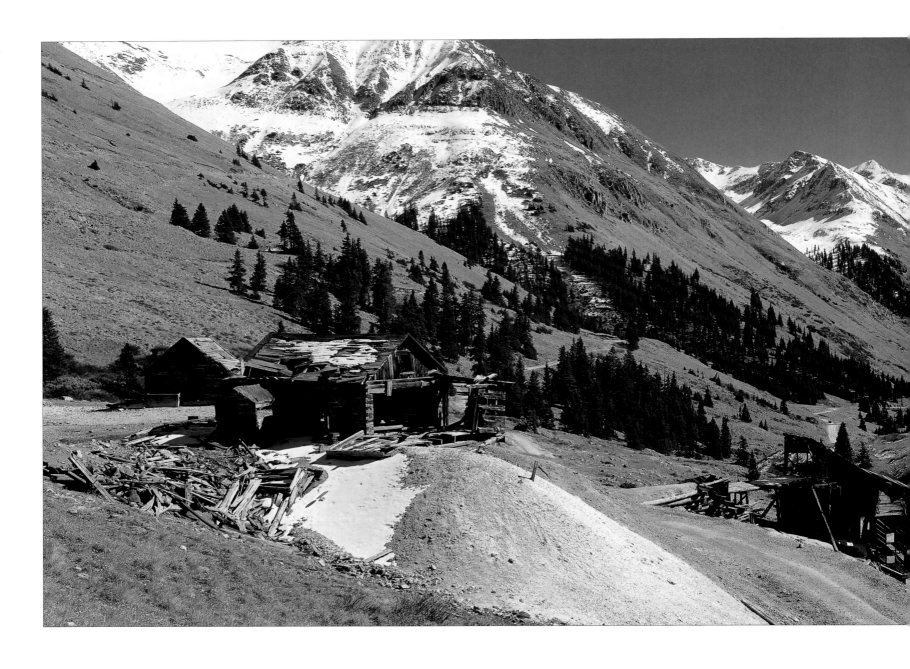

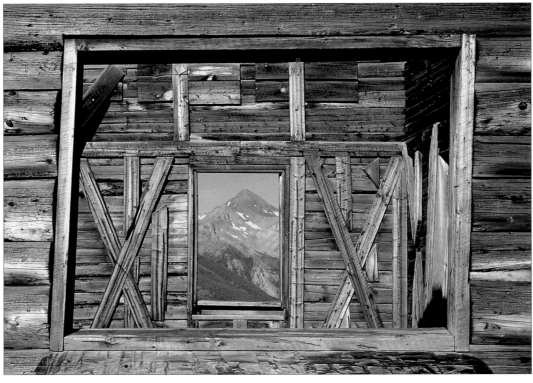

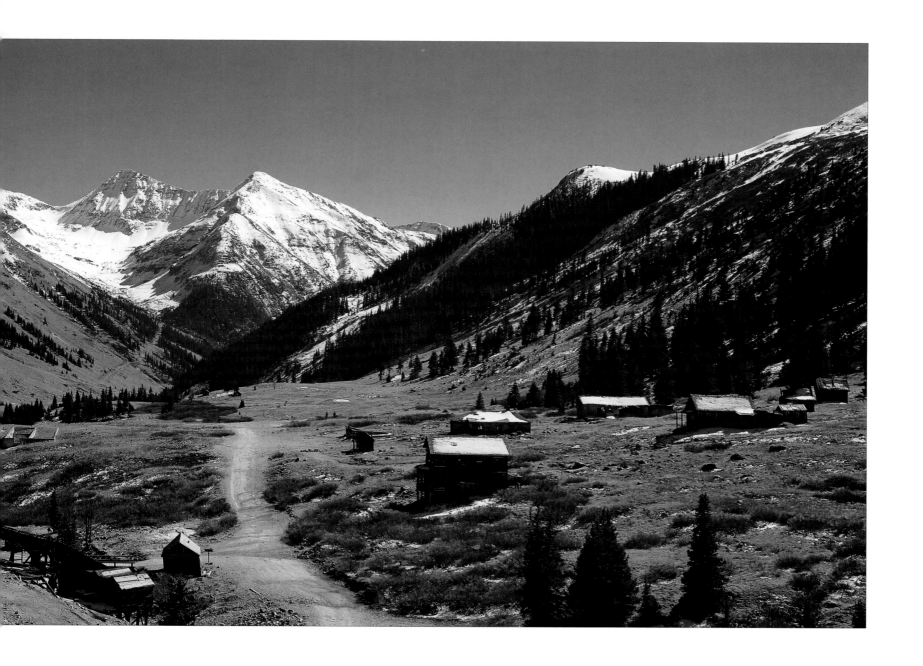

Animas Forks, San Juan Mountains

𝒜nimas Forks, founded in 1875 in the Animas River Valley west of Cinnamon Pass, was once a busy town at the terminus of the Silverton Northern Railroad. In 1904, it boasted Colorado's largest stamp mill, the noisy Gold Prince. Today the only sound heard is the wind whistling through the abandoned buildings of a bygone era.

Left: Timeworn Alta near Telluride

ℋigh in the Uncompahgre National Forest lies the ghost town of Alta. Another victim of the boom-and-bust cycles of the Four Corners' mining heyday, Alta boasted a school, boardinghouse, rough-hewn log cabins and ore mill, not to mention a marvelous view of magnificent Wilson Peak in the distant San Miguel Mountains.

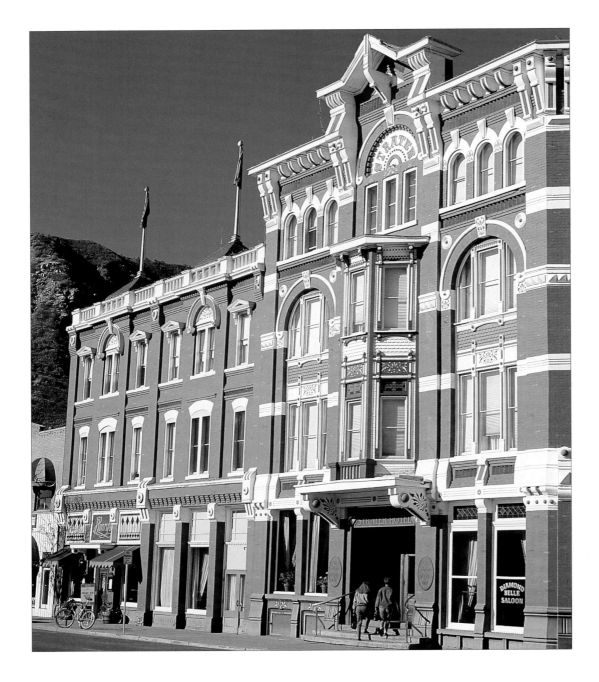

Historic Strater Hotel, Durango

\mathcal{C}onstructed in 1897, the Strater Hotel is a striking example of the Victorian architecture which adorns Durango's two national historic districts. A railroad terminus, the town was a supply depot for nearby ranchers and farmers as well as mining camps located deeper within the formidable San Juan Mountains.

Right: Square Tower House, Mesa Verde National Park

\mathcal{C}olorado's first national park, Mesa Verde is located in the arid plateau country of the Four Corners. A land of canyons, sandstone cliffs, and mesas covered with piñon and juniper, Ancestral Puebloans reached a cultural zenith here during the late 13th century, then abandoned their ingeneous dwellings for reasons still not fully understood today.

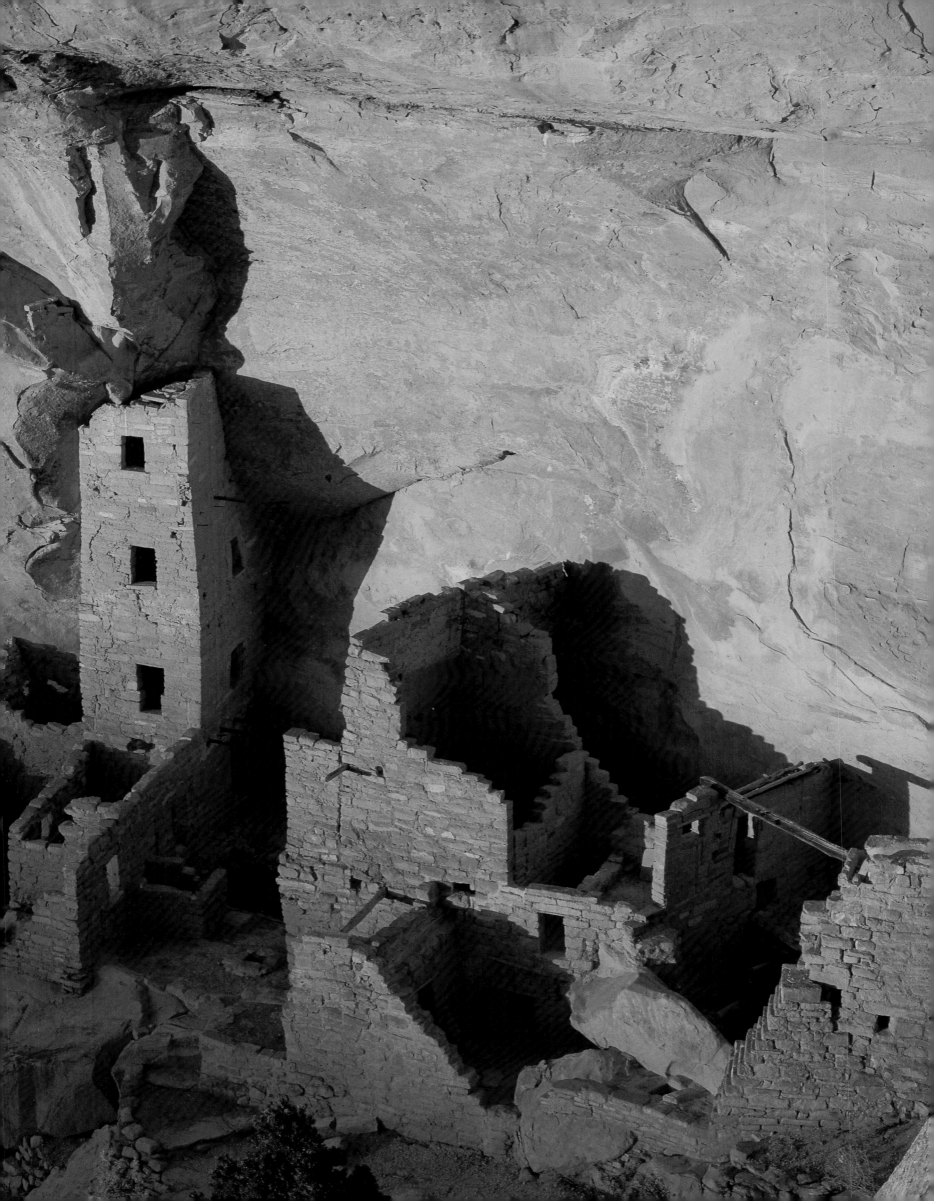

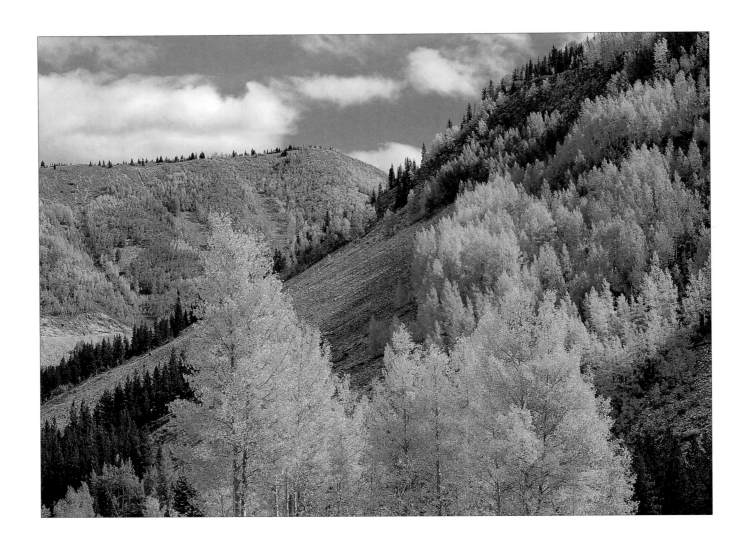

Autumn along the San Juan Skyway, San Juan Mountains

*O*ne of the first U.S. Scenic and Historic Byways, the San Juan Skyway is often considered the finest of 21 notable Colorado scenic byways. The Skyway's 236-mile course winds through a terrain marked with spectacular volcanic calderas, glacial valleys and box canyons, passing through the Four Corners' principal cities—Durango, Silverton, Ouray, Telluride and Cortez.